R. Atkinson Fox
HIS LIFE AND WORK

RITA C. MORTENSON

ISBN# 0-87069-437-5

Cover design: Geri Wolfe
Interior layout: Mary Jane Strouf

Library of Congress Catalog
Card Number 84-052274

Published by: L-W BOOK SALES
 PO Box 69
 Gas City, IN 46933

Printed by IMAGE GRAPHICS, Paducah, Kentucky

This book is respectfully dedicated to:

My husband Bob, who has provided economic and moral support, eaten a ton of cheese sandwiches, and moved the filing cabinet five times in the past four years.

The college instructors, especially Berniece Craig, Jack Florida, and Dr. Robert C. Jones, who turned me on to learning and encouraged me to write.

My grandmother Stella Horn Rickel, who was the first to believe in me and who takes such pride in everything I do.

The memory of Charles H. Fox. I wish I could have finished this in time for him to have seen it.

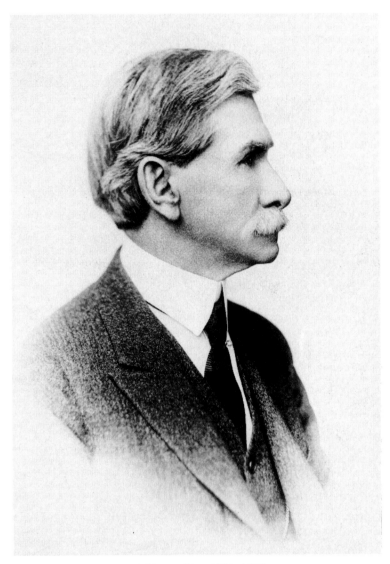

R. Atkinson Fox 1860–1935

CONTENTS

Foreword 6

Preface 7

Acknowledgments 8

Photograph Credits 9

1 A Few Words About Style 10

2 Remembrances of Family and Friends 12

3 Fox at Home 18

4 Fox in His Studio 21

5 The Oils 25

6 The Publishers 37

7 The Prints 45

8 Pseudonyms and Other Confusing
 Signatures 133

Appendix 141

About the Author 144

FOREWORD

The project known loosely and affectionately as "Fox Hunt" was born in the spring of 1980. It grew from my frustration as a writer, researcher, and antique dealer, with the lack of information on the artist whose prints were being avidly sought by so many collectors. "R. Atkinson Fox collectors, UNITE," read the tiny ad in a March 1980, issue of *The Antique Trader*.

Collectors from all over the United States responded to this plea in the search for the prolific but elusive R. Atkinson Fox. At the time the ad appeared, a single mention of Fox in a *Dictionary of World Painters* was the sum total of my information. I didn't own a Fox print.

During the following two years, I corresponded with collectors, librarians, and officials at museums and art societies, wrote three articles on Fox, published an unprofessional newsletter, and focused my efforts on finding the Fox family. We could, I knew, compile a catalog or collector's guide of available prints without the family, but then we would never know the man.

The high point of "Fox Hunt" came in the fall of 1982, when I finally found Fox's surviving children. They are the ones who have put the "life" into *R. Atkinson Fox: His Life and Work*.

As the family members worked together to compile statistics and memories, the interest in Fox, and "Fox Hunt" continued to grow. Three more articles were published, and every issue of *The Antique Trader* in which a "Fox Hunt" article appeared was a sellout. The magazines themselves are now collector's items, and prices are rising rapidly on the secondary market.

Harried by the demands for copies of past articles each time a new one appeared, Kyle Husfloen, *Trader* editor, issued a special limited number of reprints of the six articles on better quality paper. "The Fox Folio" quickly sold out and has been reprinted.

Such high collector interest is a credit to Fox the artist. It is a credit to Fox the man that he left not only an important body of work, but a memory so joyous that his children have kept it alive to be shared on these pages.

I wish Fox were alive today. I'd like to introduce him to the modern interpretation of the Morris chair, the recliner. I'd like to watch his eyes light up at the keyboard of a computer and hear his hearty chuckle as it talks back to him. I'd like to tell him the atom bomb was worse than he imagined, and that today we take "blimps" into outer space and bring them back. I'd like him to know how many people enjoy and appreciate his work.

I never knew R. Atkinson Fox, but I miss him.

PREFACE

As you read this book, please keep in mind that where I use the collective "we," I'm referring not only to the members of "Fox Hunt" but to anyone who might have written to me. When I use the personal "I," I'm referring to efforts initiated by myself, usually involving research or some personal contact, such as with a publisher or a member of the family.

For your convenience, prints are arranged according to subject matter. A detailed table of contents is included to aid readers in locating and identifying certain prints.

Illustrations are numbered Fig.1 through Fig. 419, with Fig. 1 being the first picture in the book and Fig. 419 being the last.

The numbers that appear in parentheses are "Fox List" numbers. The "Fox List" was complied during my research to facilitate communication between collectors and dealers. Each print was numbered in the order in which it came to my attention. Titles, of course, might have been easier, but not all Fox prints are titled, and one hesitates to invent a title for someone else's work-especially since the original title might surface later. I am retaining the "Fox List" numbers in consideration of those collectors and dealers who, through membership in "Fox Hunt" or the articles in *The Antique Trader,* have cataloged large collections or inventories according to this system.

Numbers that appear directly after the title or the publisher's name are usually the publisher's inventory or identification number. Large numbers preceded by a letter, such as G-666293 or K-218148, are copyright numbers of the Copyright Office in the Library of Congress. Publisher's numbers and copyright numbers are included for information only and are not necessarily of concern to the reader wishing to locate and identify a print.

This book is by no means complete. Although Fox was respected as an artist during his lifetime, his importance was not recognized. Thus, little or no effort was made to preserve the letters, sketches, and other private papers that could have been so helpful now. In addition, many prints exist that are not documented, and there are still-unexplored avenues of research that might reveal more details of Fox's life and work.

I started this project four years ago to facilitate communication between collectors and dealers. When I came to know the family and, through them, R. Atkinson Fox, the project became more than that. It became an effort to pay tribute to a man who created a body of work that has been enjoyed so much by so many. And it became a desire to share with others what I have learned about Fox, not only as an artist, but as a man, father, husband, and friend.

Buyers beware. Reproductions and laser copies are everywhere. If you are buying "old" and paying "old," the seller should be willing to provide a written, money-back guarantee.

New Collectors are coming into the (dare I say "fold"?) everyday, so there is still some demand for the more common, widely available prints. However, prices for these prints have not changed much in the past several years. Prices for the scarce or highly desirable prints, however, have risen steadily. The most elite of these often change hands quietly, among the innermost circle of the collectors, without ever reaching the open market.

Still, the mail occasionally brings a photo of a previously unlisted print of desirable subject offered at a reasonable price at a show or shop. And always there is the isolated garage-sale bargain. May it always be so, for the hunt is half the fun.

Thanks again to Neil Wood and L-W Books for their continued interest in R. Atkinson Fox.

Happy Fox Hunting

Rita Mortenson

◆ ACKNOWLEDGMENTS

Although my husband is credited in the dedication of this book, he deserves a word of thanks all his own. No one could have been more supportive, understanding, or helpful. My children, too, have endured the disadvantages of having a mother who works full time and then comes home and works some more. And frequently they have found themselves in the awkward position of trying to explain exactly what it is their mother does.

Every "Fox Hunt" member has contributed to this book. Wtihout their enthusiasm and generous sharing of time, money, and - most important - their collections, there would have been no magazine articles and no book on Fox. Although several members have gone far beyond "active membership," I am going to avoid naming anyone for fear of leaving someone out.

I owe a special debt of gratitude to the Fox children. We know Fox as a warm, loving man with a gifted intellect and ready humor only because of memories his children nurtured over the years and have so generously shared with us.

My first liaison to the family was Fox's son Charles, who died in 1982 of a massive heart attack, suffered while playing golf with a friend on a beautiful spring morning. His wife Ethyle, an enthusiastic and talented correspondent, wrote to me, "I know that's the way Charles would have wanted to go, but it's so final. I miss him dreadfully. I'm sorry you didn't know him in person. He was the kindest, most gentle, patient, and beautifully talented person I knew. We would have been married forty-five years this coming October. He was delighted to know someone wanted to write about his father."

After Charles' death, Bill Fox took over as my link to the family. Bill is a quiet, gentle man with an easy laugh, and his wife Lil is known by family and friends for her jokes. Bill and Lil paid me and my family the honor of visiting our home in the fall of 1982. We couldn't have been more comfortable with friends we had known all our lives. Bill has been tireless and generous in supplying information, pictures, and any other materials I might request.

Also deserving special recognition is Kyle Husfloen, editor of the Antique Trader. He has helped and promoted this project by publishing every article I've sent him, even when the photographs - gathered from a variety of sources - weren't up to Trader standards. Kyle has also been generous with his time and expertise when I needed advice.

During my research, a number of librarians and museum personnel, as well as two former Fox publishers who are still in business, have been extremely helpful. I would like to thank:

Rebecca Sisler, RCA executive director.
Nancy Allen, librarian, Mus. of Fine Arts, Boston
Patricia Tyler, librarian, Seattle Public Library.
Colleen Dempsey, Public Archives, Canada.
Maija Vilcins, National Museums of Canada.
Charles Kratz, UMKC Library.
Miriam Lesley, Free Library, Philadelphia.
David Kiehl, Metro. Museum of Art, New York.
Jim Burant, Public Archives of Canada.
C. E. W. Graham, McCord Museum, Montreal.
Sam Daniel, reference librarian, Library of Cong.
Dick Howlett, Thos. D. Murphy Co.
S. G. Huntington, Brown and Bigelow.

For this second edition, I am deeply grateful to Neil Wood of L-W Books who recognized a need and moved to fill it.

PHOTOGRAPH CREDITS

In preparing this book, it was not possible to bring all the prints to one location to be photographed under uniform lighting by a professional photographer. The prints represented in this book belong to collectors all over the United States. Some have been photographed by professionals. In some cases, a relative or neighbor with a "good camera" has lent a helping hand. And some prints simply have been leaned against a tree and snapped by whatever camera was available. Wallace-Homestead deserves thanks for recognizing that it is more important for you to see a photograph of a print than to omit it because it fails to meet their usual high standards. Again, I wish to thank all who sent photographs of prints from their collections.

All prints credited "Library of Congress Collection" were photographed by Linda Christenson, a free-lance photographer in Arlington, Virginia.

I was unable to credit the photographs of Fox Hunt Numbers 76, 169, 175, 183, 186, 189, 194, 208, 211, 212, 224 and 303, as well as the two Lewis-signed prints in the chapter on pseudonyms. These pictures had no names on their backs, and, over time, the pictures were separated from their accompanying letters. I regret not being able to credit these contributors for their efforts, but I thank them very much.

1
A FEW WORDS ABOUT STYLE

There are two basic attitudes toward art. One is the elitist belief that art must be isolated from the uncultured public. It must be "by the few, for the few." I don't dismiss the significance of this approach, for as the artist searches for previously unexpressed relationships between thought and matter that will elude the "uncultured public," something new is created that increases our understanding of the universe.

The other approach to art involves relating to and enriching everyday life. Art is strictly cultural and culture is strictly human. From the beginning of time, we have sought to enrich our lives by decorating our surroundings with images or representations of those things we value. Thus, machinery is sleek, a cow is picturesque, and the relationship between child and parent remains a thing of beauty.

Fox always worked with subjects that related to and enriched everyday life. He avoided the ultimate craftsmanship of the photographic realist in favor of his own technique, which was softer, warmer, and allowed the viewer more latitude for imagination and interpretation.

His earliest work, and that which he did for himself, friends, and family, throughout his career, was probably his best. Naturalism was his forte. He was the "best painter of horses and cows of his time," according to his grandson Charles Atkinson Fox. And he made a living doing what he did best—painting landscapes, rural subjects, and soft, expressive portraits.

There is little doubt that the financial needs of his large family persuaded Fox to begin painting for publication. This, of course, meant sacrificing a good deal of creative freedom. He was required to paint what publishers wanted, and publishers wanted what would sell—subjects with mass appeal. There was still a demand for his beloved landscapes, rural scenes, and pretty girls, but during the 1920s, he also was expected to turn out a certain amount of work in the popular Art Deco mode. Fox liked these pictures the least, but they were popular and widely distributed at the time, and they still are sought by collectors who specialize in that period.

Collectors often ask how to identify a Fox print. The most desirable way, of course, is by the signature. But signed prints can be few and far between for the eager beginner. One "Fox Hunter," Charles Mandrake, has been highly successful at picking up unsigned prints that are later verified as Foxes. With much modesty (and some arm twisting on my part) Chuck consented to share his technique—not a little of which, as he explains, is based on intuition. When intuition says "maybe," Chuck gets out his magnifying glass to search for clues that say "Fox."

Of the artist's flowers, for example, Chuck says, "Fox had a way of painting flower buds. He often laid down the petals with one or two strokes in a certain way, and he used the same types of plants again and again. He most frequently employed what I call an 'old school' technique, with rather softened edges, on his landscapes; his principal subjects are usually sharply defined against the background. His clouds are soft, with very similar configurations, and he used a particular blue in his skies. The hills we so frequently see descending to water's edge in the background are generally shaped and detailed in the same way. I also look at his way of indicating leaves and the texture of tree trunks.

"I feel Fox painted a lot from memory (a fact verified by the Fox children). Where Maxfield Parrish, for example, would actually pile sand on a piece of glass to indicate hills descending to the water's edge and use this as a model for lighting and texture, I believe Fox painted backgrounds particularly from his 'mind's eye.'

"In scenes with people, female faces are generally similar, except where he was painting a particular person. Certainly they don't all look alike, but Fox had a certain way of indicating features—hair, for example.

"Finally, in a number of his paintings, Fox used a high proportion of medium to pigment, resulting in a thin paint that smoothed and blended softly. However, I have also found pictures on which the paint was thicker and left tiny ridges or brush marks.

"Actually, the longer I look for Fox, the less I rely on details such as technique, composition, and color. I find that, after looking at so many prints, I have subconsciously assimilated these details to the point that I can generally recognize a Fox at a glance. Any experienced collector will know what I mean."

Experienced collectors have little problem distinguishing RAF's work from that of Maxfield Parrish, but beginners often are confused by the two. Chuck Mandrake addressed that problem as well.

"Parrish painted, often from photographs, with a photographic viewpoint. From the 'camera's eye,' so to speak. Actually, we don't see that way, as our eyes are designed to focus on one area at a time. Everything else in our realm of vision at the time will be less sharply defined than that which we are focusing on. We refer to this as seeing out of the corner of our eye. In nature, particularly, I see things out of the corner of my eye that are form and color and cry out 'Fox.'"

The Printing Process

Is it an original print? The perfection of photographic reproduction in the nineteenth century made it necessary to redefine the term "original print." Until recently, only lithographs, silkscreens, woodcuts, and etchings earned the label "original," because they all required the "hands-on" creative participation of the artist in the reproduction process itself.

Photographic processes have allowed artists to work within the medium they like best, such as oil on canvas, but still sell the work to a publisher for reproduction on calendars, magazine covers, advertising, illustrations, or other purposes. Photographic reproduction has been snubbed just as the older processes were when they first became popular as "poor man's art."

Collectors have redefined "original" as it applies to artists whose work has been reproduced by photographic processes. If the print exists in the form for which it was originally painted—whether it be a Rockwell magazine cover, a Rose O'Neill illustration, a Parrish ad, or a Fox calendar or print, it is an original. And collectors do make the rules, you know.

The work of Rockwell, O'Neill, Parrish, and others has been so popular that modern reproductions do exist. This hasn't happened with Fox—yet. At the time I am writing this, if you have a print signed "R. Atkinson Fox," there's no reason to think it's not an "original print."

2
REMEMBRANCES OF FAMILY AND FRIENDS

My father never became an American citizen. Becoming an American citizen required, at the time, the signing of a pledge to bear arms against any enemy of the United States. With the possibility, however remote, that "the enemy" might one day be Canada, my father could not sign. He was very proud of his Canadian heritage.

Charles Fox

R. Atkinson Fox was born in Toronto on December 11, 1860. He was one of four sons born to Sarah Atkinson and William Henry Fox, a Presbyterian minister. Little is known of RAF's early life. In fact, his son Bill recalled having heard just one story—about the time young RAF's chemistry set exploded and blew him down the front porch steps.

One of RAF's brothers, William Wesley, became a well-known, highly respected journalist-photographer. His colorful and heroic life was reviewed in this obituary from the *Toronto Globe*.

W. W. Fox Is Dead: Veteran Newspaperman

By the death at Cochrane, reported yesterday, of Mr. William Wesley Fox, Ontario loses one of its veteran newspapermen of the old school. The remains will be brought to Toronto for burial. Final arrangements for the funeral service, which will be held at the residence of Mrs. Stacey, a daughter, 11 Winchester Street, have not been completed.

Mr. Fox was actively engaged in newspaper work till about six years ago, when he was appointed Provincial Deputy Game Warden for the mining district, a position which he filled till his death. He is survived by a widow, two daughters, and two sons.

In the literary world he filled the dual role of a newspaperman and a photographer, and penned many articles accompanied by photographic illustrations, which appeared in the leading publications of Canada from time to time.

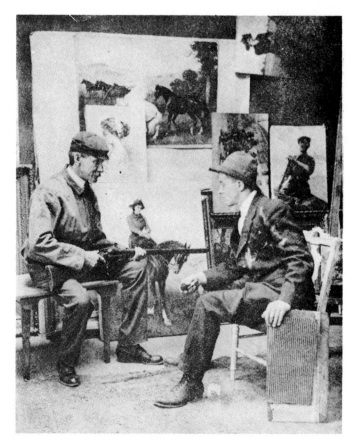

Fig. 1. R. Atkinson Fox (left) with his nephew Garnet B. Fox. Paintings by RAF hang in the background.

When the rebellion in the northwest broke out Mr. Fox enlisted for active service and wrote special articles for the "Toronto Mail." Returning to Toronto, he became affiliated with the Queen's Own Rifles. After serving with that regiment for a few years he enlisted with the Toronto Field Battery, and afterwards took a special training course at Kingston and obtained a first-class certificate.

When Major Moody and his exploring party invaded the Hudson Bay territory in the interests of the Dominion Government, Mr. Fox accompanied the party and wrote special articles for several Toronto newspapers. For many years Mr. Fox contributed special articles, which periodically appeared in "The Globe."

At the time of the big conflagration in the Porcupine district a few years ago, Mr. Fox distinguished himself by his bravery for saving a French family—husband, wife and two children. Obtaining a canoe, he rescued the entire family who had (been) forced to seek refuge in a lake. He rowed the family to a point of safety.

The husband, in recognition of the heroic efforts of Mr. Fox, offered him a substantial sun of money, which he declined to accept. Subsequently the French Consul at Montreal visited Cochrane and conferred upon Mr. Fox the cross of the Legion of Honor. Mr. Fox had a very large circle of friends, to whom he was known as a good, straight, level fellow, always ready to lend a helping hand.

William, known to RAF's children as Uncle Will, had four children of his own. One of them, Garnet B. Fox, became an artist whose calendars were published in the United States. Garnet probably knew more about his uncle RAF's early life in Canada than anyone. He knew, for example, that RAF's first wife was a concert pianist, and he could point out the church in Toronto where his grandfather had practiced his ministry.

According to Fox family friend Oscar M. Mayer, Garnet served in the Canadian Navy, lived with RAF and his family in Chicago for several years, and died in Toronto around 1977.

Another of RAF's brothers, Henry Watson Fox, was known to RAF's children as "Uncle Harry." He told them stories of having heard the news of Lincoln's assassination and of having been "up in the bush" (northern Canada) with Uncle Will.

A third brother, listed in the family Bible as Joseph W. P. Fox, "disappeared," according to family folklore.

Starting Out

RAF worked in Toronto as an artist and portrait painter from 1877 to 1884. His address in 1884 was 58 Adelaide Street, Toronto. In 1885, he worked for T. Lyons, a stained-glass manufacturer. (Letters to a man who is reportedly conducting research on stained-glass manufacturers in Canada have remained unanswered.) The name R. A. Fox was included in exhibitions of the Royal Canadian Academy of Arts (RCA) and the Ontario Society of Artists in 1885.

Fox apparently moved to the United States between 1885 and 1890. Auctions of his work were held in New York in 1891 and in Boston in 1893. The Boston catalog lists his address as New York. He exhibited with the Philadelphia Art Club in 1897 ("Bull") and 1898 ("Cattle"), and "Bull" was illustrated in the 1897 catalog. The Philadelphia Directory shows Fox's address as 1308 Walnut Street, Philadelphia, for 1900 to 1902. There is no listing in the 1903 directory.

Fox married Anna Gaffney in 1903, when he was almost forty-three and she was twenty-five. The marriage license, issued September 24, 1903, lists Fox's address

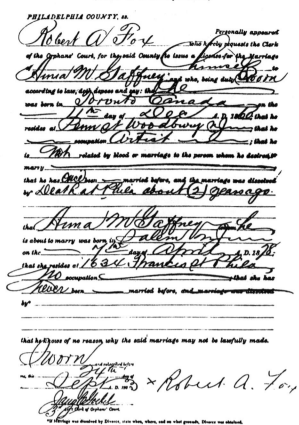

PHILADELPHIA COUNTY, ss.

Fig. 2. Application for a license to marry Anna M. Gaffney, signed Robert A. Fox.

as "Penn. St., Woodbury, N.J.," and Anna's as "1634 Francis St., Philadelphia." It also states that Fox had once been married before, and that the marriage was "dissolved by death" in Philadelphia about two years before.

Bill Fox was an adult before he learned that his father had been married before. He is convinced that there were no children from that marriage. "My father loved and enjoyed his children too much to have ever lost touch with any he might have had."

Little is known of Anna's background, except that both her parents were born in Ireland and that, after coming to the United States, her father did some farming in New Jersey, a popular tobacco-growing area. Anna delighted in telling her children of the first time her father planted tobacco. After all the work involved in getting the stuff into the ground, then fighting the vagaries of nature—floods, droughts, and insects—and then harvesting and hanging it in a shed to dry...it was stolen. According to Anna, he never planted tobacco again.

13

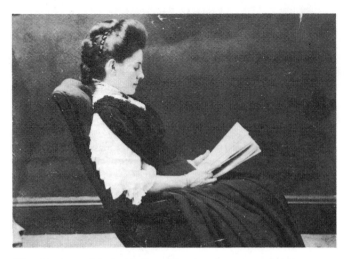

Fig. 3. Anna Marie Gaffney Fox in an early photograph.

From the marriage license, we know that Anna was born in Germantown, Pennsylvania, on April 7, 1878. She often spoke of a sister Marguerite, who died in New Jersey in the late 1940s or early 1950s. All that is known of another sister is that she lived in Louisiana.

A Growing Family

RAF and Anna became the parents of eight children. Robert Atkinson Fox, Jr., born June 23, 1904, in Woodbury, New Jersey, had two children—R. Atkinson Fox III and Kitty Ann. RAF Jr. is deceased.

Anna Marie Fox, born April 6, 1906, in Wenonah, New Jersey, is married and has no children.

Charles Henry Fox, born August 15, 1908, in Elizabeth, New Jersey, had one son, Charles Atkinson (Chuck) Fox. The elder Charles made his living as a commercial artist. "I have always wished we kids had paid more attention to my father's art when he was alive," he once wrote to me. "We could have learned so much, and I know it would have meant a lot to him."

William Albert Fox was born October 8, 1909, at Elizabeth, New Jersey. Bill, who has served as my liaison with the family since Charles' death, is married and has one child. He never made a career of art, but paints as a hobby in his retirement.

Lillian Theodora Fox (Dot) was born February 8, 1911, also at Elizabeth. Dot is the mother of two sons and one daughter. Her husband died in October 1973.

John Gordon Fox (Jack) was born September 23, 1913, while the family still lived in Elizabeth, New Jersey. Jack enjoyed sketching famous people—movie stars, for example—and sending the sketches to them. Frequently they would be autographed and returned. Jack died in 1960 and is buried beside his mother in a Chicago cemetery.

Flora Mae Fox (Flo) was born February 15, 1919, and was the last Fox child born in Elizabeth. Flo is married and has a son and daughter.

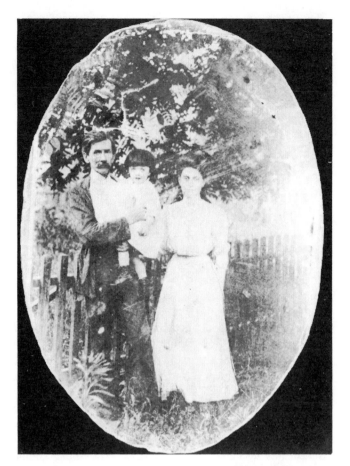

Fig. 4. RAF and Anna with their first child, Robert Atkinson Fox, Jr.

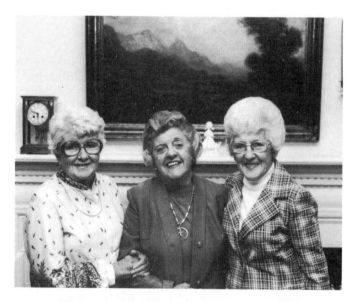

Fig. 5. Three of the four Fox daughters in a recent photo. Left to right: Flo, Ann, and Dot. Note Fox landscape over mantel.

14

The youngest child, Hazel Fox, was born February 18, 1920, after the Foxes had moved to Asbury Park, New Jersey. Hazel is married and has two sons and one daughter.

The Fox family moved several times before settling in Chicago. After RAF Jr.'s birth in Woodbury, New Jersey, in 1904, they moved to Wenonah. Both Woodbury and Wenonah are near Philadelphia, where most of RAF's business was at the time.

Sometime between Ann's birth in 1906 and Charles' in 1908, the family moved to Elizabeth, New Jersey, which is closer to New York. Their house at 1107 Bayway was built to order by Richard Hayes in an area of new homes on the outskirts of town. Bill recalls that the house was heated with gas produced by a machine in the basement. It was Uncle Harry's responsibility to take care of the carbide machine.

Bayway was an unpaved street. A man known as the "little old lamplighter," came along each day, just before dark and just after dawn, to turn each gas streetlight on or off. Bill recalls motorcycle races held along muddy Bayway as tests for the military early in World War I.

Across the road from the house was a field that was kept in crops. Dr. E. P. T. Osbaldeston, a friend of the family, would take the Fox children for walks in this field and regale them with tall tales. A Crimean War veteran, the doctor had been an eyewitness to the Charge of the Light Brigade, a friend of Edwin Booth (brother of John Wilkes) and Henry Ward Beecher, and operator of a massage parlor, among other things. His lengthy obituary characterized him as a colorful romantic who sent a pair of blue silk pajamas and a note of instructions to the undertaker, just before putting two .32-caliber bullets in his body—one in his heart and one in his head—at the age of ninety-nine.

Other friends and neighbors in Elizabeth included the Berliners, Horners, Bauers, Prays, Traphagens, Sumners, and Morgans. (Charles A. Fox was named after Charles Morgan.) Groups of these friends often got together with the Foxes. While they played cards, Fox would engage them in lively discussions of current issues.

Anna and RAF enjoyed taking their children to parades in Elizabeth. These were colorful military events, and Bill recalls that some of the marchers wore uniforms from the Spanish-American War. The "horseless carriage" was still enough of a curiosity to warrant special automobile parades.

Two of the Fox children offer interesting contrasts in their remembrances of RAF's "studio" in Elizabeth. Ann remembers that "Father had a studio behind the house in Elizabeth. It was a special building with a skylight and several windows." Charles' recollection is less romantic: "In Elizabeth, Father painted in an outbuilding, as there was no room in the house. It must have been hectic at home."

Bill recalls the family planting a tree in front of the house in Elizabeth. "We spoke of when it would grow bigger, but we moved to Asbury Park before there was much growth at all."

Asbury Park is on the Atlantic Ocean, about forty miles south of New York City. The house on Eighth Avenue, were the Foxes lived, was once occupied by a former president of Mexico. Leisure-time activities there included a rare meal out at RAF's favorite restaurant, the Ross-Fenton Farm, and walks along the boardwalk and beach. Anna and RAF also enjoyed taking rickshaw-type rides along the beach and listening to Arthur Pryor's Band and other celebrity performers at the Asbury Park Auditorium.

Motorized vehicles were still objects of curiosity—trips of any distance were made by train, and there were always more horse-drawn vehicles than autos on the ferry crossing the Delaware or Hudson Rivers. Airplanes were strictly for the military and special sight-seeing tours.

World War I was in full force while the Foxes were living in Asbury Park, and the parades and military exhibitions were exciting to the Fox children. Bill recalls one wartime fund-raiser that featured a human fly who scaled a five-story department store building in downtown Asbury Park. Everyone in town would come outside to look when the military planes flew over to drop pamphlets and perform stunts.

Bill recalls that it was 1919 when the family moved to West Long Branch, New Jersey, because he remembers hearing the siren at 11:00 am, November 11, 1919, celebrating the first anniversary of the armistice. He and Jack thought the alarm was a swarm of bees and ran inside for protection.

The children also recall seeing the airship *Shenandoah* fly around their school from its base at nearby Lakehurst Naval Air Station. Lakehurst was allocated to the Navy as a base for lighter-than-air craft in 1919. It was from this base that America's first dirigible, the *Shenandoah*, made its initial flight in 1923. It was also at Lakehurst that the *Hindenburg* burned May 6, 1937. The *Shenandoah*, too, eventually crashed and burned with heavy loss of life. RAF frequently mentioned that he would like to fly in "a blimp."

The Foxes' three-acre farm in West Long Branch was a short distance from Shadow Lawn, President Wilson's summer home. A large sign at the south entrance to town proclaimed, "WEST LONG BRANCH, SUMMER CAPITOL OF THE UNITED STATES."

The children, particularly, enjoyed springtime in the country. Each boy had his own small plot in the garden. Because RAF and Anna had little time for gardening, Uncle Harry, a frequent visitor, took care of it.

Living on a farm also allowed the children to accumulate quite a menagerie. In addition to the "mean horse" Uncle Harry used for plowing, there were rabbits, chickens, nine cats, and three dogs, including a collie named Rover that RAF used as a model in several paintings.

Fig. 6. Anna at West Long Branch, New Jersey.

RAF made frequent business trips to Chicago from West Long Branch. During one of these trips, he was seriously injured when hit by a taxi. Anna went to Chicago and stayed with him until he could be moved to the hospital in West Long Branch. While in Chicago, Anna was a guest of Sam and Ann Ford. Sam was an employee of the John Baumgarth Company.

The Move to Chicago

Shortly after this incident, RAF and Anna decided to move the family to Chicago, probably to cut down on his time away from home. Bill recalls the move: "It was quite an adventure for all of us, making the trip by train to Chicago. I'm sure Mother had her hands full with the eight of us. I remember going to Asbury Park to catch the train for Philadelphia. At the Philadelphia station, some sailors offered us kids some candy. I think that, after some hesitation, Mother let us accept it. It was night crossing Pennsylvania, so we did not see the mountains as we had hoped. During the day we crossed Ohio and Indiana, arriving in Chicago after dark. It was around Christmas, so the days were short. I don't remember exactly who met us, but I think they were all connected with the John Baumgarth Company. We couldn't all fit into one car, so some of us had to go in a cab to our new home on Bittersweet Place very close to Lake Michigan. When we arrived, all our furniture was there, and all we had to do was go upstairs and crawl into our already made-up beds. I wonder how they did that?"

In Chicago, the family lived at several different addresses, and RAF rented several different studios. The family made friends that they are still in contact with today.

Among the first friends the Fox boys made in Chicago was a son of Dr. W. A. Newman Dorland. Dr. Dorland was the author of a medical dictionary that is still used by hospitals today.

Another family friend was Oscar Mercer Mayer. Mr. Mayer wrote to me, "I grew up next door to the Fox family as far back as 1923....I still keep in contact with all the remaining children and am quite familiar with the family....Mr. Fox (RAF) influenced me tremendously in the arts—so much so that my son, Mercer Mayer, is a foremost illustrator of children's books today." (Three new titles from Mercer Mayer were featured in a recent publisher's catalog: *Just for You, Just Grandma and Me,* and *Just Me and My Dad.*)

Mr. Mayer also sent along photos of some "preliminary sketches" given to him by RAF. "I might mention," he explained, "that the enclosed photos of Mr. Fox's work were preliminary sketches done from a sidetracked railroad car at Mr. Fox's disposal to make sketches for calendars for the railroad—those selected ended up as paintings approximately 36″ x 48″ in size. His daughter Ann can't believe I talked the old boy out of these sketches and even had him sign them—after all, I was only seventeen years old. But that is how close we were. (My father died when I was thirteen and the Foxes were first to inform me.) Mr. Fox was like a father to me and, of course, I thought he was great."

The Foxes' first home in Chicago—a large apartment on Bittersweet Place, near Lake Michigan—was a far cry from the New Jersey countryside. Fox rented a studio on Edgecomb Place, a few blocks away. Later, he moved to a larger space above some stores on Irving Park Boulevard, still within walking distance from home.

Eight growing children soon required more space, so the family moved to a house at 4843 North Paulina. Fox was able to use a room on the second floor as a studio.

Later, the family moved again to a still larger house on Patterson Avenue. Wherever the Foxes lived, their home was always open to friends and neighbors, and it was a rare meal that saw family only sit down to eat. The Fox children still correspond with many of the people who visited or stayed with them during the time the family resided in Chicago. Stuart Norgard, currently of Westwego, Louisiana, lived with the family when he was a teenager. He recalls: "Fox had a soft spot for young people, and I lived at their home in Chicago for a period of time. He liked me and I liked him. His eight children also seemed to inherit these traits from him."

The following is excerpted from a letter to Bill Fox from Al Anderson: "What I recall was that your father had a quiet and modest spirit, was friendly, with a good sense of wit and humor, subtle and otherwise. I remember you, your mother, and the others having some good laughs and kidding each other. I do not recall seeing, maybe once, your dad sitting painting up in his second-floor studio on Paulina Street. I remember your saying when you moved to Paulina Street that he preferred northern exposure of light when he painted. I recall he was always dressed in his business suit, along with his vest sprinkled with a few cigar ashes from his favorite brand of cigars. I recall only pleasant memories of the good times we had with your family on Paulina Street."

When the Depression hit, the Fox family home became even more open to friends who needed a meal or a place to stay. It was a kind of neighborhood club with boarders and guests always trying to help out or repay their hosts in whatever way they could.

After the Edgecomb Place and Irving Park studios, Fox shared a studio with the professional photographer Beatrice Tonneson on Pine Grove Avenue, south of Diversky Park. Ms. Tonneson had a hearing impairment that required her to keep an amplifier on her telephone bell. RAF often mentioned how the bell startled him when he was engrossed in a painting. RAF took a streetcar back and forth to his studio, for, although he had owned an Overland and a Maxwell, it was always Anna or one of the older boys who drove. Fox never drove a car.

Fox's Final Days

Fox's final address was 4450 North Lincoln in Chicago, the home where he died January 24, 1935. He had been in poor health for several years. Bill recalls that "During this time, he made efforts to paint, holding up his right arm with his left arm, but he just couldn't do what he wanted to accomplish. It was very sad."

RAF's doctor, A. J. McCarter, who signed the death certificate, reported that Fox had been ill since December 28, 1934. The principal cause of death was chronic myocarditis (inflammation of the heart muscle) and arteriosclerosis, which had been diagnosed two years earlier. Acute bronchitis was listed as a contributory cause.

RAF's death was a great loss to all his friends and family, but it was hardest on Anna. She missed him terribly. As the children grew, Anna and those children who remained at home moved to several different apartments, all on Chicago's North Side, and all within two miles of one another. Anna enjoyed good health, even to the extent of taking a train trip to New Mexico shortly before her death in Chicago in May, 1964.

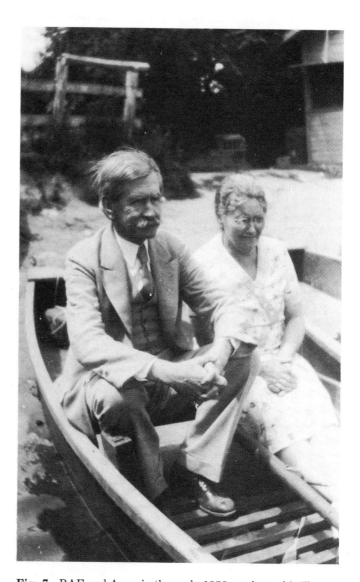

Fig. 7. RAF and Anna in the early 1930s, prior to his illness.

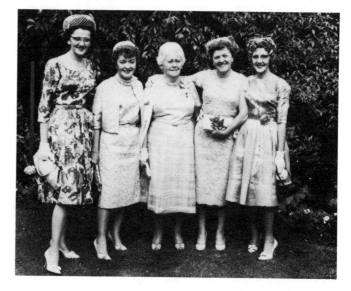

Fig. 8. Anna Fox (center) with her four daughters, probably around 1949. Left to right: Hazel, Flo, Anna, Ann, and Dot.

17

3
FOX AT HOME

My father liked and enjoyed just about everything in the world.

Bill

I can never remember him raising his voice to Mother or to any of us eight kids, although there must have been plenty of times he would have been justified in doing so.

Dot

What's in a name? Collectors recognize the distinctive signature R. Atkinson Fox or, perhaps, R. A. Fox. They are most likely to refer to the artist as Fox in conversation and as RAF in written communication. The shaky R. A. Fox on the artist's marriage license application bears little resemblance to the bold calligraphy on his prints, but then he probably didn't sign his marriage license application with a paintbrush.

How would you address the artist if you happened to meet him? If you were a casual friend or business acquaintance, you might start with "Mr. Fox" but quickly would be invited to call him "Robert." If the relationship became close, he would soon become "Bob" or "Rob." Anna called him "Bob." The children's friends addressed him as "Mr. Fox." I have noticed that his daughters usually call him "Daddy," and his sons refer to him as "my father."

Along with his art, Fox's family was the most important part of his life. He was probably away from home more than he would have liked. But even those separations evoke positive memories from the children. "We would meet him coming from the train," Ann recalls. "He would have balloons, Tootsie Rolls, and other treats for us. I particularly remember a gelatin-type fish that would curl up from the heat of my palm."

He was a devoted husband and had a sense of humor. Although none of the children recalls ever having heard them argue, Anna was not above fussing, and Fox was not shy about teasing her in return. A favorite family story that has been passed down to the great-grandchildren has Fox at the head of the table, Anna at the other end, and children and guests arranged up and down the two sides. A typical evening meal. As usual, Fox loads his coffee with sugar, stirs it, then lifts the cup to drink with the spoon still in the cup. "You'll poke your eye out," fusses Anna. Without a word, Fox grasps the spoon with one hand and with the other he bends down the handle until it is pointing at the saucer. "Now I won't," he says and continues drinking.

Fox loved sugar. He loaded his coffee with it—in fact, there was always undissolved sugar at the bottom of his cup. He also enjoyed building a neat cone of sugar on a slice of tomato. He didn't go in much for commercial candy but was always a willing customer when one of the girls made fudge or butterscotch, or if there happened to be cake or ice cream handy. One of his favorite ways of teasing the children was to distract their attention during dessert and pretend he was going to take the cake icing they had been saving for last. But, of course, he never really took it.

It is not surprising that in a family with eight children, mealtime was a memorable occasion. Some of the Fox children's fondest memories involved the contrast between the refined attire and careful attention to etiquette required at the table, and certain peculiarities in their father's eating habits, as well as the lively humor that flavored mealtime conversations.

"Daddy always ate his eggs from the shell, in an egg cup," Ann recalls. "And he never ate the center of a slice of bread, only the crust." Sometimes Fox enjoyed snacking on an apple, cutting off the slices with his pocket knife as he ate. This made Anna crazy. Fox would counter by calling her Patsy Volliver, a teasing reference to her Irish heritage. To a comment made by one of the children, he might remark, "You have a good head, but so does a cabbage." Such affectionate teasing and friendly banter was balanced with firm expectations in terms of behavior and decorum. Fox always wore a jacket to family meals and the children never left the table until they were excused.

After dinner, Fox might retire to his favorite Morris chair, the granddaddy of today's recliner, and settle back with a cigar—he smoked at least ten a day of the blackest he could find. The children delighted in hiding his cigars behind books in the bookcase and "finding them" when he thought his supply was exhausted. Fox prepared for such situations by keeping a supply of rubber bands in his pockets. He would shoot them at the children, then pretend he had no idea where they had come from.

Fox insisted his children be raised as ladies and gentlemen. He never allowed them to slouch in their chairs, he insisted the boys stand when a lady entered the room, and he couldn't abide chewing gum. But Anna was the true disciplinarian.

Anna was always "Mother" to her children. Nothing else. "Mother." Once, when Charles had climbed on a pile of hollow tile stored on a construction site, his mother had punished him for it. Anna described the incident to her husband and instructed Charles to "Tell your father what happened."

"I got a damn good licking," was Charles' reply.

Sometimes Fox's soft heart for the children sabotaged Anna's well-meaning efforts. "Daddy never spanked me," Lillian (Dot) recalls, "not even when I deserved it. But Mother would make me sit in a chair for whatever length of time she thought necessary. Daddy would come along and say 'What's the matter, kid?' and slip me a quarter. Sometimes, if I'd had to sit for an especially long time, he'd make it half a dollar."

When he had some time to himself in the evening, Fox enjoyed reading. Settled back in his favorite chair, surrounded by a small collection of art glass and his prized bronzes, he might pick up a copy of the weekly *Illustrated London Times,* one of the art magazines he subscribed to, or his daily issue of the *New York Times.* Fox always kept up with the news and was well aware of what was going on in the world. He was interested in science and astronomy and was fascinated with the potential force of the atom.

Some of the books Bill recalls seeing in his father's library include *The Outline of History* by H. G. Wells, *The Works of Shakespeare* in four volumes, *The Works of Longfellow,* the multivolume *Stoddard's Lectures,* a set of *The Encyclopedia Brittanica,* and *The Standard Dictionary of Facts.*

When friends dropped by, Fox enjoyed lively conversation and an occasional game of checkers. The children don't recall ever seeing him play cards or chess. And they never saw him take a drink. ("Mother said he used to, though, before they were married," confides Dot.) He wasn't particularly religious, but could spend long hours arguing religion with Sam Ford, an employee of Baumgarth Company, one of his publishers. And he had little interest in sports. Bill recalls being surprised that his father even knew what a home run was.

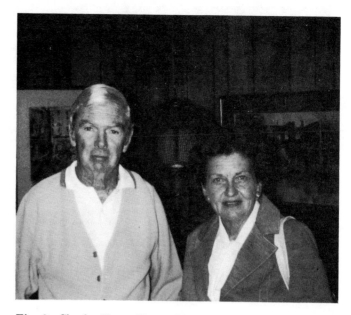

Fig. 9. Charles Henry Fox and his wife Ethyle shortly before Charles' death on April 25, 1982.

Fox did enjoy music, however. And he maintained a fine collection of classical and semi-classical records. Bill remembers his father sitting in front of a fire, listening to the phonograph. "We children had the job of changing the records and winding the machine. Daddy or Mother made the selections, of course, but they always had some children's records for us." But when the children got a little older and played their own records, Fox was not above shouting "Turn that damn thing off." He had no use for "contemporary" music. The more things change, the more they stay the same.

Despite such minute differences as music preference, the Foxes were a close family. When one of the children came down with whooping cough, for example, they all caught it. Bill recalls his mother cooking "something on the stove with lots of onions in it that she gave to us as medicine."

Christmas was always a big event in the Fox household. When the children were young, one of the parents would put "Oh Come All Ye Faithful" on the Victrola, and all the children would march into the living room. There, under the evergreen tree, were piles of packages to excite the children. As they got older, the marching stopped, but the excitement remained. All eight children exchanged gifts with their parents and with each other. As long as Anna lived, she made Christmas a great event for her children and for the grandchildren who called her "Nana."

And, as long as Anna lived, she wore the ring inscribed "R.A.F. to A.M.G., 9/3/03."

Fig. 10. Charles H. Fox with his son Charles Atkinson Fox (Chuck).

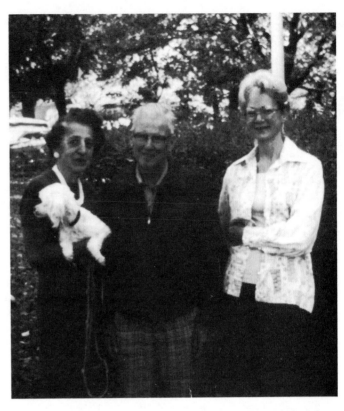

Fig. 11. The author (right) with Bill Fox, his wife Lil, and their dog Gypsy, in October 1981. Photograph by Bob Mortenson.

4
FOX IN HIS STUDIO

One time I tried to paint a horse, and I asked my father how to make it look round or three-dimensional. His advice was to shade it from light to dark on the outline edges. So I took this reddish-brown horse and (in black) shaded it from light grey to black all around the body, neck, legs, head and everywhere. He sure was round.

Charles H. Fox

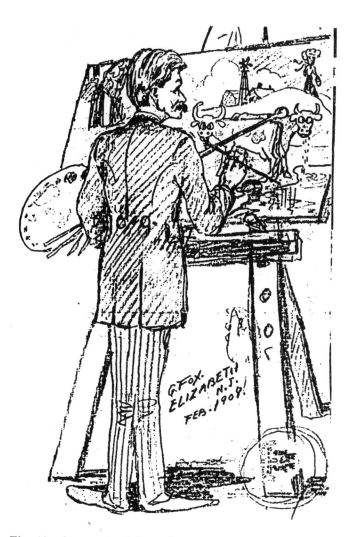

Fig. 12. A portrait of the artist at work by RAF's nephew, Garnet B. Fox.

Fox arranged to have a studio of some sort in or near each place the family lived. Like most artists, he preferred northern light because it produced fewer shadows and was relatively uniform throughout the day. Natural light was a must. There were no fluorescent lights at that time, and the artist had learned that yellowish incandescent light played havoc with his colors.

Although the children were never allowed to play in the studio, they did come to relay messages between their parents. At times they were welcomed in to watch their father paint. According to Charles, "Dad worked all the time—even on Sunday."

Most of Fox's paintings were on canvas, but some smaller ones were on a hard-surfaced board he referred to as Bristol Board, a brand name. The canvas was stretched on a wooden frame with wooden keys in the corners to ensure uniform tautness.

Bill recalls that his father used a large, sturdy easel with a recessed shelf below for paints and brushes. He apparently did not have a lightweight easel for portable painting. "I don't remember him ever going outside to paint," Bill states. "He painted his landscapes inside from sketches and from memory." (The only extant sketches we know of are owned by Bill Fox and RAF's friend Oscar Mayer. These are small examples, in oil, referred to as "preliminary sketches" by the owners.)

Fox often prepared a canvas with a coating of what he called "red lead." Although none of the children knew why he did this, a contemporary artist explained that it was to smooth the canvas for the painting and to ensure that the entire canvas was covered. His palette was made of wood and had two metal cups clipped to the surface. One was for linseed oil, and the other held turpentine.

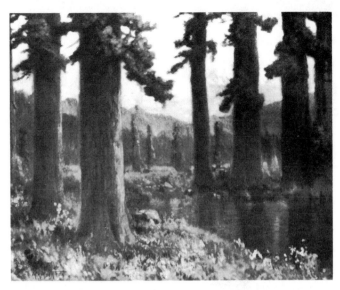

Fig. 13. Oil on canvas by R. Atkinson Fox shows evidence of having had paint applied with a palette knife. Owned by Bill Fox.

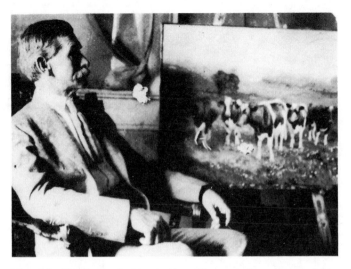

Fig. 14. The artist in his studio with a painting of one of his favorite subjects—cows.

Although they never saw him use it, the children recall that RAF had at least one straight, flat palette knife. And one of the oils in Bill Fox's possession appears to have been done with a knife. The paint on the lower left, in the foreground, is quite thick. And, although one almost has to see the original to be certain, several of the prints show evidence that paint was applied to their originals in this manner also.

Occasionally, Fox used a tapered wooden rod, known as a "rest stick," to steady his hand when he was doing something that required fine detail.

When the children were watching him, Fox would frequently allow one of them to put the last dab of paint on a canvas. He or she had thus "finished the picture."

In addition, Fox often let the children "help" clean his brushes. "Dad kept a large and extensive assortment of sable and camel's hair brushes in varying sizes," Bill recalls. "He always took very good care of his brushes—removing the paint with turpentine, then washing them thoroughly with Fels Naptha or Octagon soap. Sometimes we kids got to do the soap-and-water part of the cleaning." "And," adds Dot, "we would paint pictures on the back of the kitchen sink, but we had to wash them off and then clean the brushes. It was a lot of fun."

Ann remembers posing frequently for her father in his studio. "Hazel and Jack did too," she notes. Charles particularly enjoyed going through the clippings file in his father's studio. "He had soldiers, scenery, battleships, animals, and pretty girls." Charles also loved to smell the paint.

In Chicago, Fox purchased all his art supplies from Devoe Reynolds, an art materials supplier located in the Loop at the time. At one point, he must have purchased some watercolors, as one is listed in the Library of Congress files. This came as a surprise to the Fox children, as none of them remembered his having done anything but pencil sketches and oil paintings.

Bill Fox remembers that his father could paint very fast—often completing a painting in a day. The job of delivering the completed painting to a local publisher, such as John Baumgarth Company or Borin Manufacturing in Chicago, usually fell to one of the boys. Transporting a large, mounted canvas, especially in the "Windy City," could be quite a problem. "We would take them on the street car or the El (Chicago's elevated transportation system)," Bill explains. This usually involved a walk of several blocks at each end of the trip. Once in awhile, when the publisher saw the painting, he would want a slight alteration. "Change the position of the girl's hands," he might say, or "Tell your father to add some flowers—here." And the trip would start all over again, in reverse, for Bill.

When it was necessary to ship a painting, as it was most frequently before the Foxes moved to Chicago, Anna always did the packing. But not even shipped paintings were exempt from a publisher's craving for change. Once, a painting came back with a long list of corrections. Charles recalled that the instructions began, "Put the farmer's wife in the doorway." It continued with orders to change this, leave out that, make bushes and flowers more coloful, etc., and *"Close* the back door!"

A copy of the print "Memories of Childhood" in Bill's collection has penciled-in instructions all over it. These

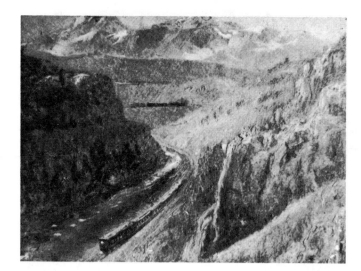

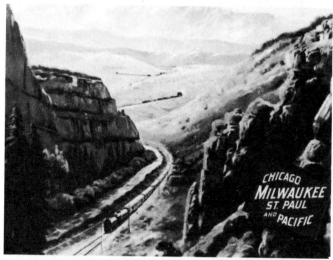

Fig. 17. Preliminary sketch in oil by R. Atkinson Fox.

Figs. 15 and 16. A preliminary sketch in oil and the subsequent print #310, an advertising calendar top for the Chicago, Milwaukee, St. Paul, and Pacific Railroad.

include "Summer sky," "Mts.?," "Lake here," "Garden House," and "House #1." The first time I saw this, I hoped it indicated that I might be able to identify, say, four basic Fox houses by number. However, after studying more than three hundred prints, I find no two houses enough alike to be referred to, for example, as "House #1."

Late in his career, Fox painted almost exclusively on commission, so he did not always have his choice of subject matter. These paintings, done for publication, were not necessarily intended to last—not like an oil on canvas done to hang over someone's couch—so RAF sometimes took a rough sketch, glued the paper to the canvas, and painted over it. This might help explain the ridiculously low selling prices on the paintings after the plates were made. And it is certainly a factor to be considered by anyone interested in buying originals by any illustrator.

Fig. 18. Preliminary sketch in oil by R. Atkinson Fox.

Fig. 19. Preliminary sketch in oil by R. Atkinson Fox.

24

5
THE OILS

Members of the art world elite have looked with disdain upon illustrators and their work. This is probably because the illustrator is obviously working on a commission—doing a job for pay. And, of course, art is supposed to be created for its own sake, not for money.

Fortunately this prejudice is dissipating, and the "poor man's art" is receiving more of the attention it deserves—witness the increasing interest in the work of such illustrators as Rockwell, Icart, Boilyeau, Fisher, Gutmann, Vargas, and Parrish, as well as Fox.

However, even if lean years (starving in a garret?) and success in oils were still the only standards by which an artist could attain credibility, Fox served that apprenticeship as well. We know from family history that Fox left home, and presumably school, at the age of fifteen. From a brief biographical sketch in *Early Painters and Engravers in Canada* by J. Russell Harper, we learn that Fox worked as a portrait painter and artist in Toronto from 1877 to 1884. That would have been from the time he was seventeen until he was twenty-four. One can only assume that these were lean years, indeed. There were no family fortunes behind him and no years in which to leisurely study and perfect his technique at school.

Fox supplemented his income in 1885 with a job at T. Lyon, Stained-Glass Manufacturer. No doubt, this experience affected his later use of color. That same year, he exhibited five paintings for the Royal Canadian Academy of Arts (RCA), and The Ontario Society of Artists in a combined exhibition held at the Society's rooms at Fourteen King Street West in Toronto.

Listed in the exhibition catalog were one hundred ninety-eight oil paintings and twenty-three watercolors by various artists. Prices for the oils (Fox showed no watercolors) ranged from a low of fifteen dollars to a high of one thousand dollars. Paintings exhibited by "R. A. Fox," their catalog numbers, and prices were:

Fig. 20. Exhibition catalog of the Royal Canadian Academy of Arts (RCA), 1885.

#125	Music Hath Charms	$50
149	A Sketch	25
167	Skinner's Cove, Labrador	50
174	Landscape	50
198	The Gourmet	150

All these paintings must have sold—if not at this exhibition, then at one time or another between 1885 and 1891, for none is listed in what apparently was the next public offering of Fox's work.

Fig. 21. Auction catalog of the Fifth Avenue Auction Rooms.

In 1891, an auction was held at the Fifth Avenue Auction Rooms at 240 Fifth Ave., New York. The auction catalog is titled, "Paintings in Oil by Mr. R. Atkinson Fox (formerly of Toronto) Comprising Forty-Four Examples, executed in the highest style of art, to which additions have been made from several Private Galleries of Characteristic Examples by distinguished Foreign and American Artists." (The creative capitalization is theirs.) The auctioneer was Robert Somerville, and the catalog was printed by H. N. Atkinson, Printer, Eighty-two Wall Street, New York.

A handwritten note on the front of the catalog reads, "Permission is hereby granted to Robert Somerville, Auctioneer, to sell the oil paintings enumerated in the within catalog on Friday and Saturday evenings, May 8th and 9th, 1891, commencing at eight o'clock each evening. H. V. Arnold, Acting Mayor." In all, one hundred and thirty-six paintings were listed. The forty-four by Fox were the following:

Catalog Number	Title
5	Old Reddy
7	Gathering Storm
9	Chums
11	A Country Road
13	Landscape and Cattle
15	A Shady Nook
17	On the Hague
19	Ideal Head
21	Four of a Kind
23	Ready for His Bath
25	Landscape and Cattle
27	Rex
30	Grand Canal, Venice
31	Grouse
33	Going Home
35	John Bull
37	Kingston Road, Near Toronto
40	Happy Hours
49	What Is It?
53	Meditation
56	A Pretty Pair
58	Miss Velvet Paws
61	Beagle
70	Evening
72	In the Barn
75	Landscape and Sheep
77	Group of Cattle
79	Waiting
81	The Pet of the Flock
83	Old Nell
85	In the Pasture
87	The Prize Winners
90	Sheep
92	The King of Beasts
94	Durham Bull
97	Helen
99	In the Wood
101	Under the Trees
104	Sheep
108	Resting
117	Bess
121	Cow and Calf
125	On the Hillside
135	At the Watering Place

Nearly two years after the Fifth Avenue Auction, on March 10 and 11, 1893, paintings by Fox were featured in an auction in Boston. The cover of the catalog reads, "Catalogue of Paintings by W. Merrit Post, N.Y., and R. Atkinson Fox, N.Y." The auction was conducted by Leonard & Company, 46-48 Bromfield Street, Boston, Mass. Of the one hundred fifty-two paintings offered, eighty were by Fox. The Leonard Company catalog is more detailed in that it includes the size of each painting. And, although the paintings are listed numerically in the catalog, I have rearranged them alphabetically here to make it easier to find a particular title.

Fig. 22. Auction catalog from Leonard & Co., Boston, 1893.

Catalog Number	Title	Size (in inches)
133	Admiration	16 x 20
17	The Amateur	12 x 16
15	At the Brook	14 x 17
27	At the Brook	20 x 24
61	At Leisure	16 x 24
143	At the Stream	16 x 20
19	At the Watering Place	18 x 24
49	At the Watering Place	18 x 24
131	At the Watering Trough	20 x 32
149	Balancing Cash	16 x 26
89	BaseBall News	13 x 17
97	The Beer Drinker	16 x 20
63	Bubbles	16 x 20
77	The Bull	14 x 17
113	Cattle and Landscape	16 x 20
69	Caught in the Act	20 x 24
122	A Close Shave	12 x 16
25	The Connoisseur	10 x 12
81	Contented	12 x 16
35	Contentment	14 x 17
124	The Convention	8½ x 24
107	The Cornetist	12 x 18½
93	Cow and Calf	16 x 20
101	Deeply Interested	16 x 20
37	Edge of the Forest	12 x 18
99	The Fishing Party	10 x 20
47	Give Us a Light	12 x 14
55	Greatly Amused	10 x 12
7	In the Pasture	12 x 20
45	In the Pasture	16 x 20
87	In the Pasture	16 x 20
67	In the Stream	16 x 20
145	In the Swing	18 x 24
129	In the Wine Cellar	12 x 16
119	Knitting	13 x 19
75	Landscape	14 x 20
71	Landscape and Cattle	14 x 20
105	Landscape and Cattle	12 x 16
120	Landscape and Cattle	14 x 22
135	Landscape and Cattle	14 x 17
91	A Lull in Business	21 x 33
115	Lunch Time	16 x 20
111	The Morning News	14 x 20
85	Morning Paper	12 x 16
5	Morning Papers	14 x 21
59	Nero	18 x 22
57	Noonday	12 x 16
103	Noonday	16 x 20
139	Noonday	14 x 22
23	Normandy Bull	16 x 20
95	Old Bess	12 x 18
142	On the Scent	18 x 26
3	Pleasant Memories	12 x 16
151	Prime Old Stuff	16 x 20
136	Puzzled	16 x 20
13	A Quiet Smoke	16 x 20
11	Reading the News	14 x 17
109	Repose	12 x 16
1	Resting	12 x 16
53	Resting	14 x 20
83	Resting	16 x 20
117	Resting	24 x 42
33	Returning Home	16 x 20
132	Returning Home	14 x 17
79	Sheep and Landscape	10 x 12
152	Sheep and Landscape	14 x 20
140	Sheep and Stable Interior	14 x 20
29	Sheep in Pasture	20 x 30
126	Sheep Watering	14 x 20
51	Sit Up, Sir!	14 x 20
31	Solid Comfort	20 x 24
138	Speak for It	20 x 24

27

Fig. 23. "Bull," by R. A. Fox, was entry #158 in the exhibition catalog of the Philadelphia Art Club for 1897.

41	A Stiff Breeze	20 x 24
65	Stocks Are Up	(No size listed)
39	Striking a Bargain	15 x 20
43	A Substantial Meal	10 x 12½
73	A Sunny Afternoon	(No size listed)
147	Telling Her Fortune	16 x 20
21	Under the Trees	16 x 20
127	Waiting for Trade	25 x 30
9	Your Good Health	16 x 20

In some cases, "Landscape" or "Landscape with Cattle" might have been a description of an untitled painting. Each painting was numbered in the auction listing, so there had to be a painting for each title.

The next professional reference to Fox is in the exhibition catalog of the Art Club of Philadelphia for 1897. Entry numbers 124, "Cattle," and 158, "Bull," were by R. A. Fox.

The Art Club of Philadelphia was also the source of a listing in the 1898 *American Art Annual*. The A.A.A. entry shows Fox's address as 1306 Walnut, Philadelphia, and mentions that he was a pupil of J. W. Bridgman. Bridgman was a well-known art instructor and author of a book widely hailed as the finest artists' book on anatomy. After 1901, Fox was no longer listed in the *American Art Annual*. And 1902 was the last year Fox's name appeared in the Philadelphia directory.

Unfortunately, we don't have access to any information regarding the prices Fox paintings might have brought at auction. Of course, we can see from the 1885 RCA catalog that asking prices for Fox paintings ranged from twenty-five dollars to one hundred fifty dollars. And we know that paintings sold to publishers for reproduction seldom brought more than one hundred dollars. But, again, these often were hastily executed on a less durable ground than were paintings sold to a collector as an investment.

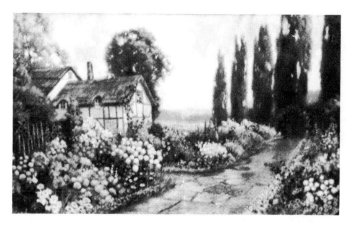

Fig. 24. "An Old-Fashioned Garden" is #12 on our Fox list. It may or may not be from the painting by that title, which was on display in Nathan's Department Store in Chambersburg, Pennsylvania

We do have one reference to a painting that was valued at eight thousand dollars during Fox's lifetime. The following is from an article in the November 15, 1929, Shippensburg, Pennsylvania, *News-Chronicle*:

Valuable Painting on Display: Chambersburg Store Showing Work of Famous Artist

Nathan's Department Store at Chambersburg is displaying an original oil painting in one of its show windows attracting unusual attention. This painting is by R. Atkinson Fox and is valued at $8,000. Mr. Fox is a recognized artist of distinction. The painting, which is 30 x 40 inches in size, was brought to Chambersburg from Chicago and is entitled "An Old-Fashioned Garden." It is enclosed in a handsome gilt frame. The exhibition of this picture is to be held in connection with a sale of framed pictures including paintings, silhouettes and etchings. It will be on display for several days.

Although none has come to my attention, there must be portraits in oil out there somewhere. We know that Fox worked as a portrait painter during his youth in Toronto. And there had to be originals for each of the portraits (#126-133) featured in the prints section of this book. Charles recalls his father telling of the portrait he made of Lillian Russell, the famous stage star of the Gay Nineties. And a publisher's blurb from the 1920s states that R. Atkinson Fox "roamed the world at will, studying and painting at the art centers, and naming among his subjects such celebrities as Presidents Harrison and Cleveland, and Princess Louise of England."

"Roamed the world at will" is, no doubt, the exaggerated product of a publisher's overactive imagination. We do know, however, that Fox studied for a time in London. Possibly the main reason the family remembers this piece of information is that, while en route from New York to England, Fox's ship broke down and was afloat for two weeks awaiting the delivery of parts.

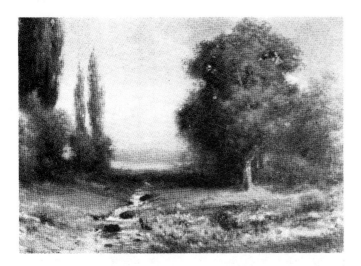

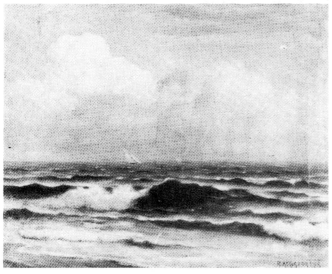

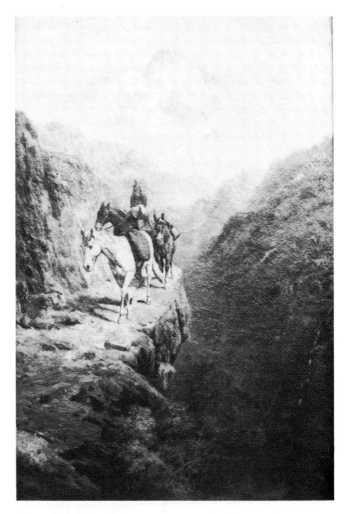

Fig. 25. Top: Autumn landscape, signed R. Atkinson Fox. Oil on canvas, 16″ x 22″. Private collection, Freeport, Maine. Sold for four hundred dollars. Bottom: "Surf with Sailboat." Signed R. Atkinson Fox. Oil on canvas, 16″ x 20″. Private collection, Freeport, Maine. Sold for three hundred seventy-five dollars. Both from Barridorf Auction Galleries, Portland, Maine.

Fig. 26. This oil on canvas by R. Atkinson Fox sold for eighteen-hundred dollars on July 10, 1981, at Wm. Bradford Auctions, Sheffield, Massachusetts.

Although there is little to indicate what a collector might have paid for a Fox original during the artist's lifetime, we do have a few contemporary figures. An oil painting signed R. Atkinson Fox (no title or description available) sold at auction at the Barridorf Galleries in Portland, Maine, on July 5, 1980, for six hundred twenty-five dollars.

"Watering," a painting described as "a cow against the sky," signed R. Atkinson Fox, 11½″ x 20½″, sold for four hundred seventy-five dollars at Richard Bourne auction in Hyannis, Massachusetts, on November 28, 1980.

Another Barridorf auction in 1981 included two Fox oils on canvas. A 16″ x 20″ painting described as "Surf with Sailboat," signed R. Atkinson Fox, carried a pre-auction estimate of two hundred to four hundred dollars. It sold for three hundred seventy-five dollars. Estimated in the same price range, a 16″ x 22″ "Autumn Landscape" brought four hundred dollars.

On July 10, 1981, a 36″ x 21″ western masterpiece featuring a weary, mounted Indian and two pack horses picking their way along a narrow ledge brought eighteen hundred dollars at a Bradfield auction in Sheffield, Massachusetts.

And on July 4, 1984, a 23″ x 35″ landscape in an outstanding gilt frame realized eleven hundred dollars at a Wolf's Company auction in Shaker Heights, Ohio.

In addition, I know of a signed, nondescript landscape in oil on canvas that was a bargain at two hundred dollars in 1982. And the original of #283, untitled, was snapped up by a lucky Fox collector in 1983 for six hundred dollars.

Fig. 27. The 31″ by 12″ original of Fox List #283, untitled, is believed to have been painted as a cover for *Field and Stream* magazine. Owned by Ron and Deanna Hulse.

A large, beautifully framed painting of cows was for sale for two thousand dollars shortly after "Fox Hunt: The Search for R. Atkinson Fox" appeared in *The Antique Trader* in December, 1980. The price has since risen to five thousand dollars and, to my knowledge, the painting remains unsold.

In that first *Trader* article, I mentioned an ad from *The National Antiques Review*. The ad featured a painting by R. Atkinson Fox entitled "George Washington Greeting Lafayette at Valley Forge." The painting was for sale for two thousand five hundred dollars. Shortly after the article appeared, I received a letter from George Michael, creator of "Antiques with George Michael" on PBS and columnist for *The Antique Trader.*

Dear Rita:

I was intrigued by your article on R. Atkinson Fox in the recent *Antique Trader.*

I have the picture of George Washington greeting Lafayette at Valley Forge that you mentioned as having been advertised on the back cover of the *National Antiques Review.* I was the editor of it at the time.

We have had the picture restored and cleaned, and it

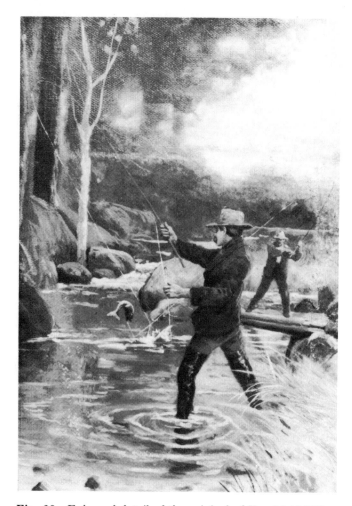

Fig. 28. Enlarged detail of the original of Fox List# 283.

looks much better than the enclosed photo. I have had this picture since 1969. It came from an estate in Pittsburgh, Pennsylvania. We have it hanging in our family room, and I have used it as a backdrop several times on my TV set. It always arouses great interest because of its subject matter.

I believe Fox was an exceptional painter. I know that most critics do not have much good to say for illustrators, but they certainly have made their presence felt.

If I can be of help to you with further information, kindly let me know.

Sincerely,
George Michael

There are many oils in the hands of collectors and other private parties who would not consider themselves collectors, who have no desire to sell their paintings. The beautiful "Mount Rainier at Sunset," for example, was inherited by a woman whose father obtained it from the publisher, The Thos. D. Murphy Co., Red Oak, Iowa (see Chapter 6). And, of course, members of the Fox family have preserved many examples of RAF's work. None is for sale.

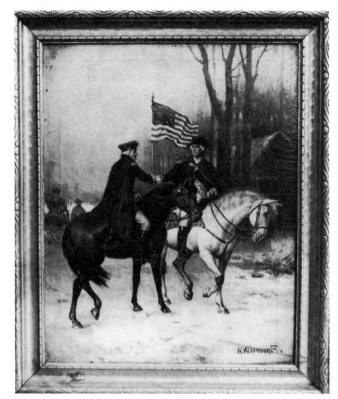

Fig. 29. "George Washington Greeting Lafayette at Valley Forge," oil on canvas. Owned by George Michael.

To determine the value of any painting, a professional appraisal is necessary. Virtually any nineteenth-century painting is of interest, but the extent of that interest or value will be determined by several factors, not the least of which is the degree to which the artist's name is known and respected. The background of the individual painting is important, too. The letter from Thomas D. Murphy establishing a direct line from R. Atkinson Fox to the buyer whose heir still owns the painting could make "Mount Rainier at Sunset" worth twice what it would be without such provenance.

But the final test of the value of a painting is going to be the quality of its execution—the desirability of the subject matter as well as the approach and, yes, craftsmanship, the artist brought to it. A bad painting, no matter how old, is not likely to be worth much.

Fox is well known today because of his prints. His subject matter, interpretation, and talent caused reproductions of his work to be cherished and preserved for today's generation of collectors. But Fox was an established artist in his own right before he turned to illustration. Originals of his work should become more widely available, and more valuable, as his fame spreads. It may be years before professional appraisers are well enough acquainted with Fox and his technique to recognize and evaluate his original work. But there is no doubt that Fox, the artist, lends credibility to Fox, the illustrator.

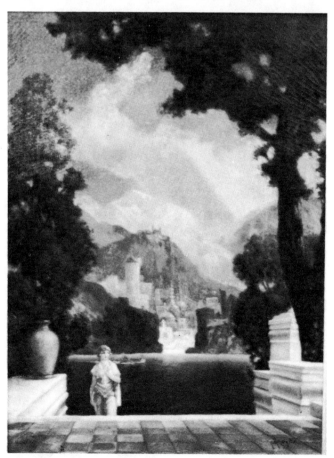

Fig. 30. "Dreamland." Signed R. Atkinson Fox. Owned by Shirley Nathan.

31

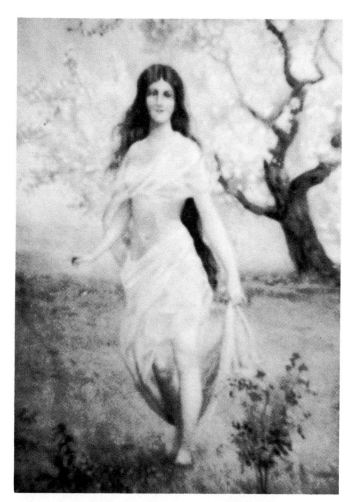

Fig. 31. Young woman in an impressionistic setting. Signed R. Atkinson Fox. Owned by Antique Haven, Stanton, Texas.

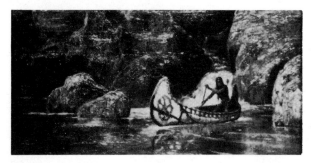

Fig. 32. No information provided.

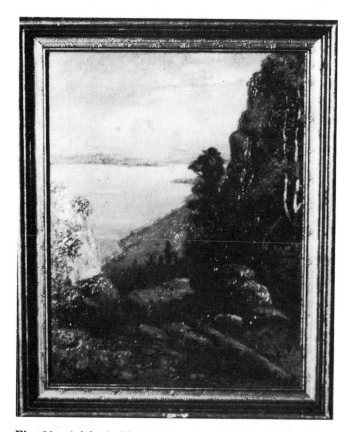

Fig. 33. A lake in Maine.

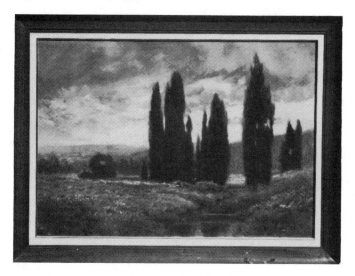

Fig. 34. 21″ x 30″, signed R. Atkinson Fox.

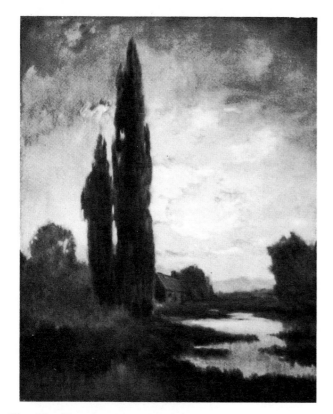

Fig. 35. 30″ x 24″, signed R. Atkinson Fox.

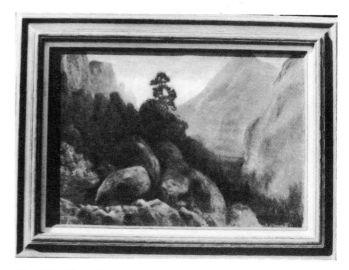

Fig. 37. No information provided.

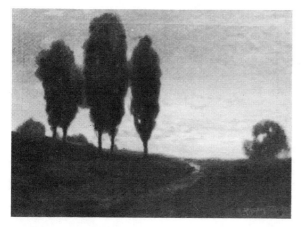

Fig. 36. No information provided.

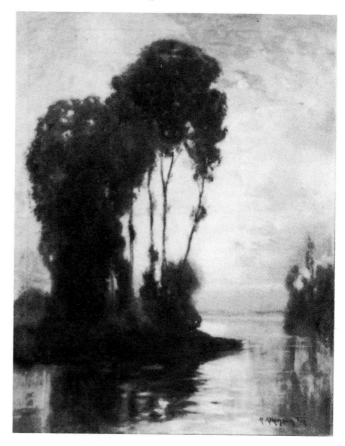

Fig. 38. No information provided.

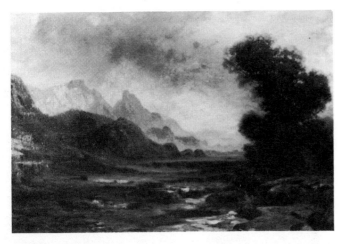

Fig. 39. No information provided.

Fig. 40. No information provided.

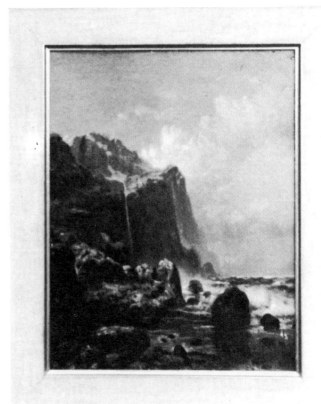

Fig. 41. No information provided.

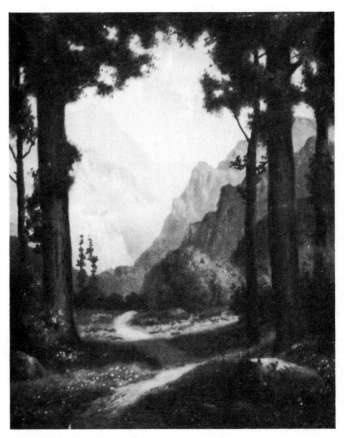

Fig. 42. 30″ x 24″, signed R. Atkinson Fox.

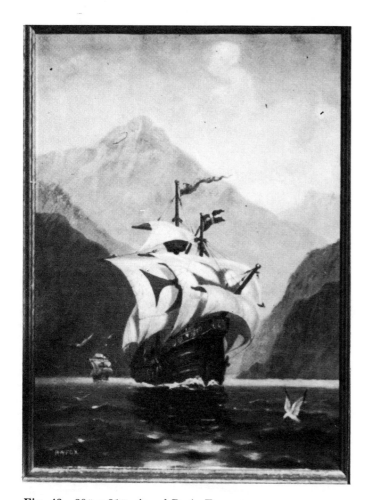

Fig. 43. 29″ x 21″, signed R. A. Fox.

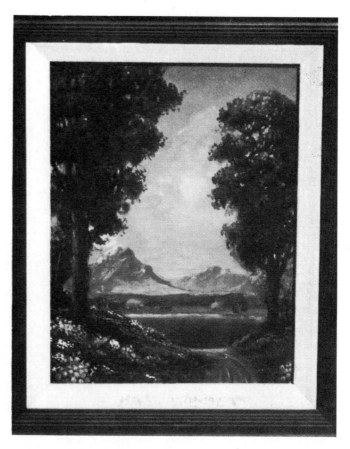

Fig. 45. 14″ x 11″, unsigned.

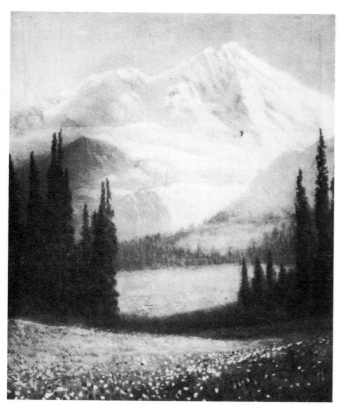

Fig. 44. 25″ x 20″, unsigned.

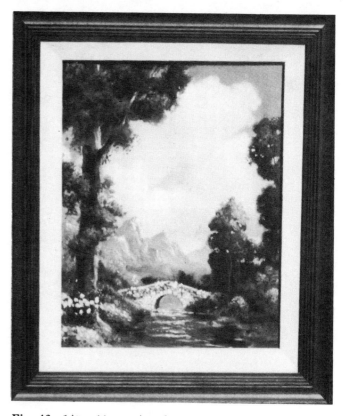

Fig. 46. 14″ x 11″, unsigned.

35

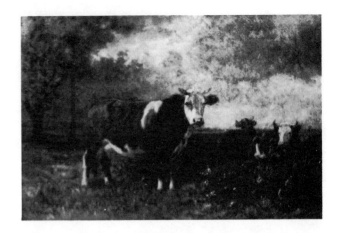

Fig. 49. Signed R. Atkinson Fox.

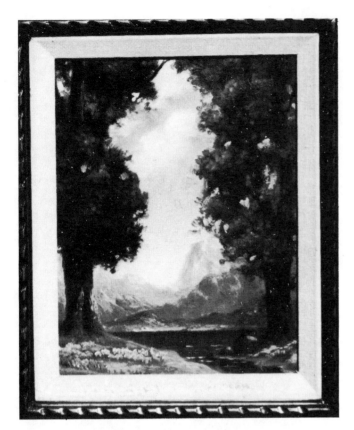

Fig. 47. 14″ x 11″, unsigned.

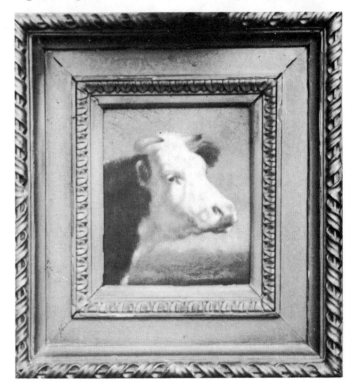

Fig. 50. Unsigned.

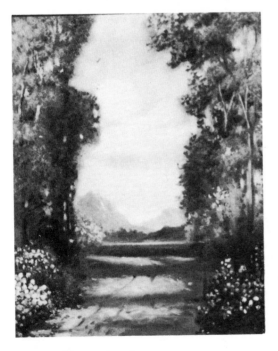

Fig. 48. 14″ x 11″, unsigned.

6
THE PUBLISHERS

We have identified twenty publishers, printers, and/or calendar companies who made or published prints of original works by R. Atkinson Fox:

American Art Works, Coshocton, Ohio
John Baumgarth Company, Chicago
Brown & Bigelow, St. Paul, Minnesota
Louis F. Dow Company
John Drescher Company, New York
Electro-Tint Engraving Company, Philadelphia
Gerlach Barklow, Joliet, Illinois
Edward Gross & Company, New York
Joseph Hoover & Company, Philadelphia
Ketterlinus, Philadelphia
London Printing & Engraving Company, London,
 Canada
Master Art Publishers, Chicago
Merchants Publishing Company, Kalamazoo, Michigan
Morris & Bendien, New York
Photo-Chromotype Engraving Company, Philadelphia
The Red Wing Advertising Company
Southwood Calendars
Edw. Stern & Company, Philadelphia
The Thos. D. Murphy Company, Red Oak, Iowa
K. Wirth

In addition to these, we sometimes find prints marked simply "Reliance." As far as we can tell, this was a framing company that may have published prints as well. Or, there may have been another company by that name that published prints.

It sometimes takes a little detective work to figure out a publisher's copyright on a picture. For example, Brown & Bigelow sometimes appears as B & B. A print published by Louis F. Dow Company may be marked simply "Dow." Edward Gross often apears as E. G. Co. Master Art Publishers was most innovative in marking its prints, using the inverted triangle and three-leaf clover logos shown here.

Of the aforementioned publishers, I found only five to be still in business—that is, with current telephone listings. Of those five, only Brown & Bigelow and The Thos. D. Murphy Company responded to my requests for information. A sixth, Master Art Publishers, replied, "We are Master Arts Typographers. The firm you seek is out of business."

Fig. 51. Mat advertising the Reliance Framing Company.

Fig. 52. Two logos known to have been used by Master Art Publishers.

The Thos. D. Murphy Company, Red Oak, Iowa, manufactures calendars only. "All of the R. Atkinson Fox paintings were reproduced by printing directly on the calendar or tipping on picture prints," explained Dick Howlett, line director for Murphy. Mr. Howlett conducted a search of the company's records and sent copies of a "painting record" for a number of Fox paintings. "As you can see," he wrote, "the paintings have all been sold or disposed of over the years."

It is interesting to note that, on several occasions, plates were consigned to other companies for reproduction. "Among the Daisies," for example, was reproduced by the American Colortype Company, Chicago, on October 28, 1903, for use in a newspaper supplement. Another occasional "borrower" was the Electro-Tint Engraving Company. We have found the Electro-Tint copyright on several prints, and one collector found an Electro-Tint Engraving Company catalog showing an address of 1227 and 1229 Race Street, Philadelphia, Pennsylvania, and listing one hundred six prints by various artists, including Fox.

Seth Huntington, creative director for Brown & Bigelow was also very helpful. He sent a list of the titles of thirty-two Fox paintings that were reproduced on calendars by Brown & Bigelow:

Catalog Number	Title
61	End of the Trail (1934)
104	Wonderland
105	When Evening Shadows Fall
166	Castles in the Air
193	Landscape
222	Rocky Tavern
235	Ship
253	The Open Gate
254	Landscape
259	Castles in the Air
268	Geyser
288	The Land of Dreams
296	Good Ship Adventure
298	Where Memories Stray
299	Summer Days
304	Ship
308	Lake Louise
319	Daughter of Incas
322	Daughter of Setting Sun
334	Port o' Heart's Desire
354	Dreamland

Fig. 53. A logo of the Edward Gross Publishing Co.

Fig. 54. File card for the painting "End of the Trail," 1934, by R. Atkinson Fox. Courtesy Brown & Bigelow.

364	The Sunny South
365	Garden of Happiness
417	Dreamy Paradise
425	Falls of Yellowstone
450	Landscape
454	By a Waterfall
522	Artist Supreme
523	White Feather
811	Puppies for Sale
902	Sunset
901	Mountains

In addition, Mr. Huntington included a file card copy for "End of the Trail." The card provides a record of the painting while it was with the company and shows a final sale to Dr. Forrest C. (Phog) Allen, c/o Kansas University Athletic Office, Lawrence, Kansas. The university has no record of the painting.

Mr. Huntington also sent a title sheet from the 1928 calendar featuring "The Good Ship Adventure." It includes some interesting details of the artist's life:

The Good Ship Adventure
(From an Original Painting by R. Atkinson Fox)

A distinctive honor accorded R. Atkinson Fox is that there are more reproductions of his work extant than those of any other living artist. A Canadian by birth, he has roamed the world at will, studying and painting at the art centers, and naming among his subjects, such celebrities as Presidents Harrison and Cleveland and Princes Louise of England. "The Good Ship Adventure" combines a splendid instance of his perfected technique with romantic history. All his years of travel have failed to deprive him of the thrill of seeing a fine ship on its course to lands and adventures unknown, and he shares this feeling with everyone through the medium of this painting. Those daring rovers of the seas whose deeds of exploration and piracy still capture our fancy, live once more here on this barque within a cozy harbour—"The Good Ship Adventure." As it delivers its cargo of friendship, may it form a refreshing interlude for you in this busy modern life; looking back once again to the days of mariners bold.

Bill Fox still has with his mementoes the ads for "Sentinel of the Ages" and "When the Day Is Done," from the 1925 and 1926 catalogs of the Louis F. Dow Company:

R. ATKINSON FOX
"Sentinel of the Ages" is a Winner
Amongst His Best Landscapes."
It is Realistic and is a Perfect
Study in Distances.

R. Atkinson Fox is one of the most versatile painters in the world today. He is not afraid to tackle any type of subject from a mountain to a cow, and his ability is so wonderful that, strange to relate, he turns out remarkable subjects in any line. However, landscapes admittedly are his forte. And in "Sentinel of the Ages" he has outdone his best previous efforts. It is a striking study in distances. It is uncanny in its realism as anyone who has been in a mountain country will admit.

The panorama that spreads out before the eye, is one that makes a lasting impression. From the giant trees in the foreground with their beautiful green foliage, the forest dwindles in the distance to toothpick-like forest dwarfs, mounting to the timberline where they melt into the background.

The tumbling stream, the sun-kissed snow-pockets and the tinted clouds all contribute to the awe-inspiring beauty of the subject.

Landscapes as a class are the most popular subjects and a good mountain scene takes its place at the top of the landscape list. "Sentinel of the Ages" is deserving

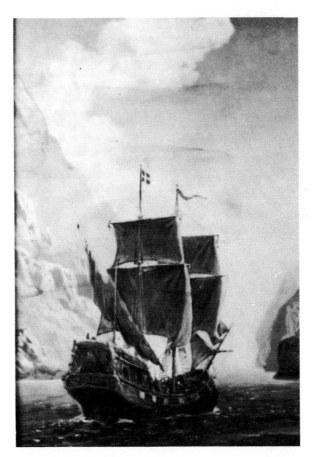

Fig. 55. "The Good Ship Adventure" was featured on a 1928 calendar by Brown & Bigelow.

of a rank as one of the finest landscapes we have ever produced. Its position among the ten best sellers proves that conclusively.

"We hope that you have not lost any of your original enthusiasm over this beautiful subject because of such continuous daily contact with it. For this is a picture that will make the advertiser, seeing it for the first time, actually gasp as his face brightens with a smile of genuine pleasure.

"'Sentinel of the Ages' breaks down barriers when selling the hard-to-interest calendar buyers."

R. A. Burr (1925)

WHEN THE DAY IS DONE

As we look at the picture 'When the Day is Done' we can vision R. Atkinson Fox sitting at the window of a cottage and glancing out over the broad expanse of the fields waiting to paint the glorious sunset, for which this country was noted. And then, just as he had set the color scheme of the sky, there walked along the road and into the picture a flock of sheep driven homeward by the faithful shepherd dog. Truly that dog and those sheep are so lifelike, so exceedingly natural that they form a brilliantly remarkable bit of the picture.

R. ATKINSON FOX

"Sentinel of the Ages" is a Winner Amongst His Best Landscapes

IT IS REALISTIC AND IS A PERFECT STUDY IN DISTANCES

Fig. 56. A Louis F. Dow Co. ad for "Sentinel of the Ages" by R. Atkinson Fox.

Beautiful Colors

It is just after a storm and the distant clouds reflect the colorful beauty of the day. The colors are there in brilliant hues and those who have seen the glories of the beautiful sunset know that they are not exaggerated, but they are rather portrayed with the effectiveness of a masterful artist. There is a great deal of action in the picture, and it combines the appeal of a beautiful scene with that of the animal life thus giving it a double appeal.

It is actions such as these that make us so fond of a dog, and it makes the dog so human. Here is a dog full of life and in characteristic action. Here is a dog that is performing his mission that the setting sun has taught him was the thing to do night after night. No master need be around to tell him what to do, but he faithfully performs his duty as regularly as the sun sets.

No Human

There is this that is remarkable about the paintings of R. Atkinson Fox. There is no man, no human being in the picture and yet it has the all-touching appeal of the human interest subject.

Looking at the picture, we are at once struck by the remarkable portrayal of the trees. Perhaps for this more than for anything else R. Atkinson Fox is noted. On the right we have the shading of the oak and elm trees which reflects the picturesque sunset. We have the underbrush, the young trees and then the taller trees. On the right are the aged poplars, two mighty giants, guarding the farmhouse and protecting the whole scene. Gigantically they rise above everything else in the picture and these facts have characteristically been portrayed with the masterful touch of the brush.

There is another very noticeable thing about the picture and those who are familiar with the farm settings will be quicker to realize how well that has been portrayed by the trees on the north and west of the farmhouse.

A Leader

No little attention must be given to the farmhouse itself, which though only presented from one angle, gives the perspective of the whole

There is everything about the picture that makes it one of the ten leaders of the line. It is a picture that is beautiful in the art of single mounts with the attractive setting on the grey frame on the black background, as well as in the center with its truly artistic border design and blending background of tan. Every detail of shading and color that is so remarkable in the picture itself is brought out in the presentation of the border and background.

All in all, there is no reason why we cannot sell a man mounts and hangers. Thus by selling him mounts and hangers we can celebrate Mr. Dow's Birthday Week.

Unfortunately, no copies of "Sentinel of the Ages" or "When the Day Is Done" have turned up in the marketplace, so neither title is included in the list or in this book.

Also from Bill Fox came the names of several publishers of prints we have not yet found: Curt Teich, a large postcard manufacturing firm in Chicago; Gibson, which Bill believes to be the same company that makes greeting cards; The Knapp Company, Inc.; and Southern Art Works. He was uncertain as to locations on these last three.

It would be easy to think of these publishers as distant, often stern employers. On the contrary, we know that close personal friendships existed between RAF and several of his publishers as well as employees of the publishing houses. As mentioned before, when Fox was hospitalized in Chicago after having been struck by a taxi, Anna stayed at the home of Baumgarth employee Sam Ford. Sam and RAF enjoyed long discussions about religion and other weighty topics.

Nathan Borin, of Borin Manufacturing Company, was a frequent visitor when the Foxes lived in Chicago. Mr. Borin was, for a time, married to Peaches Browning, who was famous in the late 1920s and early 1930s.

The Bigelows, of Brown and Bigelow, were also special friends. And whenever RAF went to the twin cities on business, he always visited with Mr. Bigelow. Fox and Anna traveled to Yellowstone National Park around 1930 and visited their friends on the way. (RAF did some sketches at Yellowstone and brought back ideas for a series of paintings for the Chicago, Milwaukee, St. Paul & Pacific Railroad. But he had never been farther west than Minnesota when he painted most of his western landscapes.)

WHEN THE DAY IS DONE

As we look at the picture "When the Day is Done" we can vision R. Atkinson Fox sitting at the window of a cottage and glancing out over the broad expanse of the fields waiting to paint the glorious sunset, for which this country was noted. And then, just as he had set the color scheme of the sky, there walked along the road and into the picture a flock of sheep driven homeward by the faithful shepherd dog. Truly that dog and those sheep are so lifelike, so exceedingly natural that they form a brilliantly remarkable bit of the picture.

Beautiful Colors

It is just after a storm and the distant clouds reflect the colorful beauty of the day. The colors are there in brilliant hues and those who have seen the glories of the beautiful sunset know that they are not exaggerated, but they are rather portrayed with the effectiveness of a masterful artist. There is a great deal of action in the picture, and it combines the appeal of a beautiful scene with that of the animal life thus giving it a double appeal.

It is actions such as these that make us so fond of a dog, and it makes the dog so human. Here is a dog full of life and in characteristic action. Here is a dog that is performing his mission that the setting sun has taught him was the thing to do night after night. No master need be around to tell him what to do, but he faithfully performs his duty as regularly as the sun sets.

No Human

There is this that is remarkable about the paintings of R. Atkinson

R. ATKINSON FOX
"WATCH US GROW"

Fox. There is no man, no human being in the picture and yet it has the all-touching appeal of the human interest subject.

Looking at the picture, we are at once struck by the remarkable portrayal of the trees. Perhaps for this more than for anything else

R. Atkinson Fox is noted. On the right we have the shading of the oak and elm trees which reflects the picturesque sunset. We have the underbrush, the young trees and then the taller trees. On the right are the aged poplars, two mighty giants, guarding the farm-house and protecting the whole scene. Gigantically they rise above everything else in the picture and these facts have characteristically been portrayed with the masterful touch of the brush.

There is another very noticeable thing about the picture and those who are familiar with the farm settings will be quicker to realize how well that has been portrayed by the trees on the north and west of the farmhouse.

A Leader

No little attention must be given to the farmhouse itself, which, though only presented from one angle, gives the perspective of the whole.

There is everything about the picture that makes it one of the ten leaders of the line. It is a picture that is beautiful in the art of single mounts with the attractive setting on the grey frame on the black background, as well as in the center with its truly artistic border design and blending background of tan. Every detail of shading and color that is so remarkable in the picture itself is brought out in the presentation of the border and background.

All in all, there is no reason why we cannot sell a man mounts and hangers. Thus by selling him mounts and hangers we can celebrate Mr. Dow's Birthday Week.

Fig. 57. A Louis F. Dow Co. ad for "When the Day Is Done" by R. Atkinson Fox.

An interesting exchange involving a painting by Fox, the Thos. D. Murphy Company, and the father of a woman in Oklahoma illustrates the esteem in which one publisher held the artist. The lady in Oklahoma wrote to me, "I have enjoyed your articles in *The Antique Trader*. For your information, files, and collection, I have an original R. Atkinson Fox signed oil on canvas picture, size 27″ x 37″, titled 'Mt. Rainier at Sunset.' The picture was from my father's estate, and how he obtained the picture is described in the enclosed letter.

The Thos. D. Murphy Co.
Red Oak, Iowa

Thos. D. Murphy, Pres. European Office
Wm. Cochrane, V.P. 133-136 High Holb
Philo D. Clark, Sec. London, W.C. England

Exclusive Art Calendars
"Merit Has Made Them Famous"

Office of the President, Red Oak, Iowa Dec. 17, 1925

Mr. Harrison W. Miller
c/o First National Bank
Hinton, Okla.

Dear Sir:

In accordance with your order of March 12, 1925 given our Mr. Cies, we are shipping you the original painting, "Mt. Rainier at Sunset" by R. Atkinson Fox.

The picture has been handsomely and newly framed in hand-carved Roman gold moulding which we think adds very materially to its artistic effect.

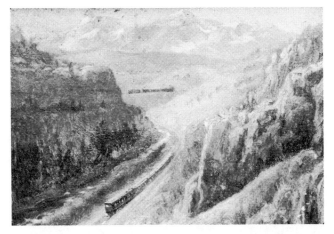

Fig. 58. This preliminary sketch in oil is owned by Oscar Mercer Mayer. It obviously resulted in the painting (Fig. 59) for the Chicago, Milwaukee, St. Paul, and Pacific Railroad.

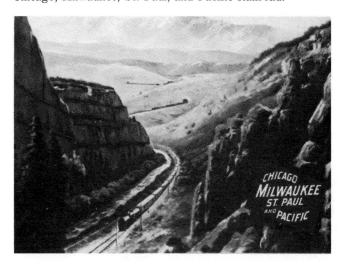

CHICAGO
MILWAUKEE
ST. PAUL
AND PACIFIC

Fig. 59. One of the results of RAF's trip to Yellowstone was this painting for the Chicago, Milwaukee, St. Paul, and Pacific Railroad.

This picture is a characteristic example of the work of this well-known artist and presents in a very attractive manner the majesty and beauty of one of the most famous mountains in America. The artist has made a specialty of such subjects, and we think the present example is done in his happiest manner.

Mr. Fox is a painter of real genius, whose work has been shown in the Paris Salon as well as in many of the best American exhibitions. His style, especially in cattle pictures and landscapes, has been compared to that of the famous Dutch artist, Van Marck. His education was acquired chiefly in the studios of New York and Philadelphia, supplemented by sundry trips to Paris.

We are sure that "Mount Rainier at Sunset" is a painting that would grace any collection and one that would prove a decoration to any home in which it might be hung. It is the kind of a picture that one will be glad to live with and one that will be admired more and more as the days go by.

Hoping that it will reach you in good order and that you will be pleased with it, we remain

Yours very truly,
Thos Murphy

Fig. 60. "Mount Rainier at Sunset." Owned by Martha Miller Rigdon.

Fig. 62. File cards for paintings by Fox from the files of the Thos. D. Murphy Co.

HEREFORDS

Reproduced by Color Photography from an Original Painting by Fox
Published by THE THOS. D. MURPHY CO., Red Oak, Iowa, U.S.A.

MR. R. ATKINSON FOX is a clever American artist who makes his home in Philadelphia, and whose power lies in his ability to give an air of absolute naturalness to his pictures and in his carefulness to detail. His work is highly esteemed, both by connoisseurs of art and by the public in general. During the last few years he has retired from active work, and anything from his brush is now exceedingly hard to obtain.

Any judge of good live stock will be pleased with "Herefords," and each individual steer will bear the closest sort of inspection, so accurately has the artist painted it. The more the picture is studied the more its startling lifelikeness impresses one. It has been drawn with a closeness of observation satisfactory alike to the critic and the naturalist, and in addition the artist has given us an exceedingly pleasing landscape effect.

Fig. 61. A preliminary sketch in oil given to Oscar Mayer by Fox. Could it have been for "Geyser" (#268) for Brown & Bigelow?

Fig. 62-M. Dolores Ramsey found this unsigned print in an Electro-Tint catalog. Could this be "Evening," the painting referred to on the file card in Fig. 62-N?

PAINTING RECORD.

CLASSIFICATION	TITLE OF PICTURE		
Figure	Curing the Mortgage	R Atkinson Fox	Oil
1658			

DESCRIPTION: chair, metal arm in rocking chair, match in one hand, burning paper in other, half grown girl stands beside him, Woman in chair also holding little girl, small boy on footstool, all watching same

| 24 x 31 | 7/31/07 | 50.00 | | | | | |
| | ACC₆ | 37.38 | | | | | |

REMARKS: Received 7/31/07 Sent Ballard Bros 11/7/09
Returned 7-19-09 Shipt Wood Lamp Sub Co 7 ½ 9 in approval Col 8-6
Painting destroyed 7-1-26 Elec WC + O C M

PAINTING RECORD.

CLASSIFICATION	TITLE OF PICTURE		
728	Herefords	R A Fox	Oil

DESCRIPTION: right, Hereford cattle lined up in a row looking

| 32 x 30 | | 60.00 | | | | | |

REMARKS: Received 4-15-10 Shipt Chicago 4-20-10
Shipt R 2-10 Ballard 11-27-12 Oct 3-21-13 Shipt
Ballard 11-29-13 Orient Litho Bros to Shp to J Hutchins
Med 2-2-14 Vol 3-13-14

1912	6 x 8	M4244	U C C₆ 4	20.10	# 780	3
	6 x 8	1228			# 779	3
	8 x 16	1272	Elect made from 1001 large			

Copyright applied for 10-13-10 as painting under title, "Herefords"

PAINTING RECORD

CLASSIFICATION	TITLE OF PICTURE		
Landscape	Harvesting	R Atkinson Fox	Oil
378	"The Harvesters"		

DESCRIPTION: Harvest scene Man with three horses and cutting wheat at right, are stooks at left, the are green trees standing in the wheat at left, In the ground is a load of wheat at right of it

| 24 x 30 | 2/7/08 | 25.00 | | | | | |
| | 20/10/08 | 28.00 | | | | | |

REMARKS: Received 2/7/08 Sent Chicago 2/9/08
Rct 4/27/08 Shipt Power Merc Co + Sold by Ballard
½ 6-11 from Ballard completed well 2-14 ½ Com Shipt
Merc Co 2-29-14 Returned 1-23-11 Shipt Merc Co

1912	7 x 10 ½	2344	U C C₆ 2/9/08	4.22		
1907	6 x 8	4241				
	16 x 22 ½	Buehler Meas St Co 6-26	9.25 Cal			

Shpt # 2 Corlett, Columbus, O # 22-12 Returned 11-2-12
Shpt BroWSutmer Bdh Md 11-1-13 Returned 11-29-12
Shp f 11 on approval to state Mut Tel Co L Surat, Ind 1-1-14
Rct 1-21-13 Shpt on up to the Handel Co Meaden Conn
2-24-11 Med 2-2-14 shipt to Stan Market Sandpoint Ida 3-6-14
Copyright as painting applied for ½ under title The Harvesters (Certificate)

PAINTING RECORD

CLASSIFICATION	TITLE OF PICTURE		
Old	The First Story		
291	The First Story	R Atkinson Fox	Oil

DESCRIPTION: the father sitting the then and the one child story of the other, the other sitter with intensive face, one of the boys, paper under table, a cane, one

| 20 x 30 | 4/6/07 | 40.00 | | | | | |

REMARKS: Received ½/6/07 Sent Chicago ½/6/07 Rct ½/07
Sent Wittmore for frame 4/6/08 Returned 4/10/08 Sent
Calzona Bros L, Mp, Cal ¾ 4/11 Shpt + Sold 2/5/08

| 1909 | 7 x 10 ½ | 2942 | Sun acc 4/07 | # 337 |
| 1907 | 6 x 8 | 4442 | | |

Copyright as print applied for 11/22/07
under above title.

PAINTING RECORD.

CLASSIFICATION	TITLE OF PICTURE		
Cattle		R A Fox	Oil
1008			

DESCRIPTION: Landscape with barn at right, In foreground are two cattle red and white with straight horns

| 24 x 36 | 2-2-13 | 75.00 | | | | 4-13 | |

REMARKS: Received 2-2-13 Shipt Chicago 12-21-14
Rct 1-6-15 Sold B A Allen Houston, Tex 11-26-35

| 9 ¾ x 13 ½ | | U C C₆ | 12-21-14 | #1561 | 3 |
| 6 x 8 | | | | 1562 | 3 |

Copyright applied for 5-1-13 as painting under title "A Corner of the Pasture"

PAINTING RECORD.

CLASSIFICATION	TITLE OF PICTURE		
Wheatfield	After the Harvest	R A Fox	Oil
1009			

DESCRIPTION: Wheatfield showing wheat in stooks, farmhouse at right sun low in sky Mountains in distance

| 26 x 36 | 2-2-13 | 76.00 | | | | 100.00 | |

REMARKS: Received 2-2-13 Shipt Chicago 2-15-10
Rct 4-4-13 Shipt + sold Geo H Wilhelm Harrisburg
Pa 2-2-14

1915	9 ¾ x 13 ½	M559	U C C₆ 2-15-13	1263 (3)
	6 x 8	M4536		1264 (3)
	3 ½ x 5	M9522		1265 (3)
	6 x 6	M6515	6-11-13	1272 (1)

Copyright applied for 5-1-13 as painting under title "The Wheat field" as print 4-24-13 under title After the Harvest

PAINTING RECORD

CLASSIFICATION	TITLE OF PICTURE		
Sheep		R Atkinson Fox	Oil
514			

DESCRIPTION: flock of sheep grazing by man on a hill coming down line is pursuing closed fence, just beyond the top of a hill

| 30 x 24 | 10/17/07 | 50.00 | | | | 40.00 | |
| | 25.00 | | | | | |

REMARKS: Received Oct 17, 1907 Consigned to Cabinet Leroy 2½ of Returned 11-19-13 Shipt Ballard 11-29½ Sold- shipt Stan Market Sandpoint Ida 3-6-14

PAINTING RECORD

CLASSIFICATION	TITLE OF PICTURE		
Landscape	In the Orchard	R Atkinson Fox	Oil
379			

DESCRIPTION: leading backward through ofs of trees is a road passing a barn on its left at right of road in foreground is a white house and a brown road apple trees in bloom are on each side of the road

| 24 x 30 | 4/5/07 | 50.00 | | | | | |

REMARKS: Received ½/5/07 Consigned to Cabinet Leroy ½/6/26 Sold by John Leroy and charged off Oct 13, 1915.

Copyright as painting applied for 3/24/08 under above title (Certificate)

PAINTING RECORD

CLASSIFICATION	TITLE OF PICTURE		
Sheep		R Atkinson Fox	Oil
292			

DESCRIPTION: Listen sheep grazing in pasture under trees

| 20 x 30 | 6/10/08 | 50.00 | | | | 50.00 | |
| | | | | | 11-17-09 | |

REMARKS: Received 4/22/07 Sent Chicago 11/6-09 Returned 4/15-09
Returned 4/22/07 Sent C H Murphy 6-10-10 Shipped on approval

| 4 x 6 x 6 | | U C C₆ | 10/17/07 | #509 (3) |
| 3 ½ x 5 | | | | |

to E W Leonfield St Marys, O, 11-17-10 Sold 12-1-10

PAINTING RECORD.

CLASSIFICATION	TITLE OF PICTURE		
	Northward Bound	R A Fox	Oil
1004	Duck Shooting		

DESCRIPTION: Ducks flying below them is stream bordered by evergreen trees Sunset sky mirrored in stream

| 36 x 24 | 2-2-13 | 75.00 | | | | 4-8 | |

REMARKS: Received 2-2-13 Shipt Chicago 12-21-14
Rct 1-20-15 Sold Sunset Feather Co San Francisco, Cal 12-21-15 Oct 3-6-16 Sold Cancelled Sold E J Allen Guthrie Okla 11-1-16

4 ½ x 6 ½	1228	2719	U C C₆	12-21-14	1597	3
9 x 12	1589	R 189		Buehler Meas St Conl 1-1-39	7012 3 Sel	
	11 x 17 ¼	# 189	Elec			

Copyright applied for 5-1-13 as painting under title "On the Way" as print 1-3-16 under title "Northward Bound"

PAINTING RECORD.

CLASSIFICATION	TITLE OF PICTURE		
Cattle		R A Fox	Oil
1008			

DESCRIPTION: Landscape with barn at right, In foreground are two cattle red and white with straight horns

| 24 x 36 | 2-2-13 | 75.00 | M Howard | | | 4-13 | |

REMARKS: Received 2-2-13 Shipt Chicago 12-21-14
Rct 1-6-15 Sold B A Allen Houston, Tex 11-26-35

| 9 ¾ x 13 ½ | | U C C₆ | 12-21-14 | #1561 | 3 |
| 6 x 8 | | | | 1562 | 3 |

Copyright applied for 5-1-13 as painting under title "A Corner of the Pasture"

PAINTING RECORD.

CLASSIFICATION	TITLE OF PICTURE		
Wheatfield	After the Harvest	R A Fox	Oil
1009			

DESCRIPTION: wheatfield showing wheat in stooks farmhouse at right sun low in sky Mountains in distance

| 26 x 36 | 2-2-13 | 76.00 | | | | 100.00 | |

REMARKS: Received 2-2-13 Shipt Chicago 2-15-10
Rct 4-4-13 Shipt + sold Geo H Wilhelm Harrisburg
Pa 2-2-14

1915	9 ¾ x 13 ½	M559	U C C₆ 2-15-13	1263 (3)
	6 x 8	M4536		1264 (3)
	3 ½ x 5	M9522		1265 (3)
	6 x 6	M6515	6-11-13	1272 (1)

Copyright applied for 5-1-13 as painting under title "The Wheat field" as print 4-24-13 under title After the Harvest

In your article ("Fox Hunt II," The Antique Trader, Feb. 24, 1982), you mentioned and illustrated the stone marker for Daddy's grave at Irving Park Boulevard Cemetery near Chicago. I feel a greater memorial to him exists in the many prints and perhaps originals that are in many homes all over the country and possibly the world. They are still bringing pleasure to people nearly fifty years after his death. Bill Fox

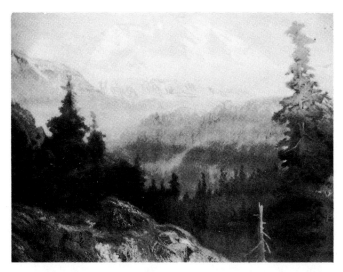

Fig. 64. (#227) Untitled. R. Atkinson Fox. © Sou(?) Art Co. 16″ x 20″. Courtesy Joe Bell.

Fig. 63. (#280) Untitled. R. Atkinson Fox. Colortype, 9″ x 7″. "'See America First' Series 105, 106, 107, 125, 126, 124, 141″ was found stamped on the back of a print. Courtesy Joe Bell.

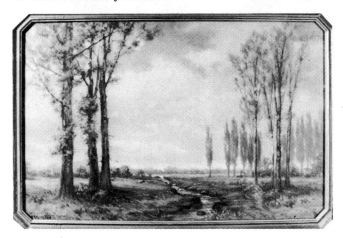

Fig. 65. (#140) "Canadian Landscape." R. Atkinson Fox. © Edward Gross Co., New York, No. 613. 6″ x 14″, 14½″ x 22″. Courtesy Loretta Goad.

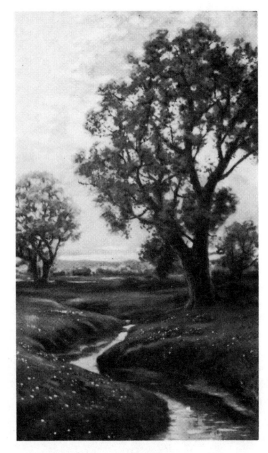

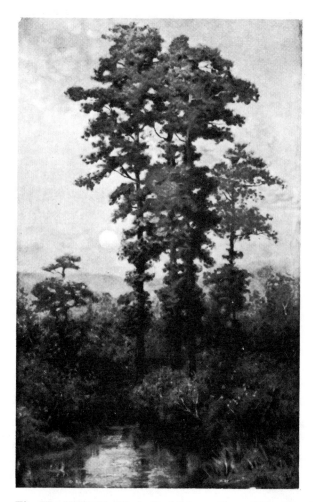

Fig. 66. (#159) Untitled. R. Atkinson Fox. © E. Gross Co. 16″ x 10″. Courtesy Loretta Goad.

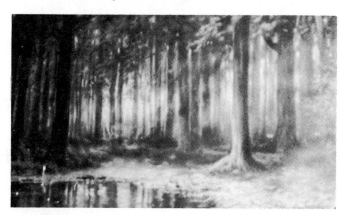

Fig. 68. (#168) Untitled. R. Atkinson Fox. 15″ x 10″. Courtesy Charles Mandrake.

Fig. 67. (#18) Untitled. R. Atkinson Fox. 9½″ x 15½″. Courtesy Donna Eby.

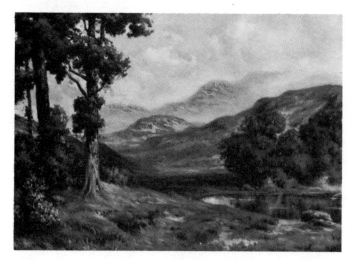

Fig. 69. (#166) Untitled. R. Atkinson Fox. 9½″ x 14″. Courtesy Charles Mandrake.

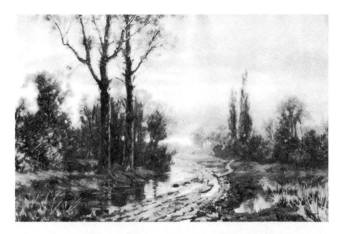

Fig. 70. (#103) "After the..." R. Atkinson Fox. No 2601. 10″ x 12″, 9½″ x 15″, 11″ x 16″. Courtesy Loretta Goad.

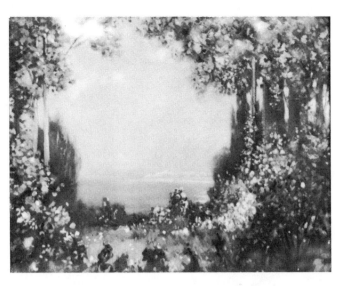

Fig. 72. (#158) "Sapphire Sea." R. Atkinson Fox. ©Master Art Publishers, Inc., under K-223113, February 12, 1937. 14″ x 20″. Courtesy Loretta Goad.

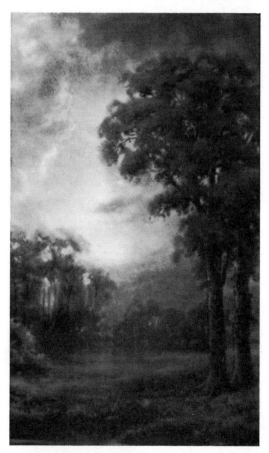

Fig. 71. (#199) "Morning Mists." R. Atkinson Fox. © R. Atkinson Fox under G-56299, June 21, 1918. © Edward Gross, No. 623. 16″ x 10″. Courtesy Loretta Goad.

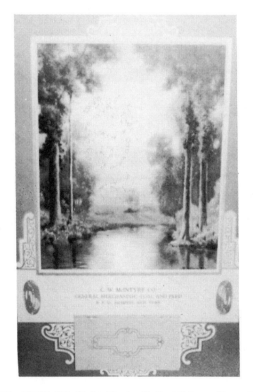

Fig. 73. (#212) "Twilight Glories." R. Atkinson Fox. 9½″ x 8″.

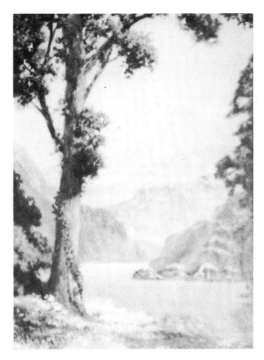

Fig. 74. (#188) "Land of Sky Blue Waters." R. Atkinson Fox. 12″ x 9″. Courtesy Loretta Goad.

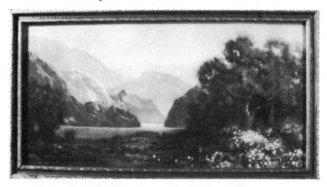

Fig. 75. (#298) Untitled. R. Atkinson Fox. No. 3908 in 1939 catalog of Southwood Calendars. Edna Jones collection. Photograph by author.

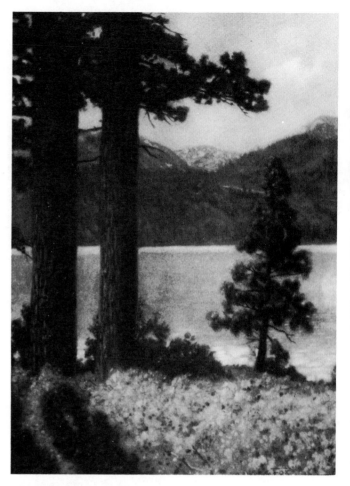

Fig. 76. (#87) "A Mountain Paradise." R. Atkinson Fox. ©Morris & Bendien, New York. 8¼″ x 16″. Courtesy Loretta Goad.

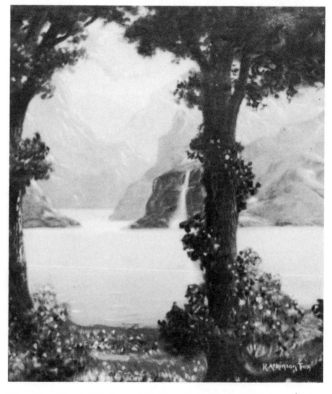

Fig. 77. (#141) "Valley of Golden Dreams." R. Atkinson Fox. 9½″ x 7″, 14″ x 11″. Courtesy Loretta Goad.

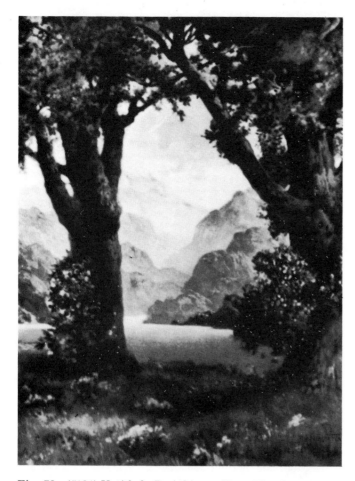

Fig. 78. (#181) Untitled. R. Atkinson Fox. The absence of a waterfall is one of the small details that distinguishes this print from #141, Fig. 77. Bill Fox collection. Photograph by author.

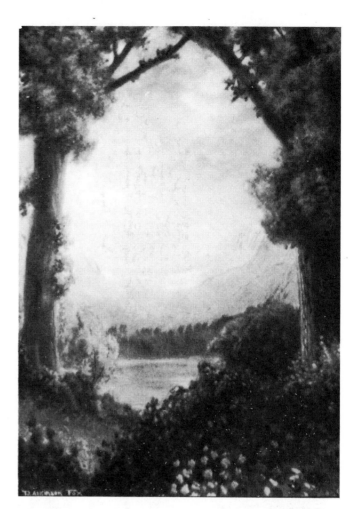

Fig. 80. (#299) Untitled. R. Atkinson Fox. No. 3916 in 1939 Southwood catalog. Edna Jones collection. Photograph by author.

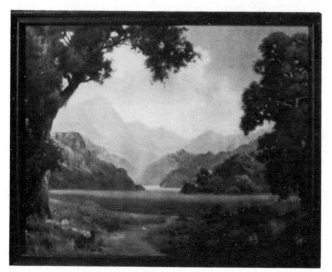

Fig. 79. (#6) "Glorious Vista." R. Atkinson Fox. Registered by Master Art Publishers under K-223114 following publication January 15, 1927. Also found marked "Borin Mfg. Co., Chicago." 18″ x 30″. Courtesy Loretta Goad.

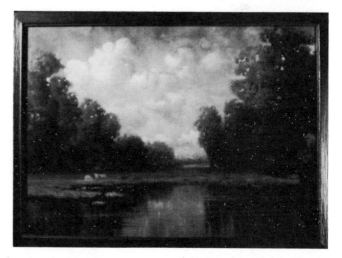

Fig. 81. (#102) "Land Where Shamrock Grows." R. Atkinson Fox. © E. Gross Co., No. 609, 1929. 14″ x 20″. Courtesy Loretta Goad.

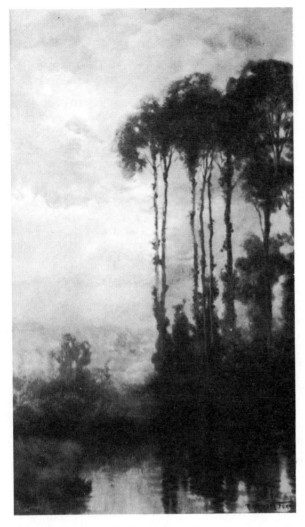

Fig. 82. (#145) Untitled. R. Atkinson Fox. © Edward Gross Co., New York. No. 603. 16″ x 10″. Courtesy Loretta Goad.

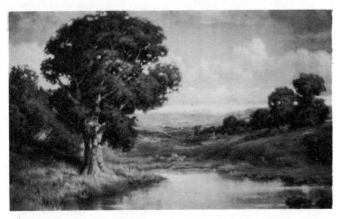

Fig. 83. (#211) "An Old Oak." R. Atkinson Fox. © E. Gross Co., New York. 9½″ x 15½″.

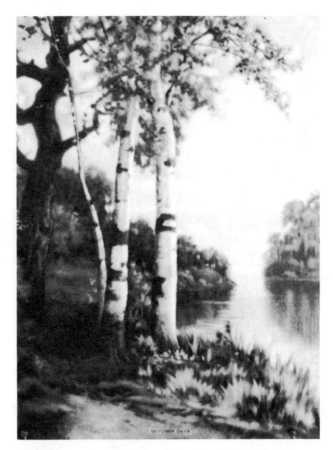

Fig. 84. (#44) "October Days." R. Atkinson Fox. Bill Fox collection. Photograph by author.

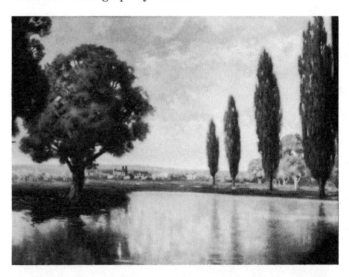

Fig. 85. (#179) "Nature's Mirror." Found as a set with Nos. 52, 137, and 180. Collectors report signature is hard to see, as it blends with shadows in the water. The name "Lowell Blake" has also been seen on the print with the Fox signature. Blake may have been a publisher. Courtesy Sherlee Tatum.

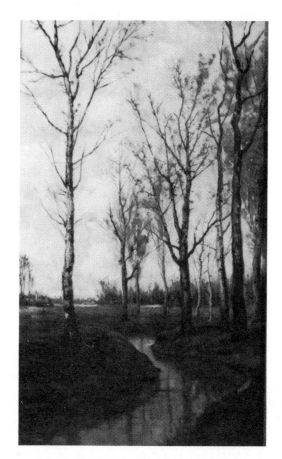

Fig. 86. (#59) Untitled. R. Atkinson Fox. © Edward Gross Co., New York, No. 502. 16″ x 10″. Courtesy Loretta Goad.

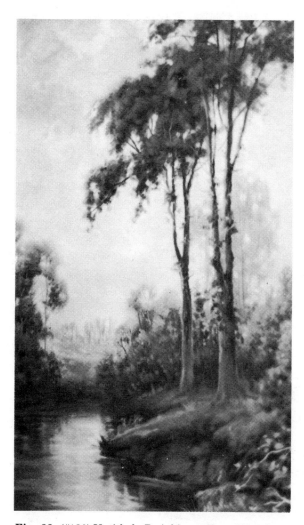

Fig. 88. (#180) Untitled. R. Atkinson Fox. Found as a set with Nos. 52, 137, and 179. 10″ x 16″. Courtesy Ron and Deanna Hulse.

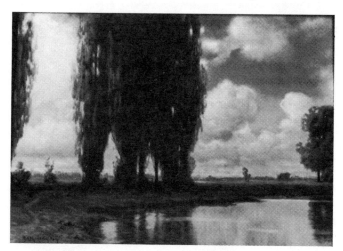

Fig. 87. (#25) "Stately Sentinels." R. Atkinson Fox. Nature Tint No. 612, Edward Gross Co., New York. 14″ x 21½″. Courtesy Loretta Goad.

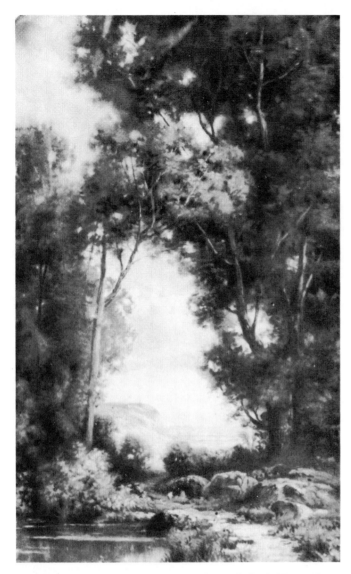

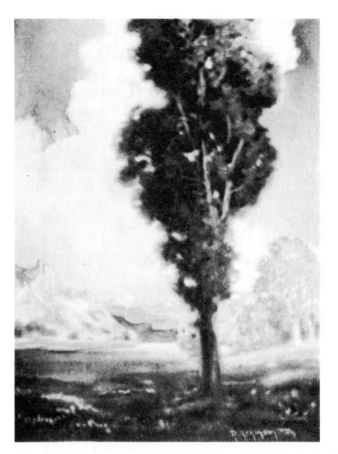

Fig. 91. (#259) Untitled. R. Atkinson Fox. © B & G., St. Paul. 5¼″ x 4″. Collection of Bill Fox. Photograph by author.

Fig. 89. (#94) "The Mediterranean Coast." R. Atkinson Fox. © Edward Gross Co., New York. 22″ x 14″. Courtesy Charles Mandrake.

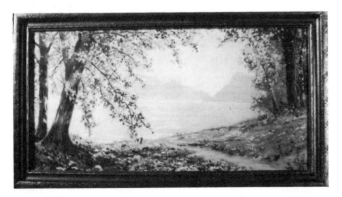

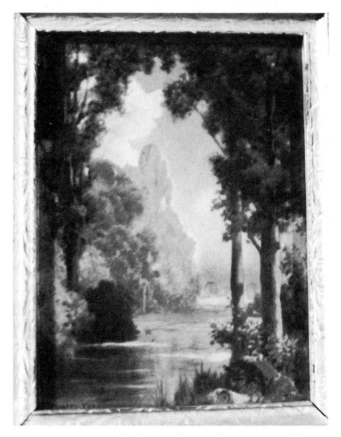

Fig. 90. (#190) "Autumn Gold." R. A. Fox. © Master Art Publishers, Inc., under K-228166, June 20, 1927. 10″ x 20″. Courtesy Loretta Goad.

Fig. 92. (#152) Untitled. R. Atkinson Fox. 5″ x 4″. Courtesy Loretta Goad.

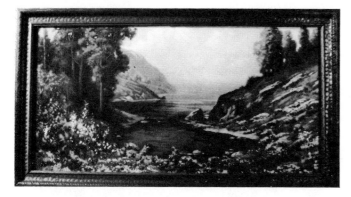

Fig. 93. (#58) "Inspiration Inlet." R. A. Fox. © Master Art Publishers, Inc., under K-228168, June 20, 1927. 10″ x 20″. Courtesy Loretta Goad.

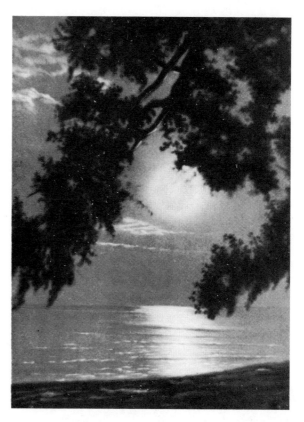

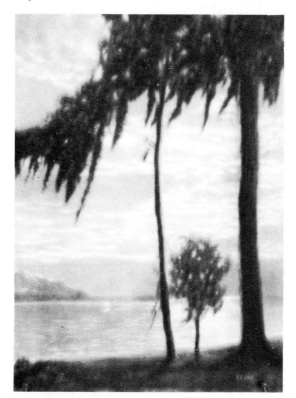

Fig. 95. (#202) "Where Dreams Come True." R. A. Fox. © John Baumgarth Co., Chicago. Found on a 1931 calendar. 9½″ x 7″.

Fig. 94. (#27) "Moonbeam Enchantment." R. A. Fox. Print is blurry. 9½″ x 7″. Collection of Bill Fox. Photograph by author.

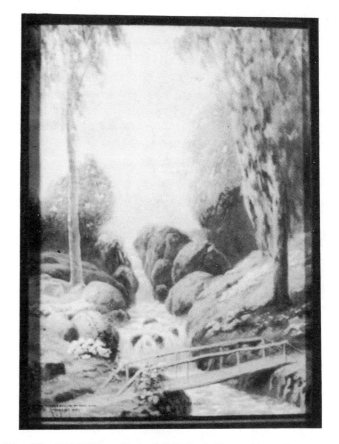

Fig. 96. (#144) "By a Waterfall." R. Atkinson Fox. © 1930, Brown & Bigelow, St. Paul, Minnesota. Tintogravure. 10″ x ⁻⁰″ x 11½″. Courtesy Loretta Goad.

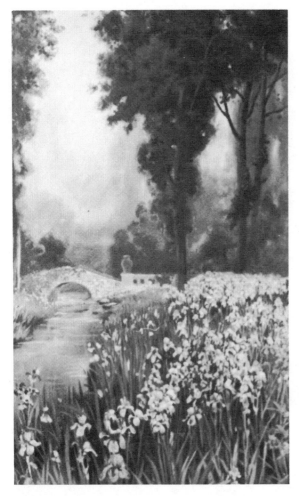

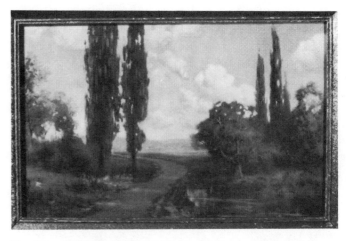

Fig. 99. (#151) Untitled. R. Atkinson Fox. © Edward Gross Co., New York and Master Art, marked as "The Good Luck Line" in cloverleaf. 10" x 16". Courtesy Loretta Goad.

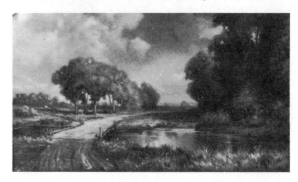

Fig. 97. (#88) "Nature's Charms." R. Atkinson Fox. © John Drescher Co., Inc., under K-219556, October 27, 1926: 22" x 14". Courtesy Loretta Goad.

Fig. 100.(#92) Untitled. R. Atkinson Fox. © Edward Gross Co., New York. Print courtesy E. C. Bischof.

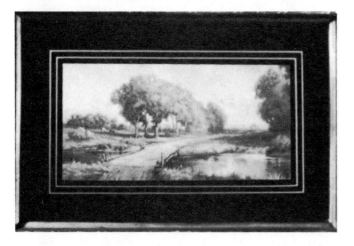

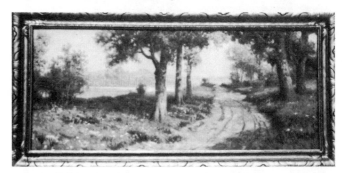

Fig. 101. (#213) Untitled. R. Atkinson Fox. 10" x 22". Courtesy Way Back When Antiques.

Fig. 98. (#92) Untitled. R. Atkinson Fox. Tray courtesy Loretta Goad.

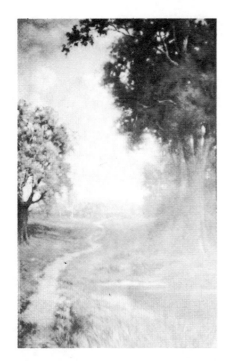

Fig. 102. (#201) "Path to the Valley." R. Atkinson Fox. ©
Edward Gross Co., No. 623. 16″ x 10″. Courtesy Loretta Goad.

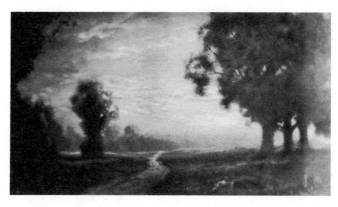

Fig. 104. (#182) "Sunset." R. Atkinson Fox. © Morris &
Bendien Co., New York, No. 4715. Courtesy Ron and Deanna
Hulse.

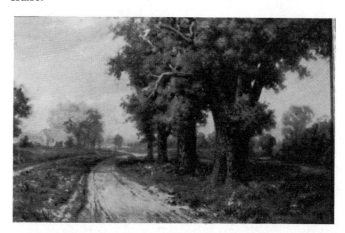

Fig. 105. (#161) "Oaks by the Roadside." R. Atkinson Fox.
© Edward Gross Co., New York, No. 621. What may be a white
church steeple is visible behind a flaming tree way down at the
end of the road. 10″ x 16″. Courtesy Loretta Goad.

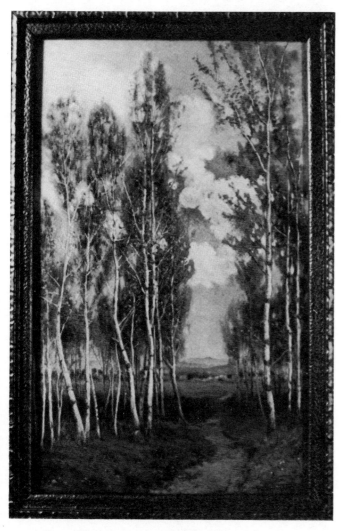

Fig. 103. (#157) Untitled. R. Atkinson Fox. © E. G. Co., 16″
x 10″. Courtesy Loretta Goad.

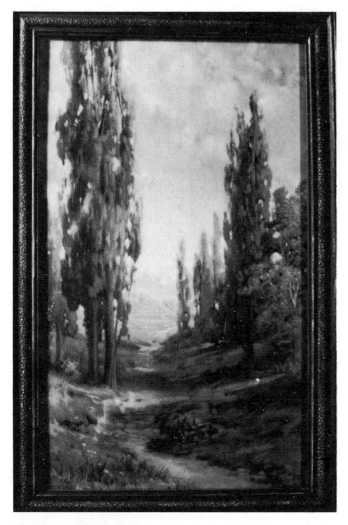

Fig. 106. (#52) Untitled. R. Atkinson Fox. Found as a set with Nos. 137, 179, and 180. 16″ x 10″, 18″ x 13½″. Courtesy Loretta Goad.

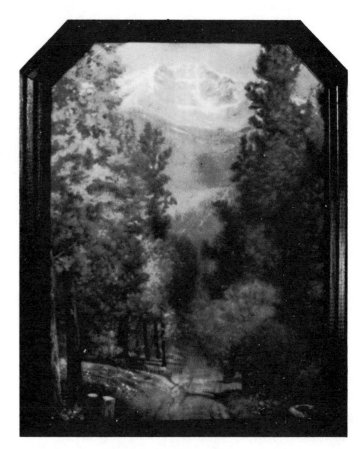

Fig. 108. (#43) "The Mount of the Holy Cross." Signed. No publisher's name, but the number 2249 appears on some prints. Note the cross formed by snow near the top of the mountain. 18″ x 14″. Courtesy Loretta Goad.

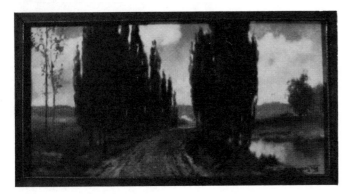

Fig. 107. (#26) "The Road of Poplars." R. Atkinson Fox. © Morris & Bendien, New York. 8″ x 16″. Courtesy Loretta Goad.

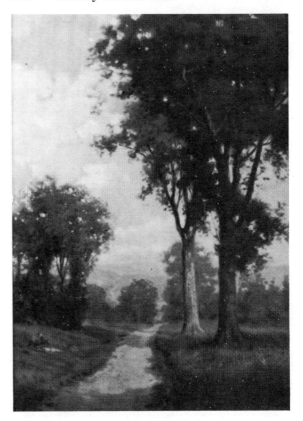

Fig. 109. (#19) Untitled. R. Atkinson Fox. © E. Gross Co., No. 608. #450 Reliance found on back of one print. 20″ x 14″. Courtesy Loretta Goad.

56

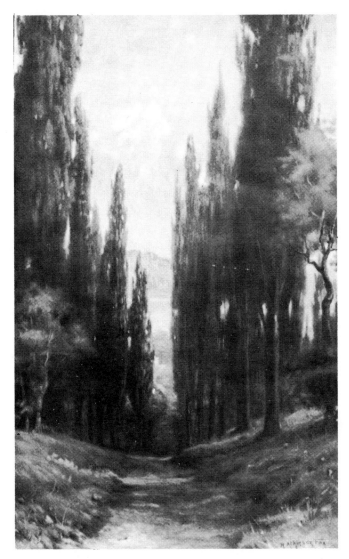

Fig. 112. (#302) Untitled. R. Atkinson Fox. Found on a 1933 calendar. 10″ x 7½″. Courtesy Barbara Kern.

Fig. 110. (#21) Untitled. R. Atkinson Fox. Edward Gross, New York, No. 807. 16″ x 10″, 18″ x 13½″. Courtesy Loretta Goad.

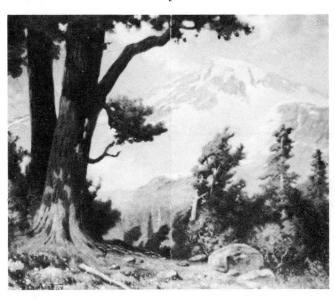

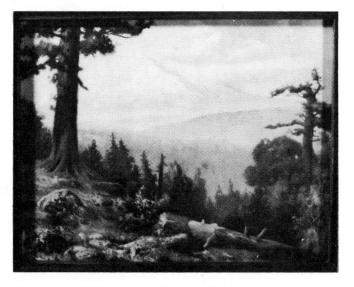

Fig. 113. (#242) Untitled. R. Atkinson Fox. Note how the wind in the valley is blowing the trees toward the right. 9½″ x 11¼″. Bill Fox collection. Photograph by author.

Fig. 111. (#136) "Mount Hood." R. Atkinson Fox. The Broderick Co., St. Paul. 8½″ x 11″, 16″ x 20″.

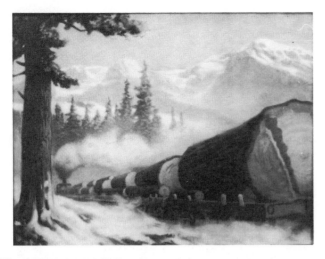

Fig. 114. (#98) "A Fallen Monarch." R. Atkinson Fox. 9½"
x 12½", 16" x 20". Gift by Loretta Goad to the author.

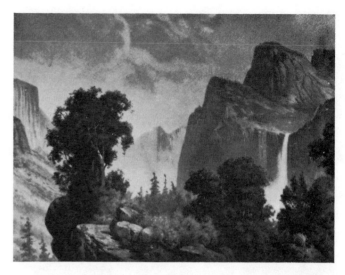

Fig. 116. (#104) "The Bridal Veil Falls of Yosemite Valley."
© 1911, Library of Congress collection.

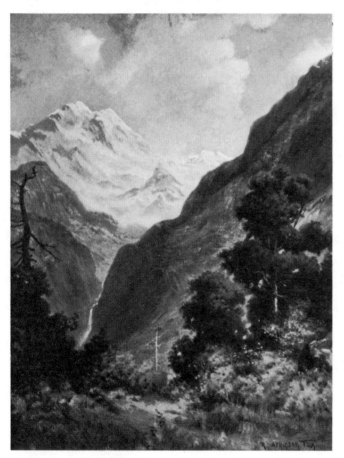

Fig. 115. (#108) "'Neath Turquoise Skies." © 1913, Library
of Congress collection.

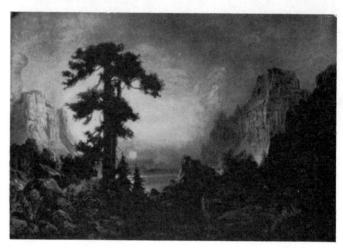

Fig. 117. (#217) Untitled. R. Atkinson Fox. Courtesy Lee
Fenner.

58

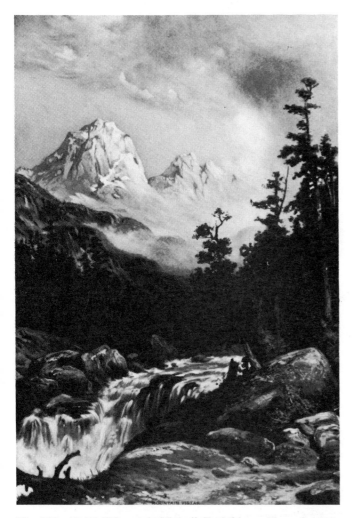

Fig. 118. (#107) "Mountain Vista." R. Atkinson Fox. © 1912, Library of Congress collection.

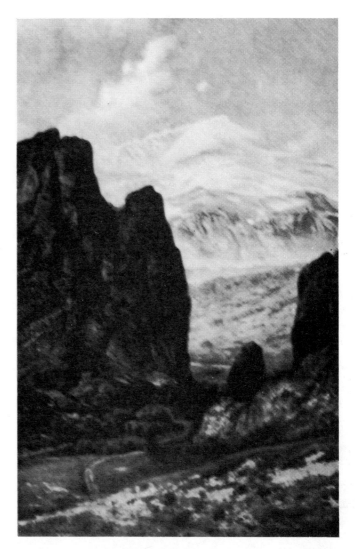

Fig. 120. (#258) Untitled. R. Atkinson Fox. 6″ x 4″. Bill Fox collection. Photograph by author.

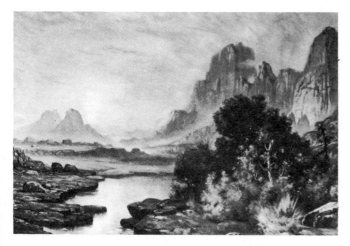

Fig. 119. (#105) "Head of the Canon." R. Atkinson Fox. © 1912, Library of Congress collection.

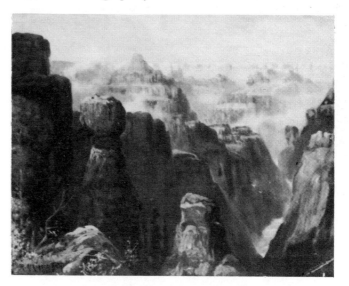

Fig. 121. (#247) Untitled. R. Atkinson Fox. © K. T. Co., Cincinnatti, Ohio. Bill Fox collection. Photograph by author.

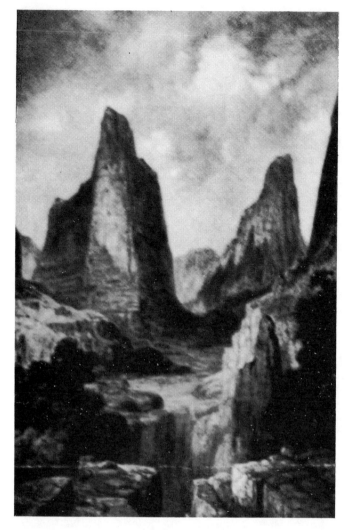

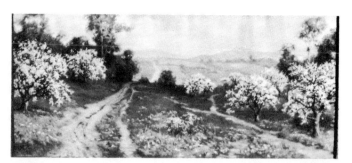

Fig. 124. (#175) "Spring Beauties." R. Atkinson Fox. ©
Edward Gross Co., New York, No. 617. Courtesy Barbara Kern.

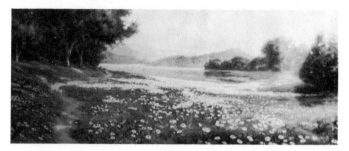

Fig. 125. (#77) Untitled. R. Atkinson Fox. © Edward Gross
Co., New York, No. 616. 10″ x 24″. Courtesy Phyllis Sherwood.

Fig. 122. (#257) Untitled. R. Atkinson Fox. 6″ x 4″. Bill Fox
collection. Photograph by author.

Fig. 123. (#162) "Dandelion Time." R. A. Fox. © Edward
Gross Co., 826 Broadway, New York. Wildflower Series No.
614. 6″ x 14″. Courtesy Loretta Goad.

Fig. 126. Detail of Fig. 125.

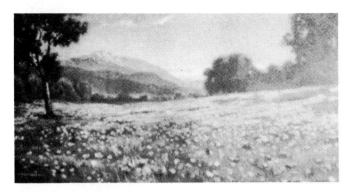

Fig. 127. (#76) "In Flanders Field." Morris & Bendien Co., New York. 8¼" x 16". Courtesy Val Orwig.

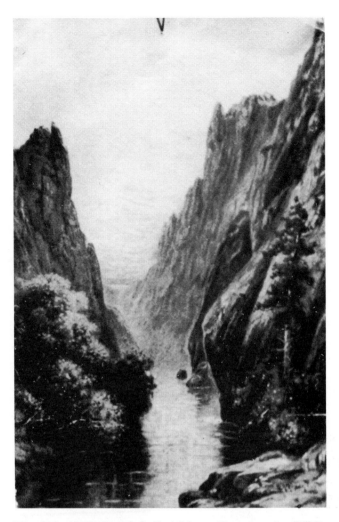

Fig. 129. (#260) Untitled. R. Atkinson Fox. 6" x 4". Bill Fox collection. Photograph by author.

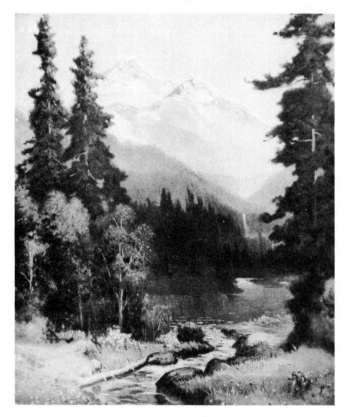

Fig. 128. (#281) Untitled. R. Atkinson Fox. 10" x 12". Courtesy Joe Bell.

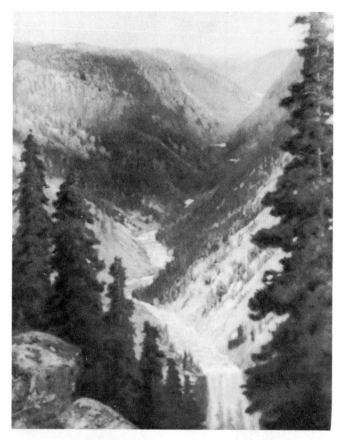

Fig. 130. (#198) Untitled. R. Atkinson Fox. Found on a 1929 calendar. 10″ x 7¼″. Bill Fox collection. Photograph by author.

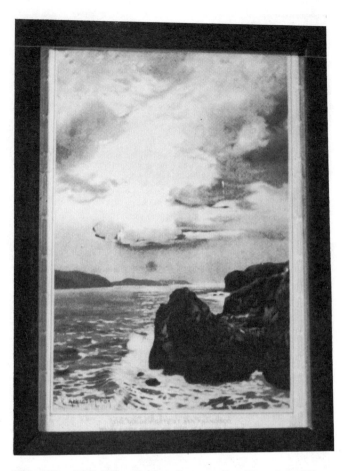

Fig. 132. (#86) "The Golden Gate at San Francisco Whose Golden Sunsets Give and Take of a Goodly Morrow." 6½″ x 4½″. Courtesy Loretta Goad.

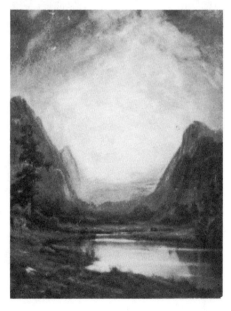

Fig. 131. (#244) Untitled. R. Atkinson Fox. Bill Fox collection. Photograph by author.

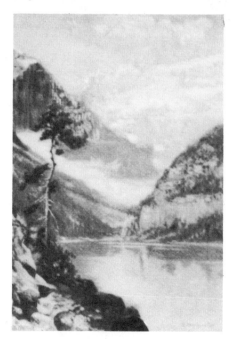

Fig. 133 (#255) Untitled. R. Atkinson Fox. 3½″ x 2½″. Bill Fox collection. Photograph by author.

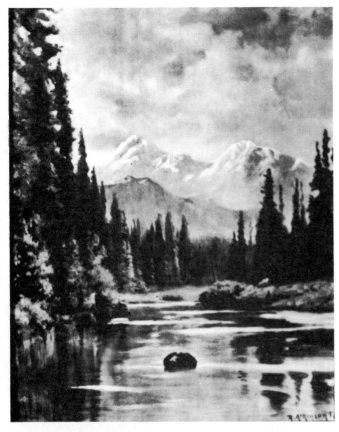

Fig. 134. (#85) "The Approaching Storm." R. Atkinson Fox. 20″ x 16″. Courtesy Loretta Goad.

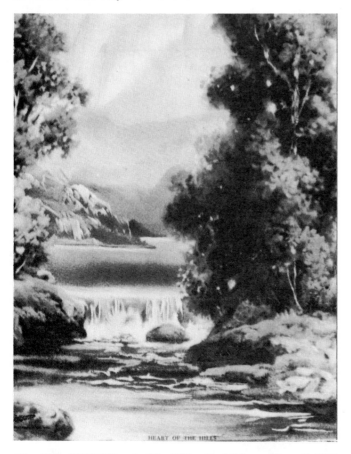

Fig. 135. (#308) "Heart of the Hills. R. Atkinson Fox. © 1926 by Brown & Bigelow, St. Paul, Minnesota. 9½″ x 7½″. Courtesy Donna Robinson.

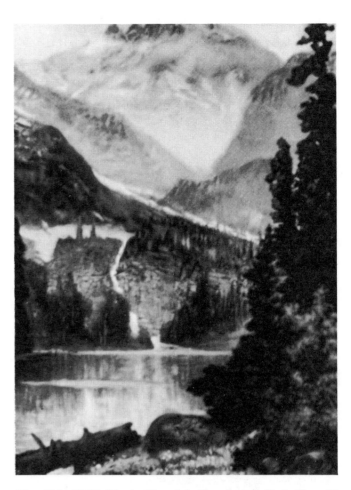

Fig. 136. (#248) "Rocky Mountain Grandeur." R. A. Fox. 9″ x 7″. Bill Fox collection. Photograph by author.

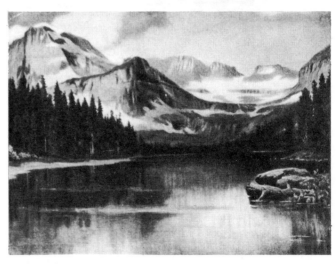

Fig. 137. (#313) Untitled. R. Atkinson Fox. K. T. Co., Cincinnatti, Ohio. 6½″ x 8½″. Bill Fox collection. Photograph by author.

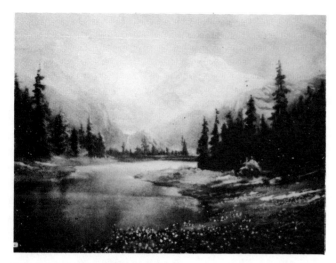

Fig. 138. (#64) "Nature's Sublime Grandeur." R. Atkinson Fox. 16″ x 20″. Courtesy Lloyd Bohanan.

Fig. 139. (#134) "Great Fall of Yellowstone." R. Atkinson Fox. © Brown & Bigelow, St. Paul, Minnesota. Courtesy Donna Eby.

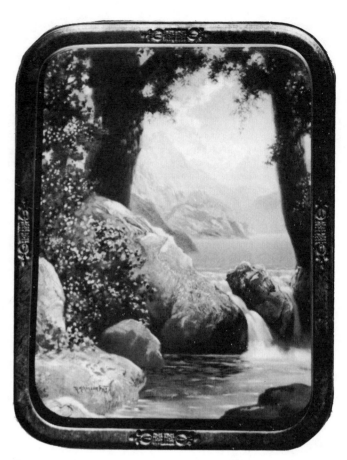

Fig. 140. (#2) "Rocky Waterway." R. Atkinson Fox. © John Drescher Co., Inc., under K-202446, March 24, 1926. Courtesy John Miller.

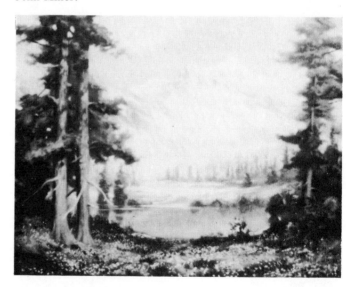

Fig. 141. (#301) "A Mountain Lake." R. Atkinson Fox. The Library of Congress lists a print with this title published by John Drescher, June 28, 1926. Because they don't have a copy or a description on file, we don't know if it is the same one. 16″ x 20″. Courtesy Phyllis Sherwood.

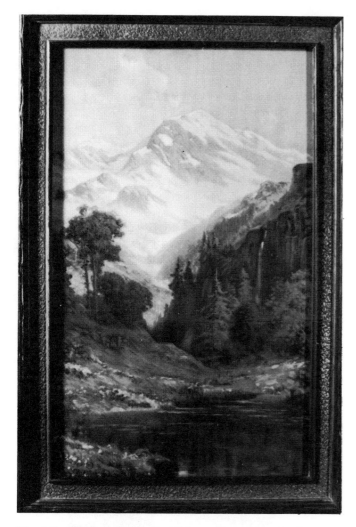

Fig. 142. (#137) Untitled. R. Atkinson Fox. 16″ x 10″ Courtesy Loretta Goad.

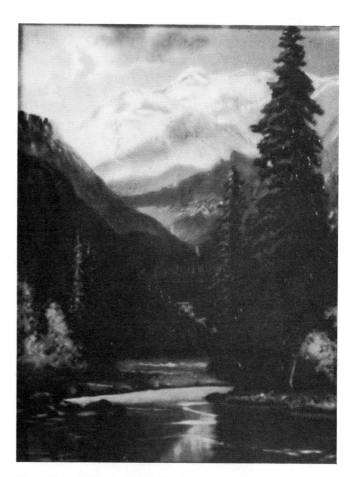

Fig. 144. (#9) Untitled. R. Atkinson Fox. Found as an embossed calendar top. The bright magenta of the background mountains is unique to this print. 10″ x 8″. Courtesy Tita Campbell.

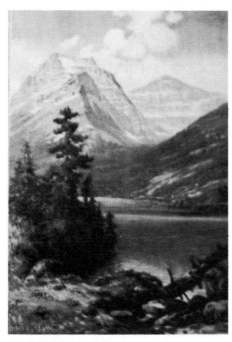

Fig. 143. (#142) "Going to Sun Mountain Where Sky and Earth Unite in Glacier Park." R. Atkinson Fox. 7″ x 5″. Courtesy Loretta Goad.

Fig. 145. (#147) "Sunset Rock Lookout Mountain." R. Atkinson Fox. Found as a postcard. Courtesy Donna Robinson.

65

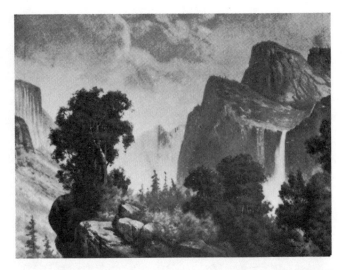

Fig 148. (#104) "The Bridal Veil Falls of Yosemite Valley." © 1911. This print from the Library of Congress collection is a closer view of the falls featured on the postcard in Fig. 147. We don't know its size.

Fig. 146. (#99) "Mount Rainier." R. Atkinson Fox. © 1913 by Red Wing Adv. Co. Found as a postcard and a 16″ x 11″ print. Courtesy Donna Robinson.

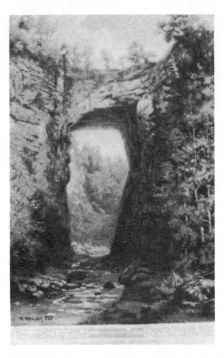

Fig. 149. (#146) "The Natural Bridge of Virginia." R. Atkinson Fox. Found on a postcard. Courtesy Donna Robinson.

Fig. 147. (#104) "The Bridal Veil Falls of Yosemite Valley." © 1911. Found on a postcard and a tiny 6″ x 3″ calendar print. Courtesy Donna Robinson.

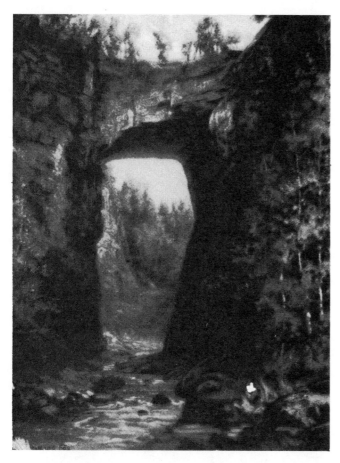

Fig. 150. (#146) "The Natural Bridge of Virginia." R. Atkinson Fox. The natural rock formation featured on the postcard in Fig. 149 is also found on an advertising blotter published in 1918 by "B & B," which I presume is Brown & Bigelow. Author's collection.

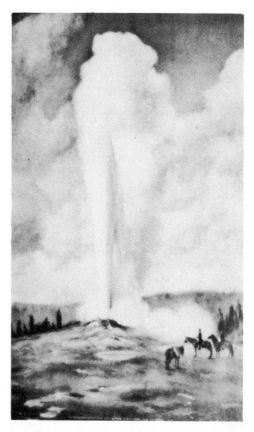

Fig. 151. (#185) "Washburn-Langford Expedition Discovers Old Faithful." R. Atkinson Fox. 14½″ x 9″. Courtesy Loretta Goad.

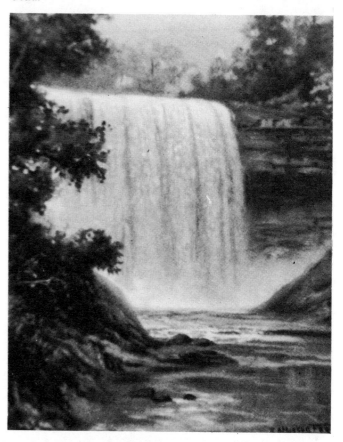

Fig. 152. (#221) "Minnehaha Falls." R. Atkinson Fox. Calendar top. 6″ x 4″. Courtesy Barbara Kern.

67

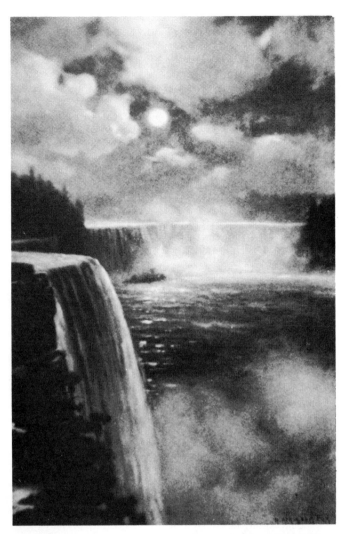

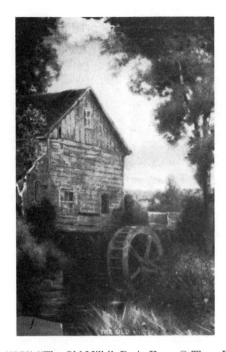

Fig. 155. (#273) "The Old Mill." R. A. Fox. © Thos. D. Murphy Co., under G-66298, July 31, 1922. 5″ x 3″. Bill Fox collection. Photograph by author.

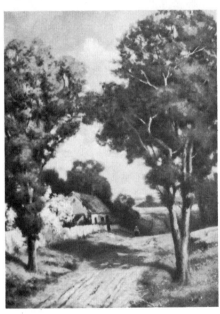

Fig. 153. (#222) "Niagara Falls." R. Atkinson Fox. This calendar top is a mate to the one in Fig. 152. 6″ x 4″. Courtesy Barbara Kern.

Fig. 156. (#274) "The Old Road." R. A. Fox. © Thos. D. Murphy Co., under G-66294, July 31, 1922. 5″ x 3″. Bill Fox collection. Photograph by author.

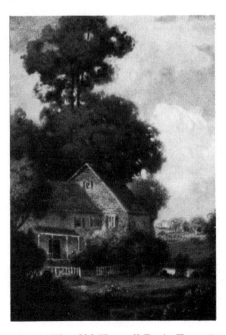

Fig. 154. (#286) "The Old Home." R. A. Fox. 5″ x 3″. Bill Fox collection. Photograph by author.

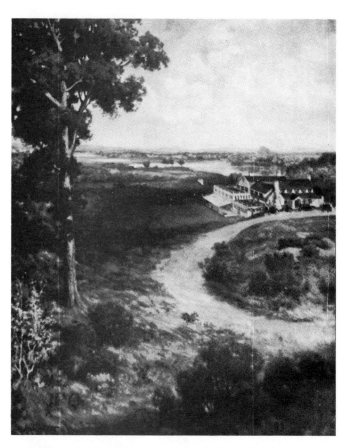

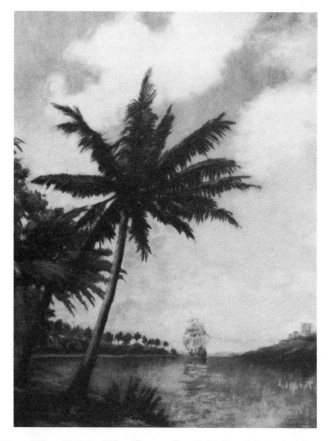

Fig. 157. (#314) Untitled. R. Atkinson Fox. 7″ x 9″. Bill Fox collection. Photograph by author.

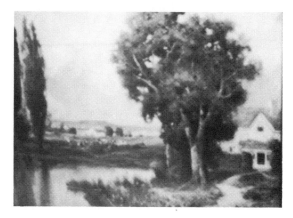

Fig. 158. (#205) "Down on the Farm." R. Atkinson Fox. 9″ x 11″. Courtesy Donna Eby.

Fig. 159. (#224) "The Sunny South." R. Atkinson Fox. Tintagravure, © 1929, Brown & Bigelow, St. Paul, Minnesota. 15½″ x 11½″. Bill Fox collection. Photograph by author.

Fig. 160. (#178) Untitled. Signed. Courtesy Phyllis Sherwood.

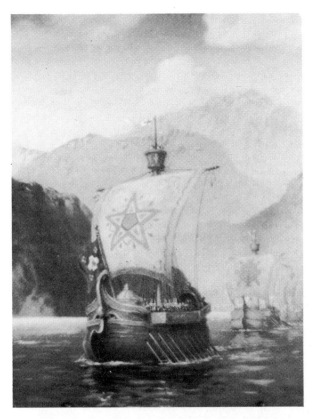

Fig. 161. (#173) "Vikings Bold." R. Atkinson Fox. 9″ x 7½″. Bill Fox collection. Photograph by author.

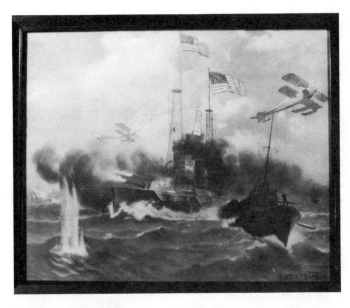

Fig. 163. (#139) "Supremacy." R. Atkinson Fox. 16″ x 20″. Courtesy Loretta Goad.

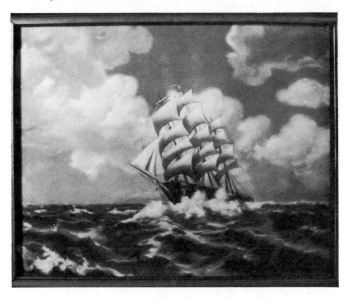

Fig. 164. (#75) "Clipper Ship." R. Atkinson Fox. © Borin, Chicago, 13½″ x 17½″. An untitled example has been found with "Rough Seas" stamped on the back. Courtesy Loretta Goad.

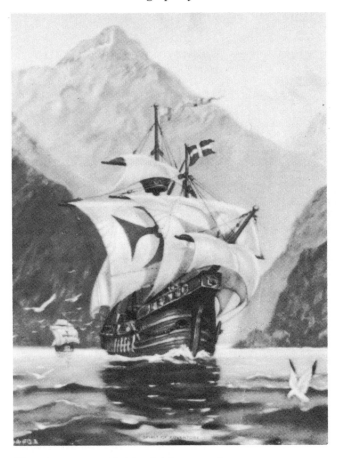

Fig. 162. (#172) "Spirit of Adventure." R. A. Fox. Bill Fox collection. Photograph by author.

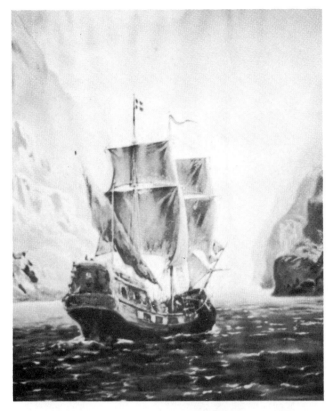

Fig. 165. (#17) "Good Ship Adventure." R. Atkinson Fox. 12½" x 9½", 16" x 12". Courtesy Charles Mandrake.

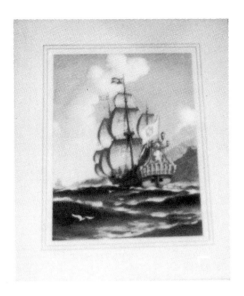

Fig. 167. (#184) "Off Treasure Island." R. A. Fox. 7½" x 5½". Courtesy Donna Eby.

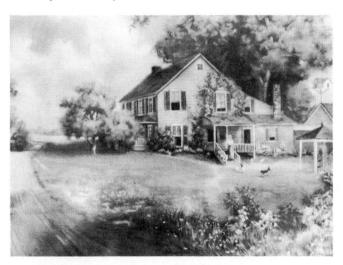

Fig. 168. (#148) "Sweet Ol' Spot." (Also "A Dear Old Spot.") R. Atkinson Fox. 9" x 12". Courtesy Donna Robinson.

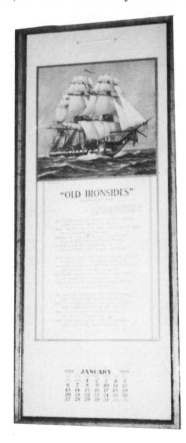

Fig. 166. (#195) "Old Ironsides." R. A. Fox. © M. P. Co. Found on a 1929 calendar over poem by Oliver Wendell Holmes. 22" x 9½". Courtesy Loretta Goad.

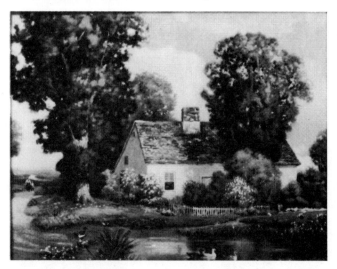

Fig. 169. (#72) "Russet Gems." R. Atkinson Fox. 9" x 12". Courtesy Loretta Goad.

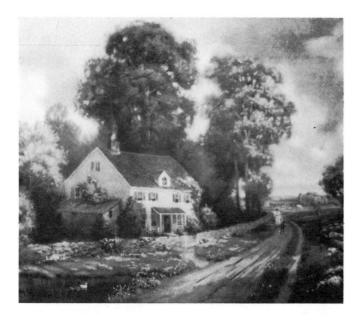

Fig. 170. (#49) "The Old Home." R. A. Fox. © Thos. D. Murphy Co., under G-66316, July 31, 1922. 16″ x 20″. Courtesy Loretta Goad.

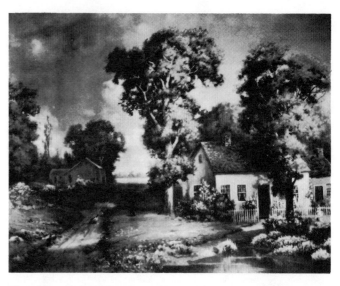

Fig. 173. (#125) "Down in Old Virginia." R. Atkinson Fox. © 1914, Library of Congress collection.

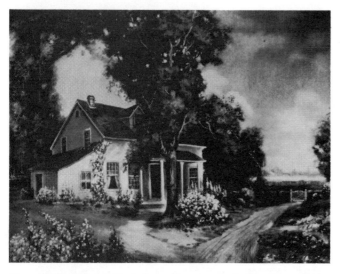

Fig. 171. (#123) "A York State Homestead." R. Atkinson Fox. © 1914, Library of Congress collection.

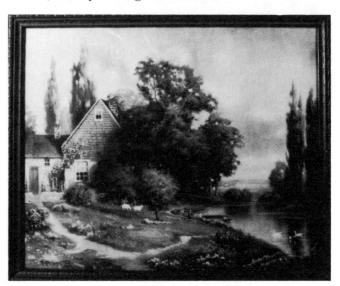

Fig. 174. (#100) "Home Sweet Home." R. Atkinson Fox. 16″ x 20″. Courtesy Loretta Goad.

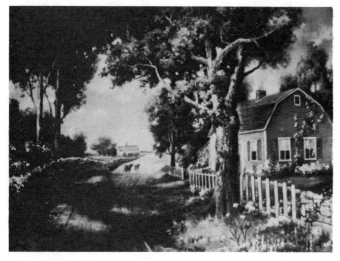

Fig. 172. (#124) "A Jersey Homestead." R. Atkinson Fox. © 1914, Library of Congress collection.

72

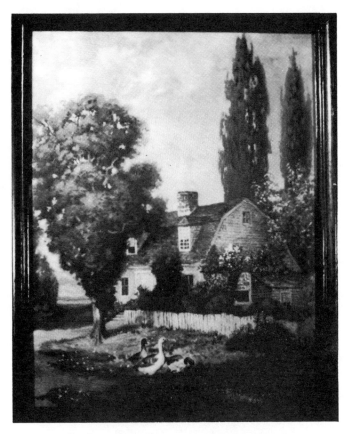

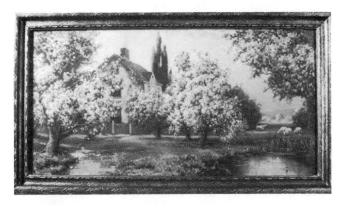

Fig. 177. (#83) "Blossom Time." R. A. Fox. © Master Art Publishers, Inc., under K-228167, June 20, 1927. 10″ x 20″. Courtesy Loretta Goad.

Fig. 175. (#155) "Where Nature Beats in Perfect Tune." R. Atkinson Fox. 20″ x 16″. Courtesy Loretta Goad.

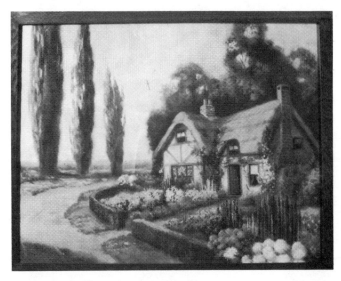

Fig. 178. (#149) "There's No Place Like Home." R. Atkinson Fox. 15½″ x 20″. Courtesy Loretta Goad.

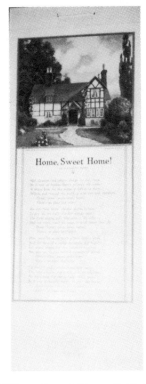

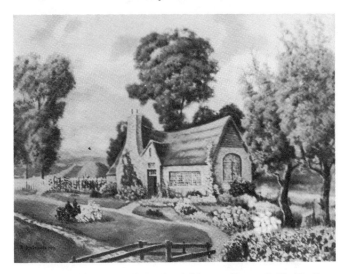

Fig. 176. (#196) "Home Sweet Home." R. A. Fox. © M. P. Co. Print is above a poem with same title by John Howard Paine. This is a mate to "Old Ironsides," Fig. 166. 22″ x 9½″. Courtesy Loretta Goad.

Fig. 179. (#253) Untitled. R. Atkinson Fox. © K. T. Co., Cincinnatti, Ohio. 9½″ x 12½″. Bill Fox collection. Photograph by author.

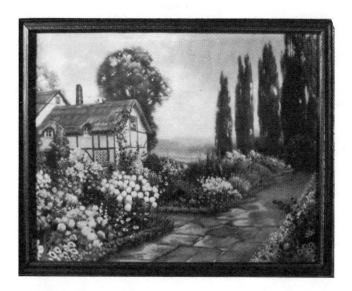

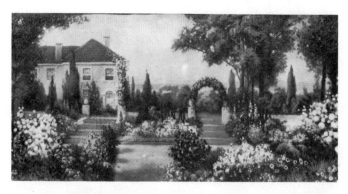

Fig. 182. (#55) "Heart's Desire." R. A. Fox. © Master Art Publishers, under K-228165, June 20, 1927. 10″ x 20″, 13½″ x 27½″. A narrower version is reported with a Borin copyright. Courtesy Tita Campbell.

Fig. 180. (#12) "An Old-Fashioned Garden." R. Atkinson Fox. Master Art Publishers and Borin, Chicago. 18″ x 30″. Courtesy Loretta Goad.

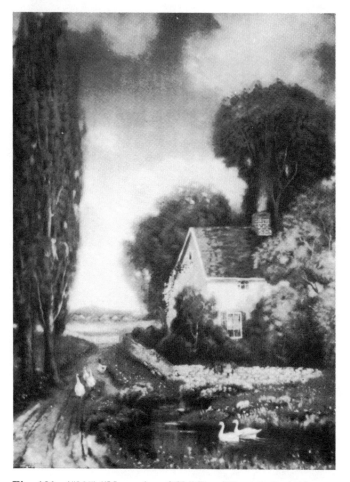

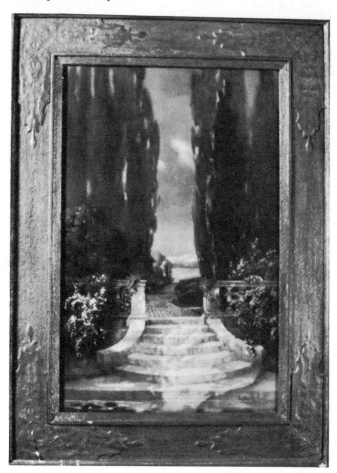

Fig. 183. (#69) "The Sunny South." R. A. Fox. Villa Series. Publication of Edward Gross Co., 826 Broadway, New York. 15″ x 10″. Courtesy Loretta Goad.

Fig. 181. (#305) "Memories of Childhood Days." R. Atkinson Fox. Courtesy Hap Sims.

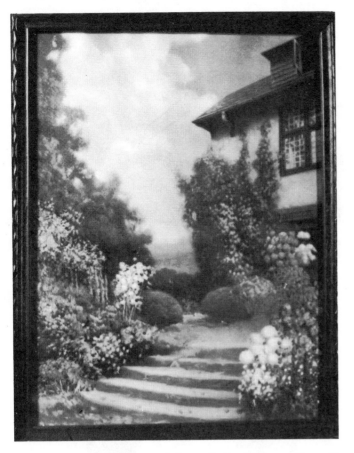

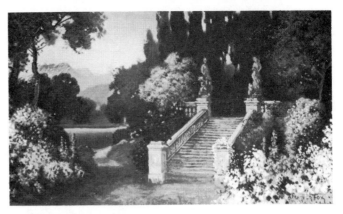

Fig. 186. (#20) "Garden of Hope." R. Atkinson Fox. Sunshine Garden Series. © John Drescher Inc., under K-194629, May 11, 1925. 10″ x 18″, 14″ x 22″. Author's collection.

Fig. 184. (#56) "Enchanted Steps." R. Atkinson Fox. © Master Art Publishers, under K-223111, February 12, 1927. 18″ x 14″. Courtesy Loretta Goad.

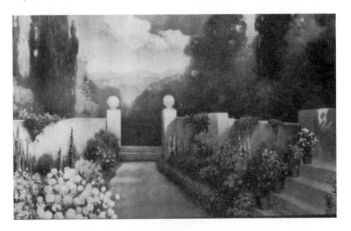

Fig. 187. (#79) Untitled. R. Atkinson Fox. © Morris & Bendien, Inc. 18″ x 30″ Courtesy Loretta Goad.

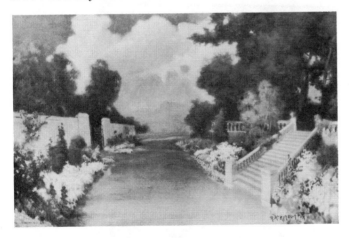

Fig. 185. (#10) "Promenade." R. Atkinson Fox. © Morris & Bendien, Inc., No. 53681. Sometimes also found with Master Art's "The Good Luck Line" in cloverleaf logo. 12″ x 20″, 14″ x 22″. Courtesy Charles Mandrake.

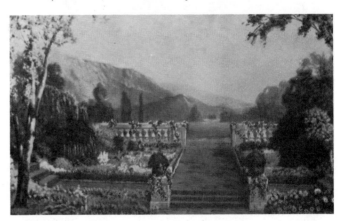

Fig. 188. (#80) "Country Garden." R. Atkinson Fox. © Borin Mfg. Co. 14″ x 24″, 18″ x 30″.

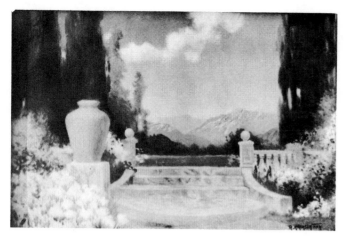

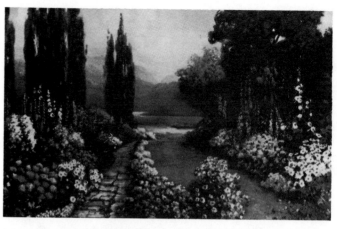

Fig. 189. (#41) "Dreamland." R. Atkinson Fox. © Morris & Bendien, Inc., New York. 8"x 12", 14" x 22". Courtesy of Donna Robinson.

Fig. 191. (#57) "English Garden." R. Atkinson Fox. © Master Art Publishers and Borin, Chicago. 14" x 20". Courtesy Charles Mandrake.

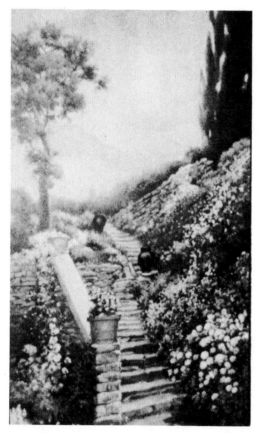

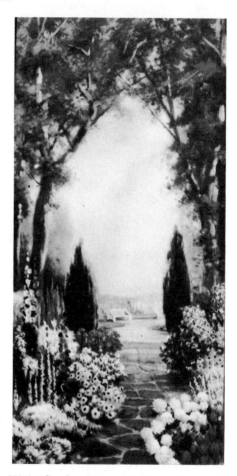

Fig. 190. (#189) "Garden of Nature." R. A. Fox. Sunshine Garden Series. © John Drescher Inc., under K-202260, March 4, 1926. 17½" x 9½". Courtesy of Donna Robinson.

Fig. 192. (#81) "Garden Retreat." R. A. Fox © Master Art Publishers, Inc., under K-228169, June 20, 1927. 20" x 10". Courtesy Charles Mandrake.

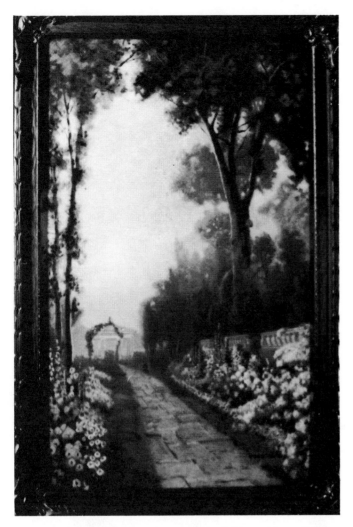

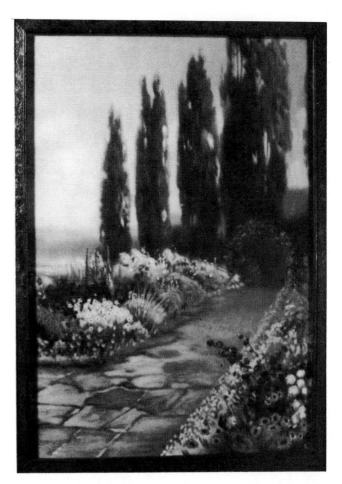

Fig. 193. (#97) "Nature's Retreat." R. Atkinson Fox. © John Drescher Co., Inc., under K-219970, November 8, 1926. Courtesy Loretta Goad.

Fig. 194. (#12-A) "Prospect." Unsigned. No. 5039. The right-hand side of "An Old-Fashioned Garden," Fig. 180, has been published as a separate print. We refer to these as "portions." Courtesy Loretta Goad.

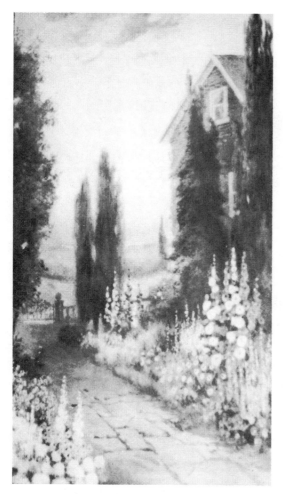

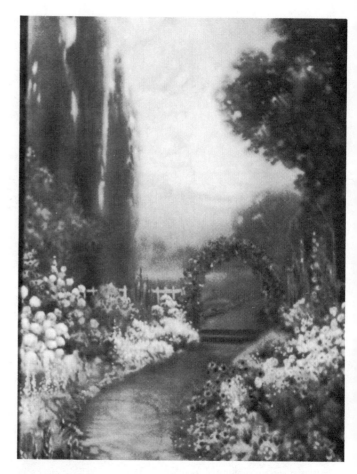

Fig. 195. (#48) "Wayside House." R. Atkinson Fox. © M. & B., Inc. 30″ x 18″. Courtesy Lee Fenner.

Fig. 197. (#37) "Blooming Time." R. Atkinson Fox. Master Art Publishers. 18″ x 14″. Courtesy Loretta Goad.

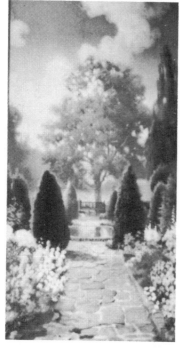

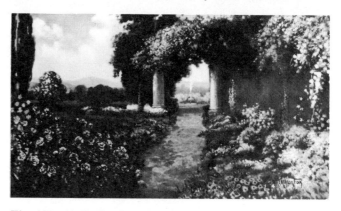

Fig. 198. (#42) "Garden of Love." R. Atkinson Fox. Sunshine Garden Series. © John Drescher, Inc., under K-194628, May 11, 1925. Courtesy Loretta Goad.

Fig. 196. (#143) Untitled. R. Atkinson Fox. © John Drescher Co., New York. 18″ x 10″. Courtesy Donna Eby.

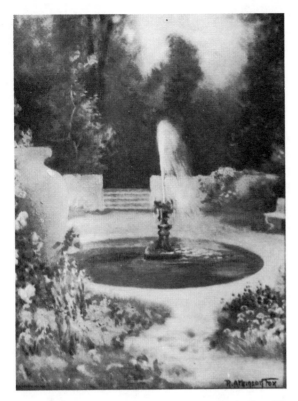

Fig. 199. (#40) "Garden of Romance." R. Atkinson Fox. Morris & Bendien, No. 8604. 10″ x 8″, 22″ x 14″. Courtesy Loretta Goad.

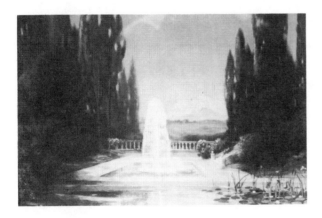

Fig. 200. (#3) "Fountain of Love." R. Atkinson Fox. © E. G. Co. 10″ x 15″.

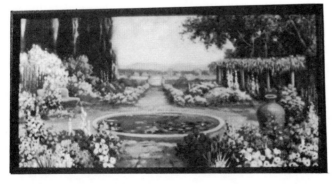

Fig. 201. (#16) "Nature's Beauty." R. A. Fox. © Master Art Publishers, under K-225989, June 1, 1927. Also reported as "Nature's Beauties" by Borin. 10″ x 20″, 14″ x 20″, 14″ x 28″ (registered size). Courtesy Loretta Goad.

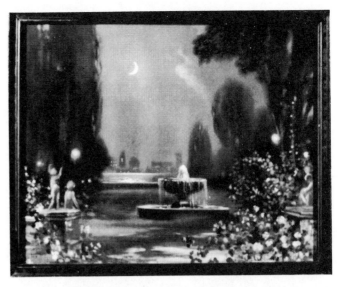

Fig. 202. (#39) "Moonlight and Roses." R. Atkinson Fox. © Master Art Publishers, under K-223110, February 12, 1927. 14″ x 18″. Courtesy Loretta Goad.

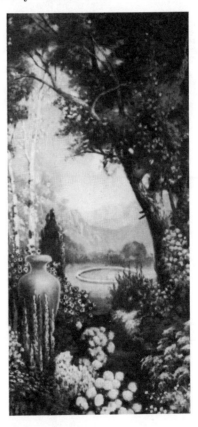

Fig. 203. (#82) "Garden Realm." R. A. Fox. © Master Art Publishers, under K-228170, June 20, 1927. 20″ x 10″. Courtesy Loretta Goad.

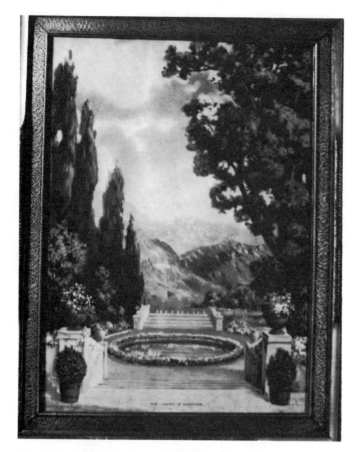

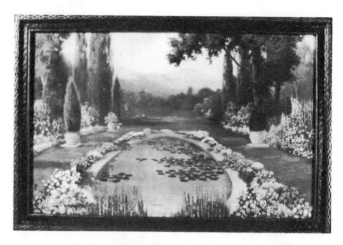

Fig. 207. (#91) "Nature's Treasure(s)." R. Atkinson Fox. ©
John Drescher Co., Inc., under K-219970, November 8, 1926.
14″ x 22″. Courtesy Loretta Goad.

Fig. 204. (#68) "Garden of Happiness." R. Atkinson Fox. ©
1929, Brown & Bigelow, St. Paul, Minnesota. 16″ x 12″.
Courtesy Loretta Goad.

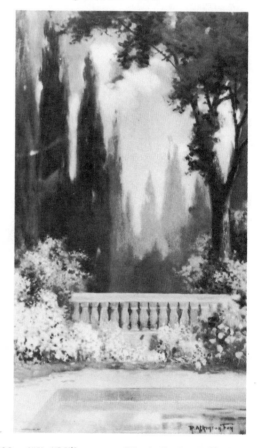

Fig. 205. (#296) Untitled. R. Atkinson Fox. 19″ x 32″.
Courtesy Mrs. Sullins.

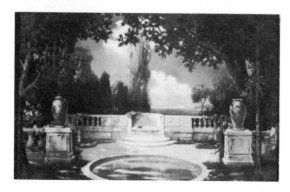

Fig. 208. (#8) "Midsummer Magic." R. Atkinson Fox. ©
Morris & Bendien Co., Inc., New York. This sometimes is found
with bright red flowers and sometimes with no red at all. 12″
x 8″, 22″ x 14″. Courtesy Charles Mandrake.

Fig. 206. (#74) "The Magic Pool." R. A. Fox. Villa Series.
© E. G. Co., New York. 10″ x 16″. Courtesy Loretta Goad.

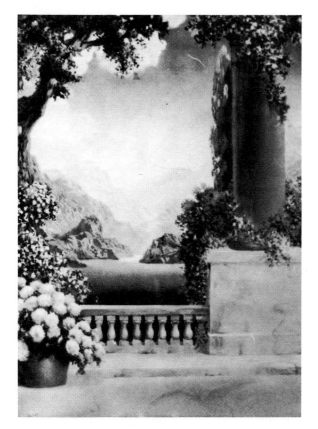

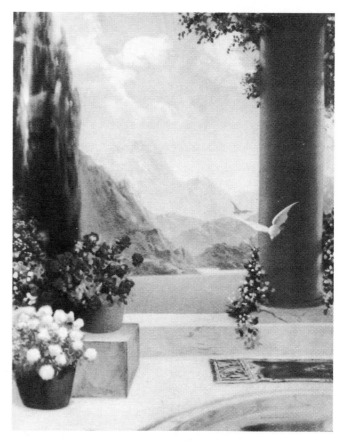

Fig. 209. (#14) "Land of Dreams." R. Atkinson Fox. Tintagravure, Brown & Bigelow, St. Paul, Minnesota, 1926 and 1932. 10″ x 8″. (I have seen a larger size but didn't get a measurement.) Courtesy Loretta Goad.

Fig. 211. (#67) "Love Birds." R. Atkinson Fox. © John Drescher Co., Inc., under K-202440, March 24, 1926. 16″ x 13″. Courtesy Charles Mandrake.

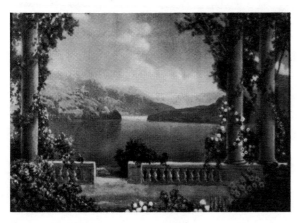

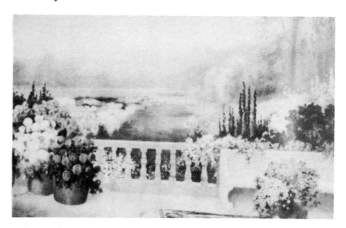

Fig. 210. (#5) "Blue Lake." R. Atkinson Fox. Borin. This, also, is found with and without a run of red ink. 14″ x 20″. Courtesy Loretta Goad.

Fig. 212. (#203) Untitled. R. Atkinson Fox. © M. & B., Inc. 18″ x 30″. Courtesy Loretta Goad.

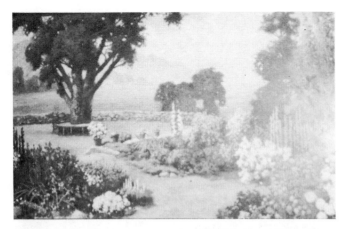

Fig. 213. (#204) "Haven of Beauty." R. Atkinson Fox. © John Drescher, Inc., New York. 18″ x 30″. Courtesy Loretta Goad.

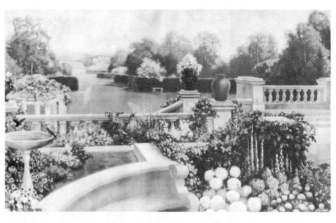

Fig. 215. (#7) "Venetian Garden." R. Atkinson Fox. © Master Art Publishers. 14″ x 18″, 18″ x 30″. Courtesy Charles Mandrake.

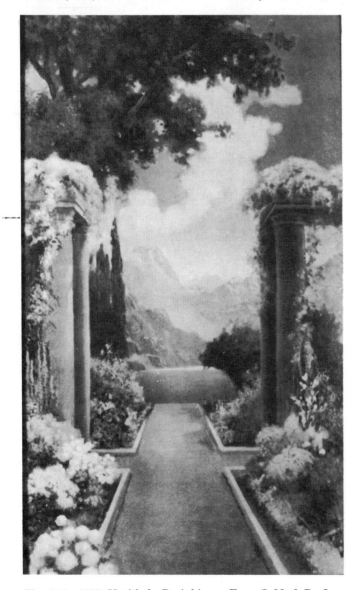

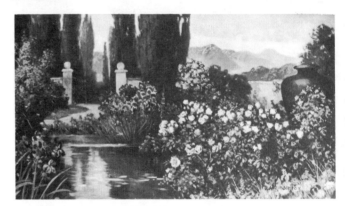

Fig. 216. (#63) "Garden of Happiness." R. Atkinson Fox. Sunshine Garden Series. © John Drescher Co., Inc., under K-194626, May 11, 1925. 10″ x 18″. Courtesy Loretta Goad.

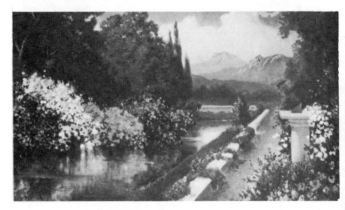

Fig. 217. (#78) "Garden of Contentment." R. Atkinson Fox. Sunshine Garden Series. © John Drescher Co., Inc. under K-194627, May 11, 1925. 10″ x 18″. Courtesy Loretta Goad.

Fig. 214. (#93) Untitled. R. Atkinson Fox. © M. & B., Inc. 30″ x 18″. Courtesy Loretta Goad.

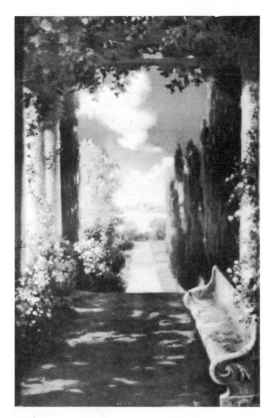

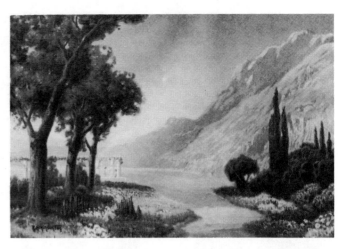

Fig. 218. (#46) "Rose Bower." R. Atkinson Fox. © E. G. Co. 16″ x 10″. Courtesy Loretta Goad.

Fig. 220. (#65) "Perfect Day." R. Atkinson Fox. © Borin Mfg. Co. 14″ x 18″.

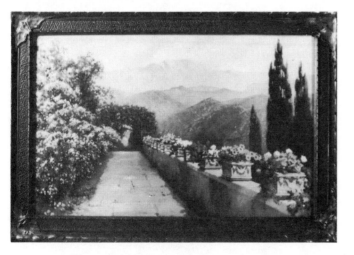

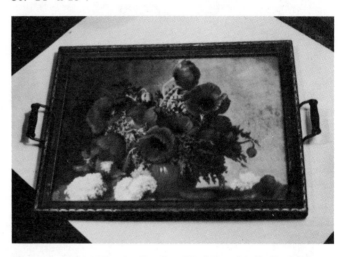

Fig. 219. (#22) "Nature's Grandeur." R. Atkinson Fox. © John Drescher Co., Inc., under K-219971, November 8, 1926. 14″ x 22″. Courtesy Loretta Goad.

Fig. 221. (#45) "Poppies." (Also "Red Poppies.") R. Atkinson Fox. © Borin Mfg. Co., Borin-Vivatone Corporation. "Poppies" has been found in print sizes 15″ x 20″ and 18″ x 30″, and under a tray as illustrated here. The prints were advertised for $1 each in an early Sears catalog. This print, with slight variations, has been found with the signature "H. Lewis." Courtesy Charles Mandrake.

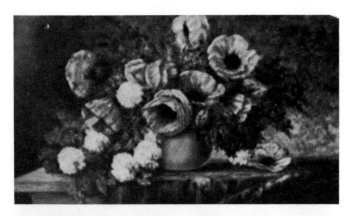

Fig. 222. For comparison, the Fox "Poppies" is at bottom. The top version is signed "H. Lewis." Note that the Lewis "Poppies" has the top flower turned differently, there are more white flowers, and the single petal to the right of the vase in the Fox-signed version is missing here.

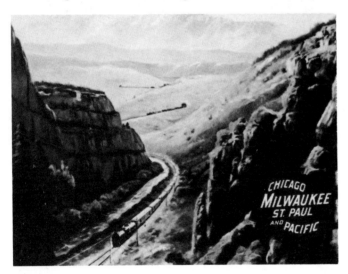

Fig. 223. (#310) "Chicago, Milwaukee, St. Paul, and Pacific." R. Atkinson Fox. 8″ x 10″. Bill Fox collection. Photograph by author.

Fig. 224. (#316) "The New Overland Express." R. A. Fox. © The K.-T. Co., Cincinnatti, Ohio, No. 33331. Print size 9″ x 12″. Courtesy Barbara Kern.

Fig. 225. (#317) "An Ambassador of Good Will." R. A. Fox. © The K.-T. Co., Cincinnatti, Ohio, No. 30532. Print size 10″ x 8″. Courtesy Barbara Kern.

84

Fig. 226. (#33) Untitled. R. Atkinson Fox. Master Art Publishers. 20″ x 13½″. Author's collection.

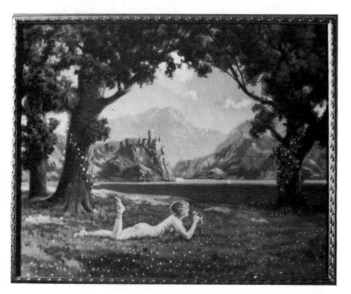

Fig. 227. (#70) "Elysian Fields." R. Atkinson Fox. 16″ x 20″. Courtesy Loretta Goad.

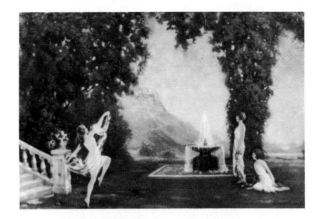

Fig. 228. (#4) "Spirit of Youth." R. Atkinson Fox. Borin. The Library of Congress lists two by this title—both copyrighted by Borin. One was copyrighted June 11, 1926, under G-77616, the other August 19, 1926, under K-218148. Also, a print has been reported with only slight differences in the girls' poses—background details are supposedly identical. It is unsigned, titled "Enchantment," and distributed by Stern and Hacker. Courtesy Loretta Goad.

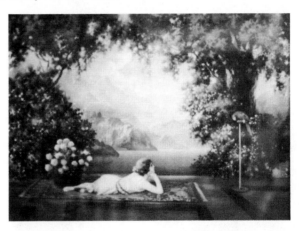

Fig. 229. (#31) "In the Valley of Enchantment." R. Atkinson Fox. © K.-T. Co., Cincinnatti, Ohio. 22″ x 27″. Courtesy Phyllis Sherwood.

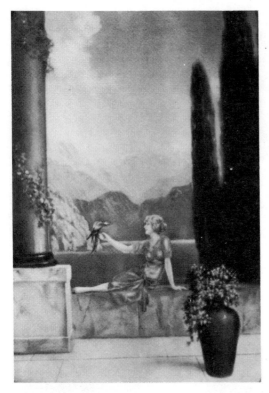

Fig. 230. (#32) "Romance Canyon." R. Atkinson Fox. I have three photos of this on file—all are cut to fit the shaped frames. Width is about 12″. Height varies from 18″ to 15¼″. Courtesy Loretta Goad.

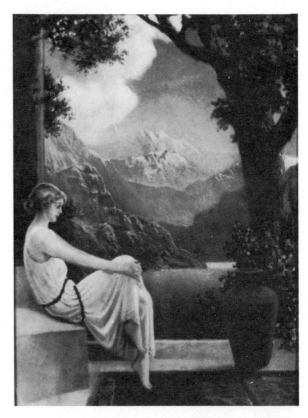

Fig. 232. (#150) "In My Garden of Dreams." R. Atkinson Fox. No. 27361. 13″ x 10″. Courtesy Loretta Goad.

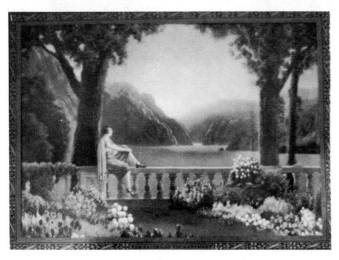

Fig. 231. (#200) "The Valley of Enchantment." R. Atkinson Fox. © Louis F. Dow Co. Found on a 1931 calendar.

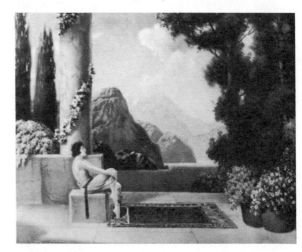

Fig. 233. (#138) "Daydreams." R. Atkinson Fox. No. 118. This print is frequently found trimmed, but I have seen complete prints in the following sizes: 4″ x 5″, 10″ x 12″, and 16″ x 20″. "Daydreams" has also been found on a greeting card. Author's collection.

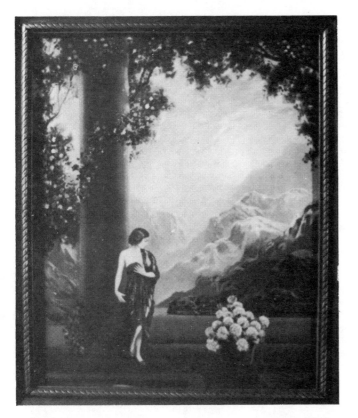

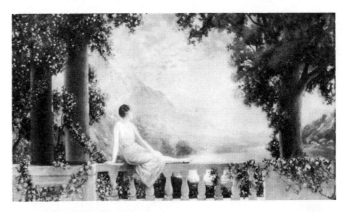

Fig. 234. (#30) "Sunrise." R. Atkinson Fox. Found as a print in sizes 12″ x 16″, 12″ x 10″, and 3″ diameter in a small round frame. "Sunrise" has also been found as a 7″ x 8″ print in an advertising thermometer. (See Fig. 235.) Courtesy Loretta Goad.

Fig. 236. (#23) "Sunset Dreams." R. Atkinson Fox. © Borin Mfg. Co., Chicago. Also by Master Art Publishers. 10″ x 18″. Author's collection.

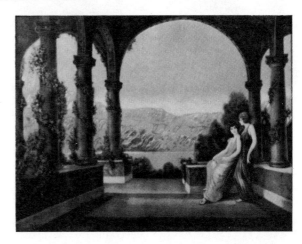

Fig. 237. (#34) "Twilight." R. Atkinson Fox. This print seems to have a particular problem with fading. 12″ x 16″. Author's collection.

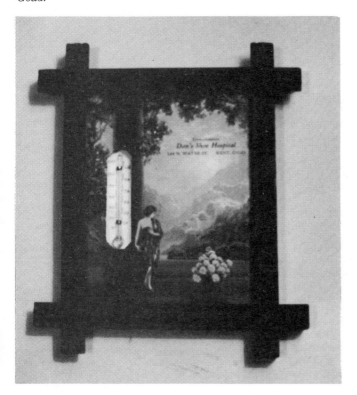

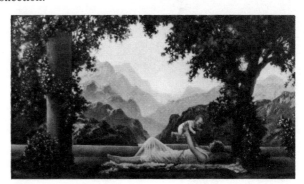

Fig. 238. (#13) "Love's Paradise." R. Atkinson Fox. Registered in the name of Molly Borin, under G-75786, October 22, 1925. This print is often found marked Fox-Urgelles, and I don't know why. 9″ x 15″, 10″ x 18″, 18″ x 30″. Author's collection.

Fig. 235. "Sunrise" as an advertising thermometer. Courtesy Charles Mandrake.

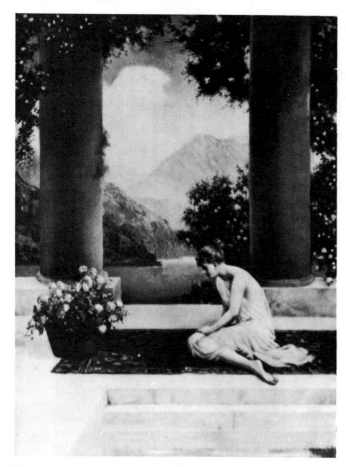

Fig. 239. (#245) Untitled. R. Atkinson Fox. Merchant's Publishing Co. 11″ x 9½″. Bill Fox collection. Photograph by author.

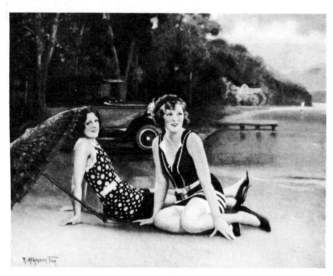

Fig. 240. (#47) Untitled. R. Atkinson Fox. 9″ x 11″ Bill Fox collection. Photograph by author.

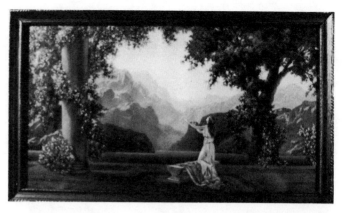

Fig. 241. (#1) "Dawn." R. A. Fox. © L. E. P., Chicago. 8″ x 14″, 10″ x 18″. A print by Robert Wood (Figs. 242 and 243) is extremely similar to this—right down to the title. Courtesy Loretta Goad.

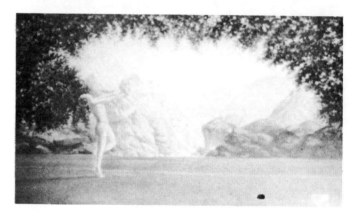

Fig. 242. "Dawn" by Robert Wood. In this version, the lady is nude. Other Wood "Dawns" have appeared with a bright white, almost silver, gown that looks super-imposed, almost as though it had been added after the print was run. Barret collection.

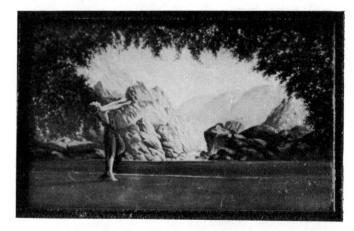

Fig. 243. "Dawn," by Robert Wood, is most often found like this—with the lady wearing an off-white, almost gray dress. Gift to the author by John Mohan.

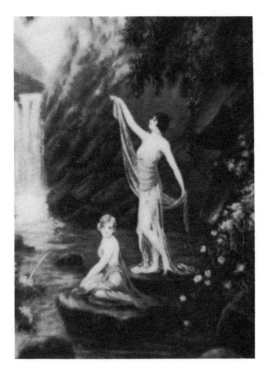

Fig. 244. (#218) "Music of the Waters." R. A. Fox. Found on a tiny wooden plaque, 3½" x 3", with the title and artist's name on the back. Courtesy Phyllis Sherwood.

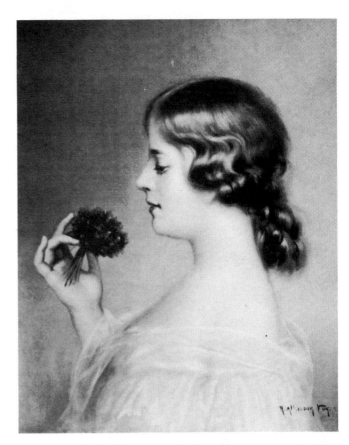

Fig. 246. (#126) "Stephanie." R. Atkinson Fox. © 1901. Library of Congress collection.

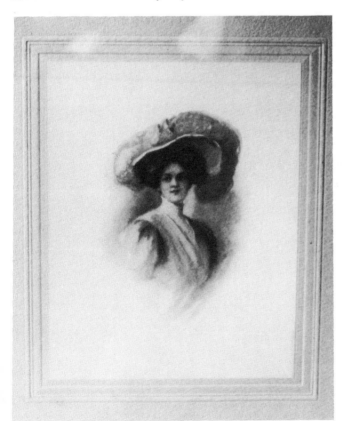

Fig. 245. (#187) Untitled. R. A. Fox. Faint signature is reportedly across the lady's bodice. Courtesy Lee Fenner.

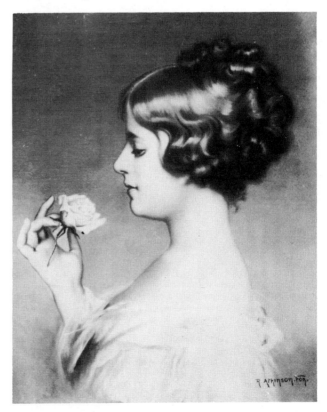

Fig. 247. (#128) "Coralie." R. Atkinson Fox. © 1901. Library of Congress collection.

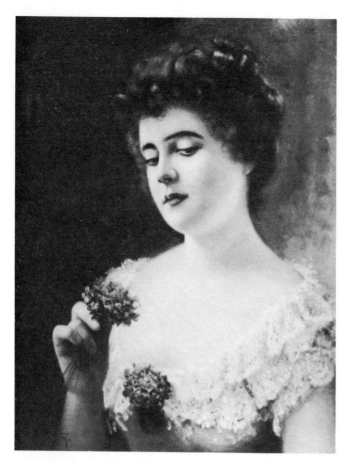

Fig. 248. (#127) "Beatrice." R. Atkinson Fox. © 1901. Library of Congress collection.

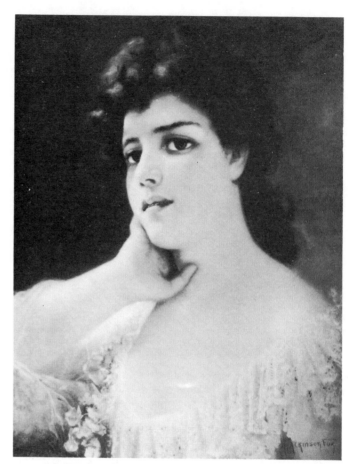

Fig. 250. (#131) "Cleo." R. Atkinson Fox. © 1901. Library of Congress collection.

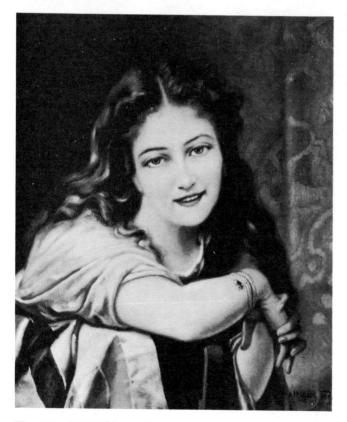

Fig. 249. (#129) "Maxine." R. Atkinson Fox. © 1901. Library of Congress collection.

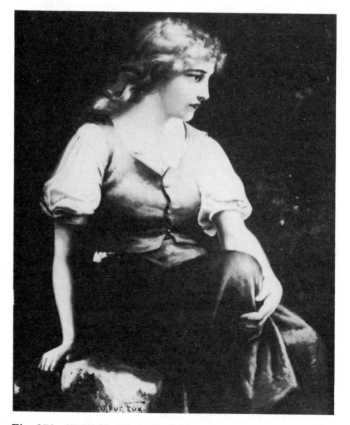

Fig. 251. (#133) Untitled. R. Atkinson Fox. © 1901. Library of Congress collection.

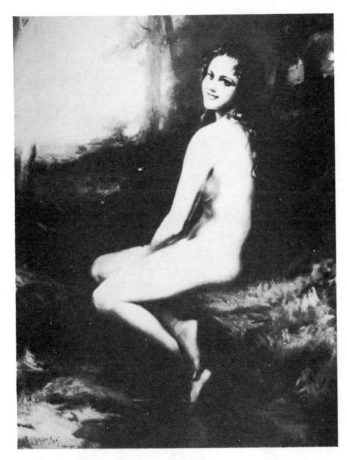

Fig. 252. (#130) Untitled. R. Atkinson Fox. © 1901. Library of Congress collection.

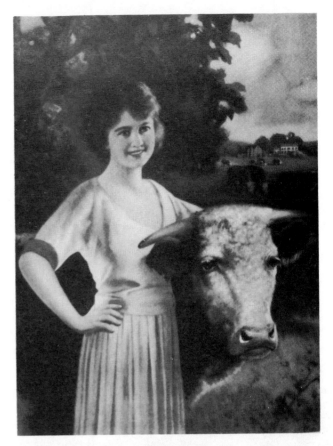

Fig. 254. (#225) "Pride of the Farm." From painting by R. A. Fox. 11½" x 9". Courtesy Ron and Deanna Hulse.

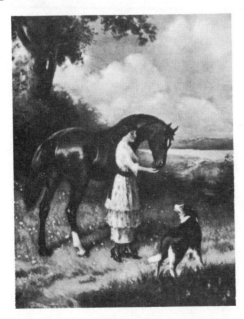

Fig. 253. (#320) Untitled. R. Atkinson Fox. Bill Fox collection. Photograph by author.

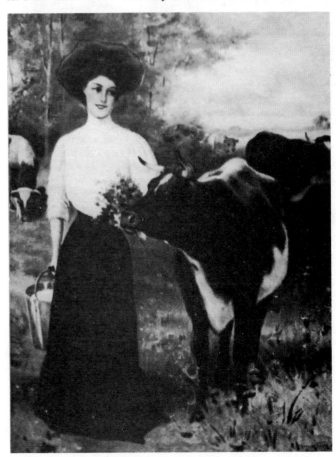

Fig. 255. (#230) "Beauties of the Country." R. Atkinson Fox. "From 'Grit,' Williamsport, Pa." 12" x 8½". Author's collection.

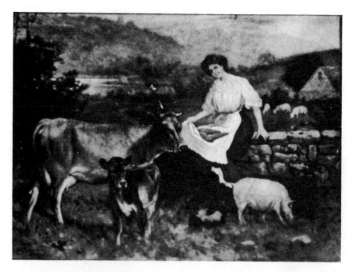

Fig. 258. (#53) "Valley Farm." R. Atkinson Fox. 11″ x 9″. Bill Fox collection. Photograph by author.

Fig. 256. (#233) "Our Country Cousin." R. A. Fox. © K. Wirth, No. 3525.

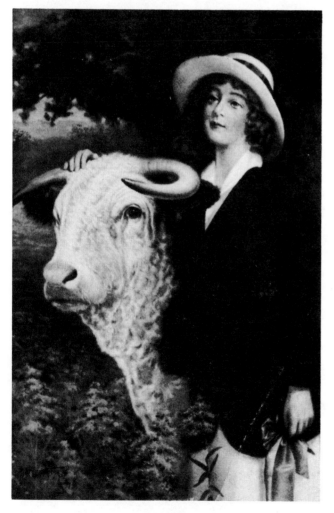

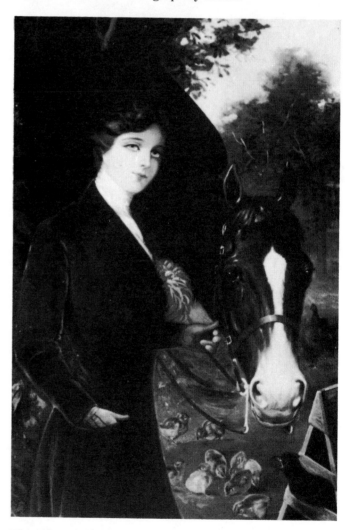

Fig. 259. (#132) "My Pet." R. Atkinson Fox. © 1911. Library of Congress collection.

Fig. 257. (#38) "The Prize Winner." R. Atkinson Fox. 11″ x 9″. Bill Fox collection. Photograph by author.

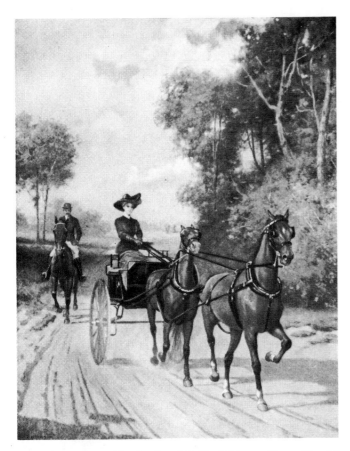

Fig. 260. (#165) "On the Road." R. Atkinson Fox. 6″ x 8″.
Courtesy Donna Robinson.

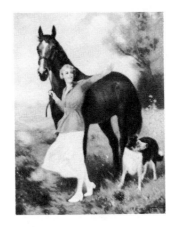

Fig. 262. (#36) "Bluegrass Beauties." R. Atkinson Fox. ©
1922. 9″ x 7″. Bill Fox collection. Photograph by author.

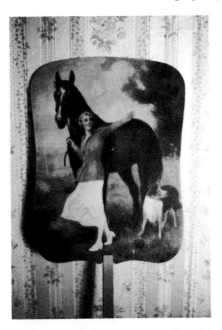

Fig. 263. "Bluegrass Beauties" on an advertising fan. The
American Art Works, Coshocton, Ohio. 8½″ x 6½″. Courtesy
Ron and Deanna Hulse.

Fig. 261. (#183) "A Campfire Girl." R. A. Fox. © Thos. D.
Murphy Co., under G-63973, November 8, 1921. 10″ x 8″.
Courtesy Ron and Deanna Hulse.

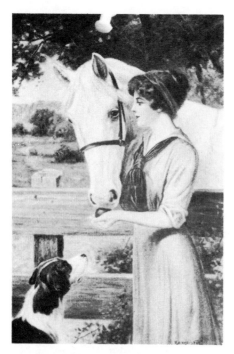

Fig. 264. (#239) "Old Pals." R. Atkinson Fox. © 1913, Red Wing Adv. Co. 6½" x 4½". Author's collection.

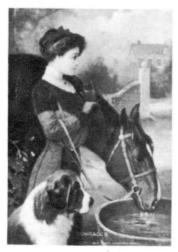

Fig. 265. (#238) "Comrades." © 1911 by the Almanac Advertising Agency. Found on the cover of a 1913 *Farmer's Homestead Almanac*. Bill Fox collection. Photograph by author.

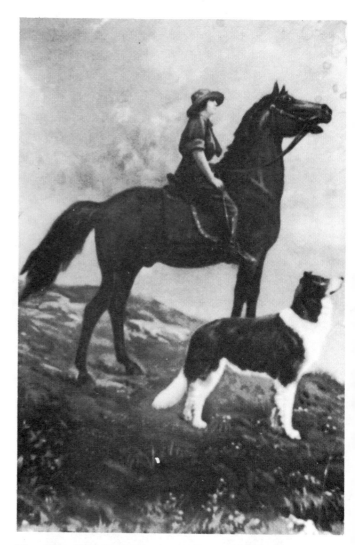

Fig. 266. (#84) Untitled. R. Atkinson Fox. Courtesy E. C. Bischof.

Fig. 267. (#291) "Jealousy." R. Atkinson Fox. Courtesy Marshall Marks.

Fig. 268. (#319) Untitled. Signed simply "Fox." Ordinarily, I would not accept this signature as valid, but a comparison of the "Fox" on this print to the "Fox" in prints signed "R. Atkinson Fox" convinces me this is indeed, our Fox. I could be wrong. Looks like the Gerber baby, doesn't it? The sweater, booties, and rattle—even the signature—are in pink. 8″ x 7″. Courtesy Donna Robinson.

Fig. 269. (#89) "Precious." R. Atkinson Fox. 12″ x 16″. Courtesy Donna Robinson.

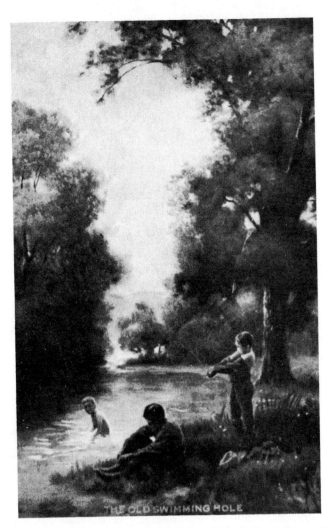

Fig. 270. (#278) "The Old Swimming Hole." R. A. Fox. © Thos. D. Murphy Co., under G-66313, July 31, 1922. 5″ x 3″. Bill Fox collection. Photograph by author.

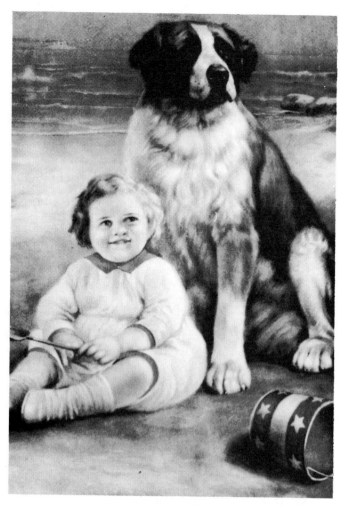

Fig. 271. (#90) "Noble Protector." R. Atkinson Fox. 20″ x 16″. Courtesy Donna Robinson.

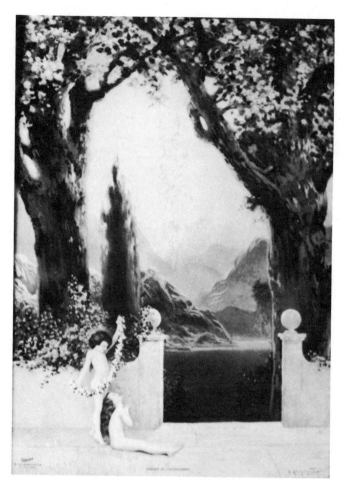

Fig. 273. (#15) "Garden of Contentment." R. Atkinson Fox. Tintagravure. © 1926, Brown & Bigelow, St. Paul, Minnesota. 16″ x 12″. Courtesy Loretta Goad.

Fig. 272. (#234) "Bubbles." R. A. Fox. London Printing and Litho Co., London, Canada. The publisher information was on the back of this calendar print along with the price—$7 for one hundred copies. Courtesy Clare Cerda.

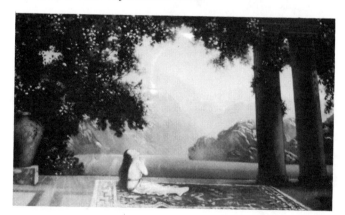

Fig. 274. Untitled. This print is signed "Sanford de Jonge." Note similarity of central figure to child in Fox's "Garden of Contentment," Fig. 274. Courtesy Ron and Deanna Hulse.

Continued on page 105

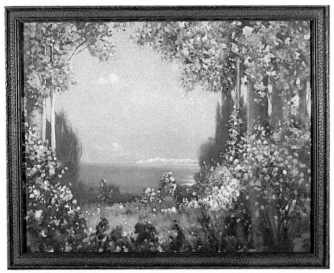

Fig. 72. (#158) "Sapphire Sea." R. Atkinson Fox. ©Master Art Publishers, Inc., under K-223113, February 12, 1937. 14" x 20". Courtesy Loretta Goad.

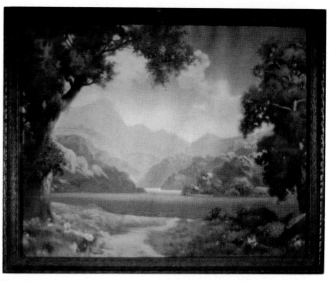

Fig. 79. (#6) "Glorious Vista." R. Atkinson Fox. Registered by Master Art Publishers under K-223114 following publication January 15, 1927. Also found marked "Borin Mfg. Co., Chicago." 18" x 30". Courtesy Loretta Goad.

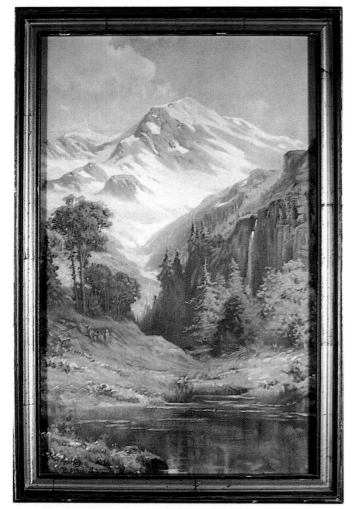

Fig. 142. (#137) Untitled. R. Atkinson Fox. 16" x 10" Courtesy Loretta Goad.

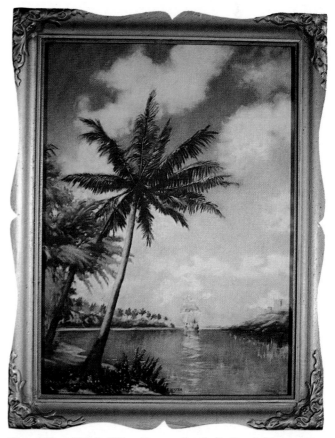

Fig. 159. (#224) "The Sunny South." R. Atkinson Fox. Tintagravure, © 1929, Brown & Bigelow, St. Paul, Minnesota. 15½" x 11½". Bill Fox collection. Photograph by author.

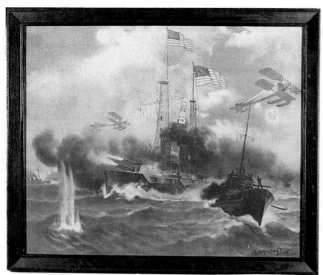

Fig. 163. (#139) "Supremacy." R. Atkinson Fox. 16″ x 20″. Courtesy Loretta Goad.

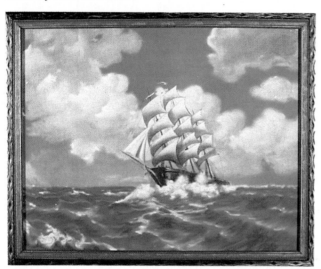

Fig. 164. (#75) "Clipper Ship." R. Atkinson Fox. © Borin, Chicago, 13½″ x 17½″. An untitled example has been found with "Rough Seas" stamped on the back. Courtesy Loretta Goad.

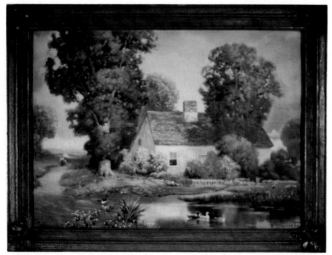

Fig. 169. (#72) "Russet Gems." R. Atkinson Fox. 9″ x 12″. Courtesy Loretta Goad.

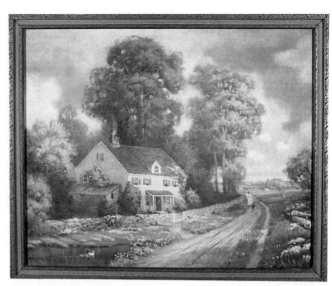

Fig. 170. (#49) "The Old Home." R. A. Fox. © Thos. D. Murphy Co., under G-66316, July 31, 1922. 16″ x 20″. Courtesy Loretta Goad.

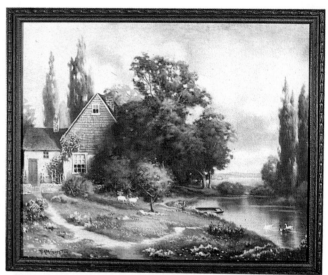

Fig. 174. (#100) "Home Sweet Home." R. Atkinson Fox. 16″ x 20″. Courtesy Loretta Goad.

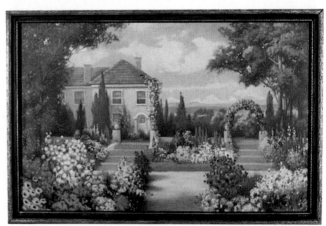

Fig. 182. (#55) "Heart's Desire." R. A. Fox. © Master Art Publishers, under K-228165, June 20, 1927. 10″ x 20″, 13½″ x 27½″. A narrower version is reported with a Borin copyright. Courtesy Tita Campbell.

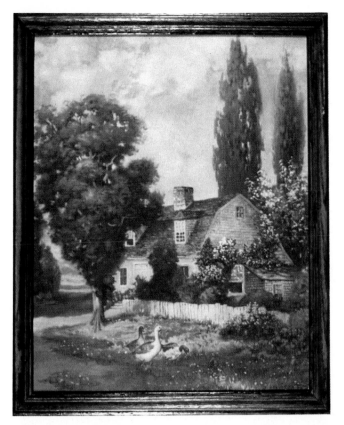

Fig. 175. (#155) "Where Nature Beats in Perfect Tune." R. Atkinson Fox. 20″ x 16″. Courtesy Loretta Goad.

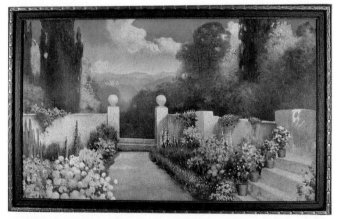

Fig. 187. (#79) Untitled. R. Atkinson Fox. © Morris & Bendien, Inc. 18″ x 30″ Courtesy Loretta Goad.

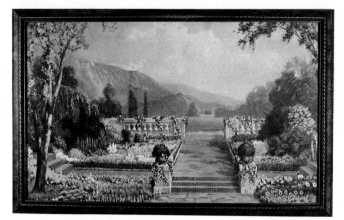

Fig. 188. (#80) "Country Garden." R. Atkinson Fox. © Borin Mfg. Co. 14″ x 24″, 18″ x 30″.

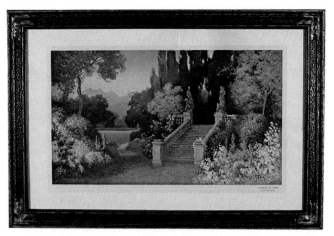

Fig. 186. (#20) "Garden of Hope." R. Atkinson Fox. Sunshine Garden Series. © John Drescher Inc., under K-194629, May 11, 1925. 10″ x 18″, 14″ x 22″. Author's collection.

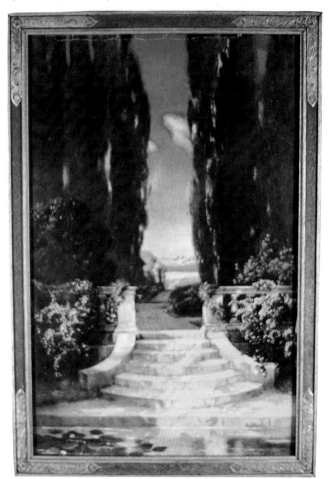

Fig. 183. (#69) "The Sunny South." R. A. Fox. Villa Series. Publication of Edward Gross Co., 826 Broadway, New York. 15″ x 10″. Courtesy Loretta Goad.

99

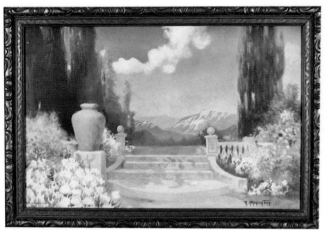

Fig. 189. (#41) "Dreamland." R. Atkinson Fox. © Morris & Bendien, Inc., New York. 8″ x 12″, 14″ x 22″. Courtesy of Donna Robinson.

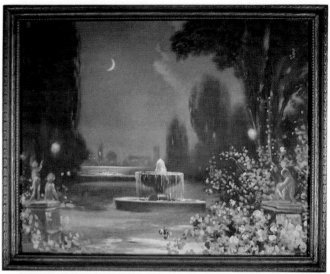

Fig. 202. (#39) "Moonlight and Roses." R. Atkinson Fox. © Master Art Publishers, under K-223110, February 12, 1927. 14″ x 18″. Courtesy Loretta Goad.

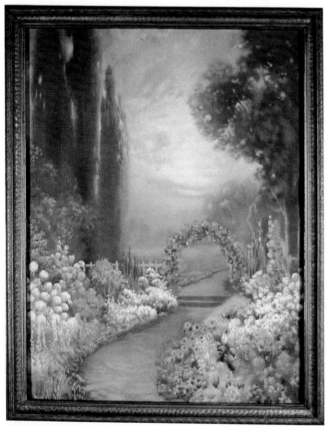

Fig. 197. (#37) "Blooming Time." R. Atkinson Fox. Master Art Publishers. 18″ x 14″. Courtesy Loretta Goad.

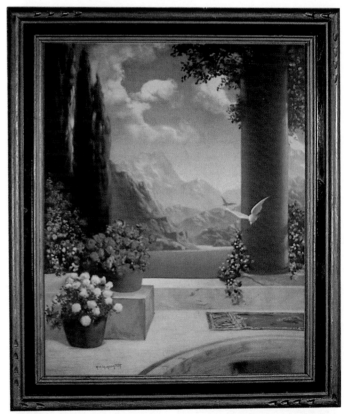

Fig. 211. (#67) "Love Birds." R. Atkinson Fox. © John Drescher Co., Inc., under K-202440, March 24, 1926. 16″ x 13″. Courtesy Charles Mandrake.

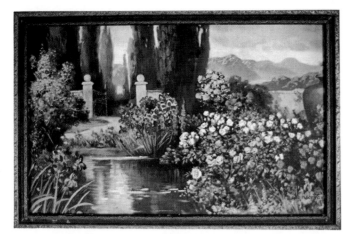

Fig. 216. (#63) "Garden of Happiness." R. Atkinson Fox. Sunshine Garden Series. © John Drescher Co., Inc., under K-194626, May 11, 1925. 10″ x 18″. Courtesy Loretta Goad.

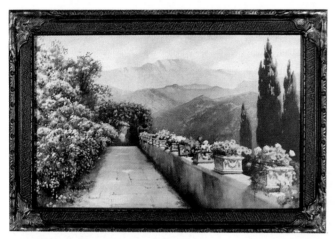

Fig. 219. (#22) "Nature's Grandeur." R. Atkinson Fox. © John Drescher Co., Inc., under K-219971, November 8, 1926. 14″ x 22″. Courtesy Loretta Goad.

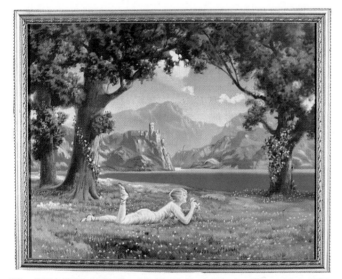

Fig. 227. (#70) "Elysian Fields." R. Atkinson Fox. 16″ x 20″. Courtesy Loretta Goad.

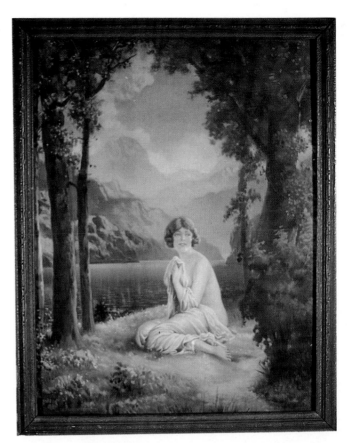

Fig. 226. (#33) Untitled. R. Atkinson Fox. Master Art Publishers. 20″ x 13½″. Author's collection.

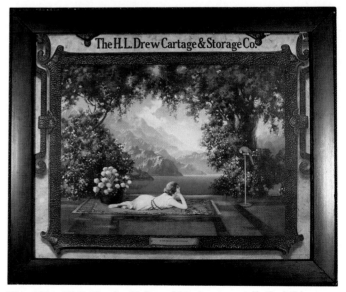

Fig. 229. (#31) "In the Valley of Enchantment." R. Atkinson Fox. © K.-T. Co., Cincinnatti, Ohio. 22″ x 27″. Courtesy Phyllis Sherwood.

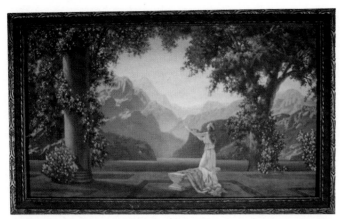

Fig. 241. (#1) "Dawn." R. A. Fox. © L. E. P., Chicago. 8″ x 14″, 10″ x 18″. A print by Robert Wood (Figs. 242 and 243) is extremely similar to this—right down to the title. Courtesy Loretta Goad.

Fig. 254. (#225) "Pride of the Farm." From painting by R. A. Fox. 11½″ x 9″. Courtesy Ron and Deanna Hulse.

Fig. 246. (#126) "Stephanie." R. Atkinson Fox. © 1901. Library of Congress collection.

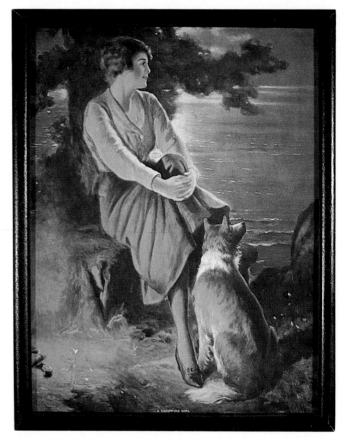

Fig. 261. (#183) "A Campfire Girl." R. A. Fox. © Thos. D. Murphy Co., under G-63973, November 8, 1921. 10″ x 8″. Courtesy Ron and Deanna Hulse.

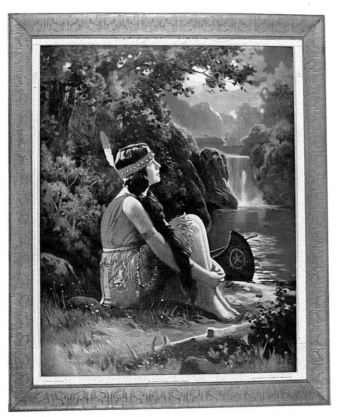

Fig. 276. (#101) "In Meditation Fancy Free." R. Atkinson Fox. © 1927, The American Art Works, Inc., Coshocton, Ohio. 24½" x 19½". Courtesy Loretta Goad.

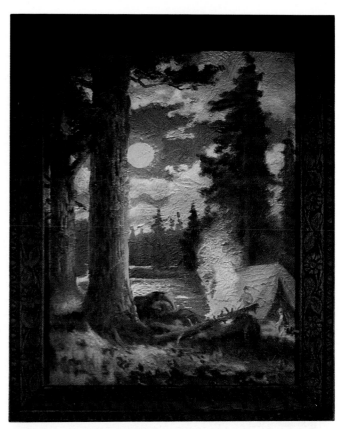

Fig. 290. (#71) "Moonlight on the Camp." R. Atkinson Fox. © F. A. S., Series K., No 1265. Found as an embossed calendar top. 9½" x 7". Author's collection.

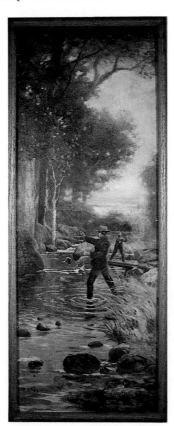

Fig. 287. (#283) Untitled. R. A. Fox. 15" x 5". Courtesy Ron and Deanna Hulse.

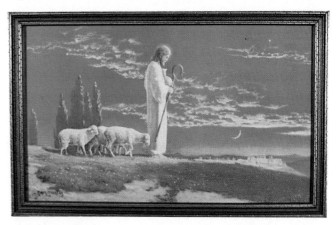

Fig. 298. (#29) "The Good Shepherd." R. Atkinson Fox. © Master Art Publishers, under K-223107, February 4, 1927. Found with Master Art logo and 1927 date; also found on a 1956 calendar. 16" x 12". Courtesy Loretta Goad.

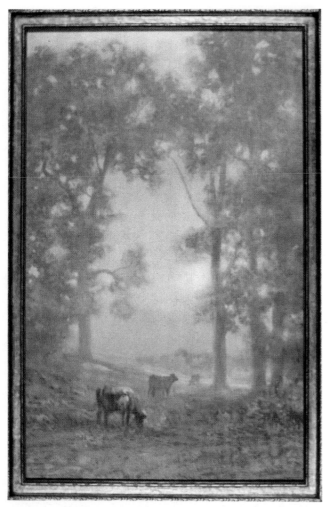

Fig. 318. (#95) Untitled. R. Atkinson Fox. © Edward Gross Co., New York, No 611. Misty greens. 22″ x 14″. Courtesy Loretta Goad.

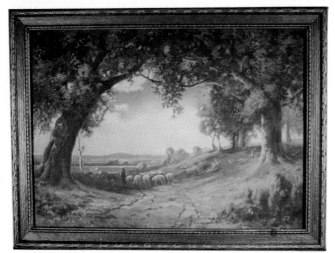

Fig. 383. (#35) "Indian Summer." R. Atkinson Fox. © Turner Mfg. Co., Chicago, Illinois. Also found with a Borin copyright. 12″ x 15″, 14″ x 20″, 20″ x 23″, 18″ x 30″. Courtesy Loretta Goad.

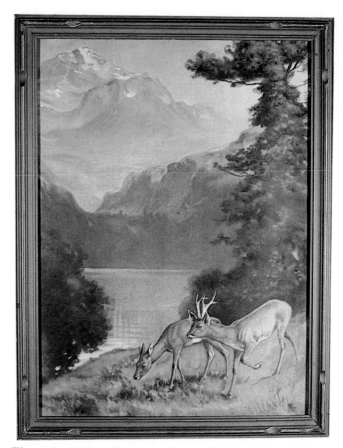

Fig. 367. (#96) "A Sheltering Bower." R. Atkinson Fox. 15″ x 11″, 20″ x 12″. Courtesy Loretta Goad.

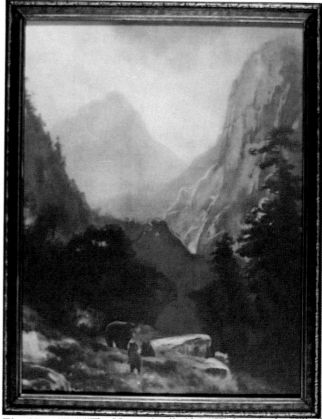

Fig. 375. (#54) "The Mountains." Also "High up in the Hills.") R. Atkinson Fox. 18″ x 14″. Courtesy Loretta Goad.

Fig. 275. (#232) "In Moonlight Blue." R. A. Fox. Courtesy Clare Cerda.

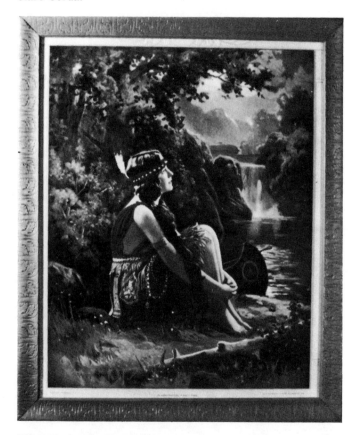

Fig. 276. (#101) "In Meditation Fancy Free." R. Atkinson Fox. © 1927, The American Art Works, Inc., Coshocton, Ohio. 24½″ x 19½″. Courtesy Loretta Goad.

Fig. 277. (#163) "Daughter of the Setting Sun." R. A. Fox. No. 28581. 20″ x 16″. Courtesy Ed Davis.

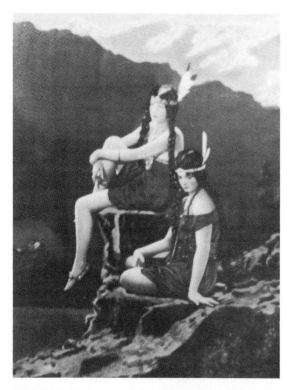

Fig. 278. (#61) "Daughters of the Incas." R. Atkinson Fox. This print was sent out with calendars for framing. A corresponding story accompanied the print. 15″ x 11″. Courtesy Tita Campbell.

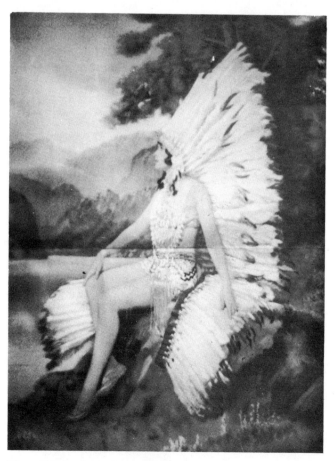

Fig. 279. (#309) "White Feather." R. Atkinson Fox. Tintogravure. © 1930, Brown & Bigelow, St. Paul, Minnesota. 15″ x 11″, 20″ x 16″. Courtesy Donna Robinson.

Fig. 280. (#164) Untitled. R. Atkinson Fox. Found on a 1933 calendar. Courtesy Charles Mandrake.

Fig. 281. (#209) "The Buffalo Hunt." R. Atkinson Fox. Electro-Tint Engraving Co., G-9613, October 7, 1932. Courtesy E. C. Bischof.

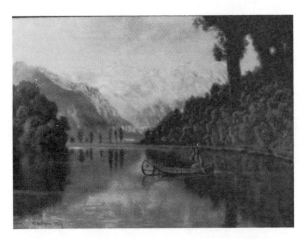

Fig. 282. (#156) "Indian Paradise." R. Atkinson Fox. © Louis F. Dow Co., St. Paul, Minnesota. 12″ x 16″. Courtesy Loretta Goad.

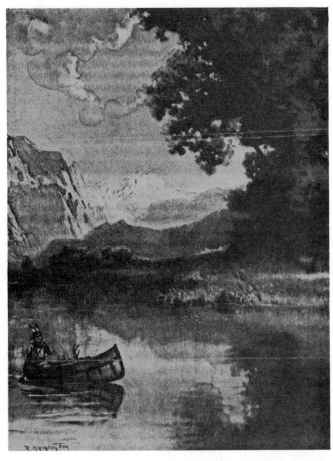

Fig. 283. (#307) Untitled. R. Atkinson Fox. 8″ x 6″. Courtesy John Mohan.

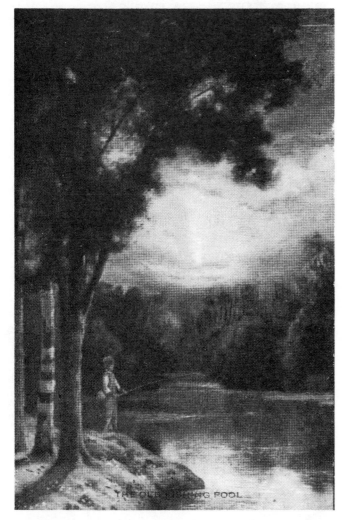

Fig. 284. (#277) "The Old Fishing Pool." R. A. Fox. © Thos. D. Murphy Co., under G-66297, July 1, 1922. 5″ x 3″. Gift from Bill Fox to the author.

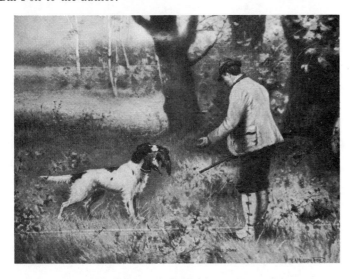

Fig. 285. (#240) "Well Done." R. Atkinson Fox. © 1906 by R. Hill. Bill Fox collection. Photograph by author.

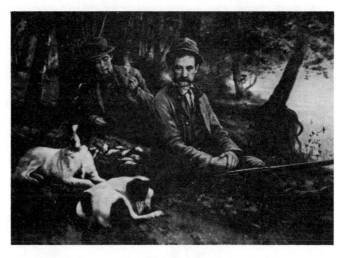

Fig. 286. (#243) Untitled. R. A. Fox. Bill Fox collection. Photograph by author.

Fig. 287. (#283) Untitled. R. A. Fox. 15″ x 5″. Courtesy Ron and Deanna Hulse.

Fig. 288. (#229) "A Thrill Before Breakfast." R. A. Fox. © Thos. D. Murphy Co., under G-78734, November 8, 1926. 8½" x 6". Bill Fox collection. Photograph by author.

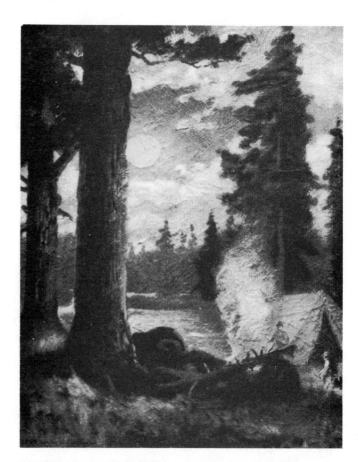

Fig. 290. (#71) "Moonlight on the Camp." R. Atkinson Fox. © F. A. S., Series K., No 1265. Found as an embossed calendar top. 9½" x 7". Author's collection.

Fig. 289. (#51) "His Last Cartridge." R. Atkinson Fox. 10" x 8". Bill Fox collection. Photograph by author.

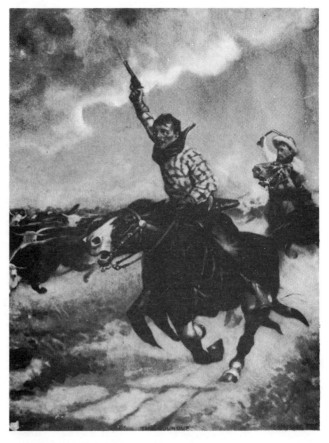

Fig. 291. (#210) "The Roundup." R. Atkinson Fox. 10" x 8". Bill Fox collection. Photograph by author.

Fig. 292. (#192) "Generals Foch, Pershing and Haig Reviewing Their Victorious Troops." R. Atkinson Fox. 16" x 20". Author's collection. Printing in the upper left-hand corner reads, "Hedding Methodist Church, Boy Scout Souvenir, Barre, Vt." along with a list of names of the leader and boys in the Beaver Patrol and the Eagle Patrol. At least one example has been found without any such marking.

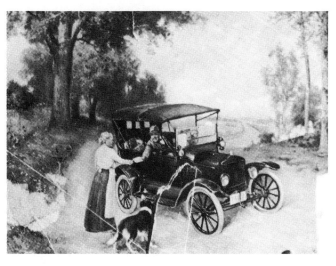

Fig. 294. (#193) "Mother's Day." R. Atkinson Fox. The Osborne Co., No. G-57439, January 6, 1919. 9" x 7". Bill Fox collection. Photograph by author. (Print shown here is badly damaged.)

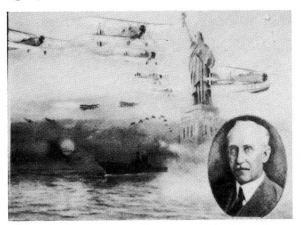

Fig. 295. (#214) "Guardians of Liberty." R. Atkinson Fox. Inset picture is of Orville Wright. 9½" x 13½". Courtesy Loretta Goad.

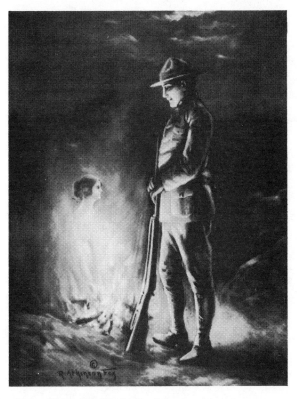

Fig. 293. (#279) Untitled. R. Atkinson Fox.

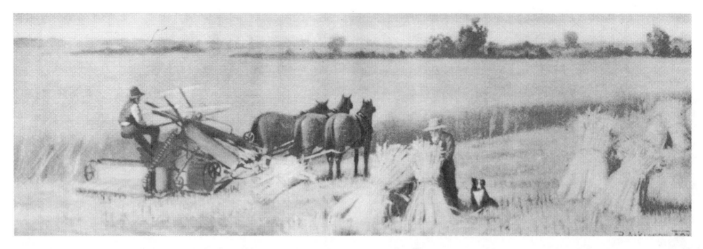

Fig. 296. (#315) Untitled. R. Atkinson Fox. 4″ x 11½″. Courtesy Barbara Kern.

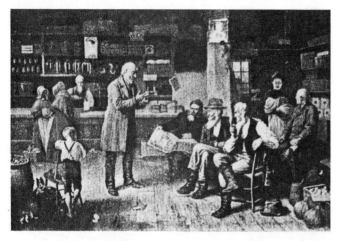

Fig. 297. (#207) "The Political Argument." R. Atkinson Fox. Found in a catalog of the Electro-Tint Engraving Co.; this is No. 2531. Reported as a print, 7″ x 10½″. Copy from catalog, courtesy Dolores Ramsey.

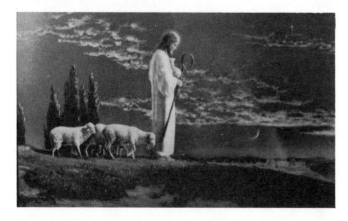

Fig. 298. (#29) "The Good Shepherd." R. Atkinson Fox. © Master Art Publishers, under K-223107, February 4, 1927. Found with Master Art logo and 1927 date; also found on a 1956 calendar. 16″ x 12″. Courtesy Loretta Goad.

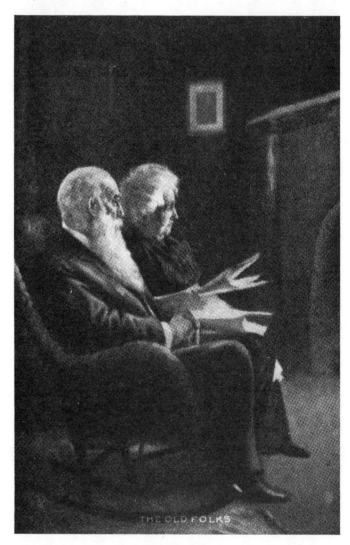

Fig. 299. (#288) "The Old Folks." R. A. Fox. © Thos. D. Murphy Co., under G-66292, July 31, 1922. 5″ x 3″. Gift from Bill Fox to the author.

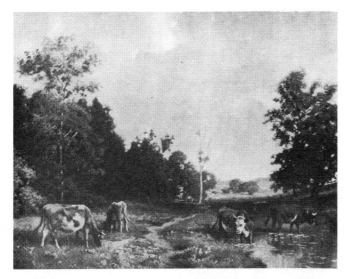

Fig. 300. (#276) Untitled. R. A. Fox. 5″ x 6½″. Bill Fox collection. Photograph by author.

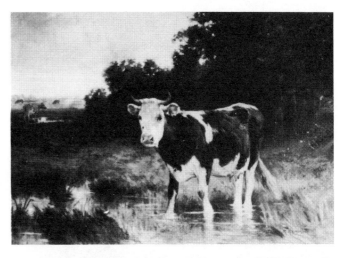

Fig. 302. (#115) "Pax Vobiscum" (Peace Be With You). R. Atkinson Fox. © 1910. Library of Congress collection.

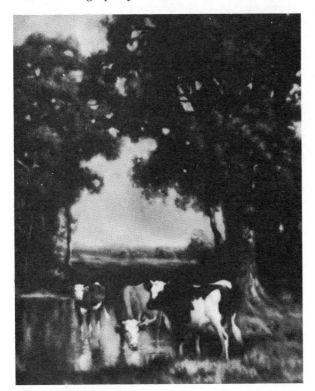

Fig. 301. (#28) "When Evening Shadows Fall." R. Atkinson Fox. 8″ x 6½″. Bill Fox collection. Photograph by author.

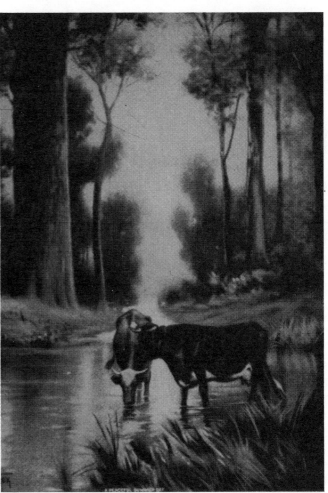

Fig. 303. (#223) "A Peaceful Summer Day." R. Atkinson Fox. Found on a 1937 salesman's sample calendar. 9½″ x 7″. Courtesy Barbara Kern.

111

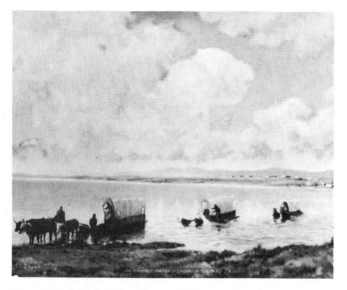

Fig. 304. (#228) "The Covered Wagon Crossing the Platte River." R. A. Fox. © Thos. D. Murphy Co., under G-78724, November 8, 1926. 8″ x 10″. Bill Fox collection. Photograph by author.

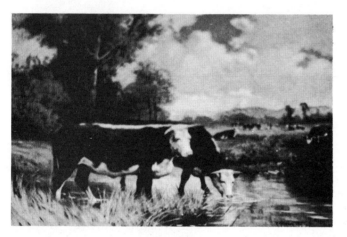

Fig. 305. (#251) Untitled. R. Atkinson Fox. 6″ x 8″. Bill Fox collection. Photograph by author.

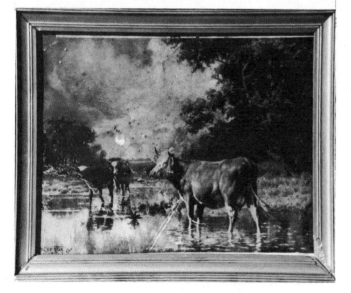

Fig. 306. (#169) "An Approaching Storm." R. Atkinson Fox. 8″ x 10″. (Print pictured here is damaged.)

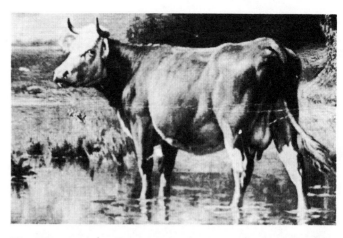

Fig. 307. (#169-A) "An Approaching Storm" (portion). This is the cow, lifted from #169, Fig. 306., found on an unsigned postcard, © G, New York, 1908. Courtesy Barbara Kern.

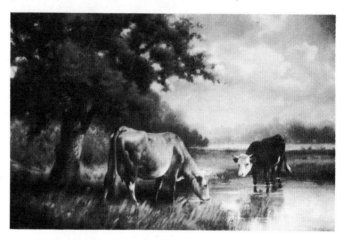

Fig. 308. (#116) "A Shady Pool." R. Atkinson Fox. © 1900. Library of Congress collection.

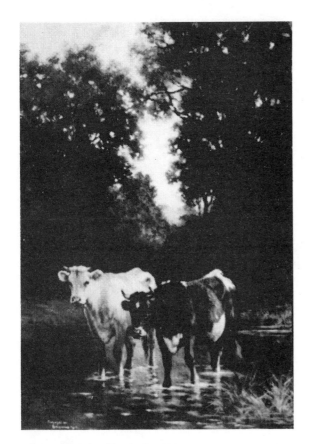

Fig. 309. (#113) "A Shady Pool." R. Atkinson Fox. © 1902 by Hargreaves Mfg. Co., Detroit, Michigan. A very small print from the Library of Congress collection.

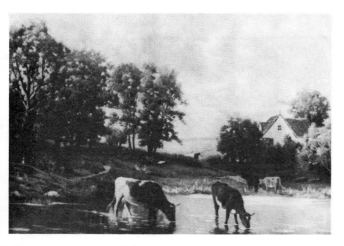

Fig. 310. (#284) Untitled. R. Atkinson Fox. 8″ x 11″. Bill Fox collection. Photograph by author.

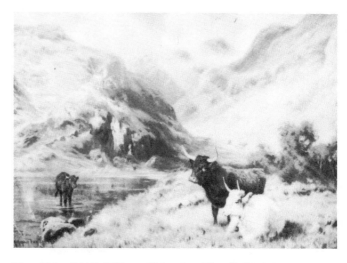

Fig. 311. (#293) "Where Skies Are Blue." R. Atkinson Fox. © 1912, Brown & Bigelow, St. Paul, U.S.A., and Sault St. Marie, Ontario. 9½″ x 14″. Courtesy Joan Jenkins.

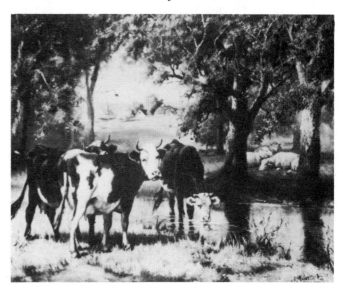

Fig. 312. (#118) "Under the Oaks." R. Atkinson Fox. © 1901. Library of Congress collection.

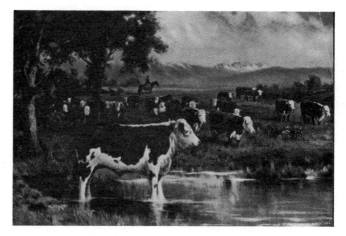

Fig. 313. (#120) "On the Range." R. Atkinson Fox. © 1912. 8½″ x 11″. Bill Fox collection. Photograph by author.

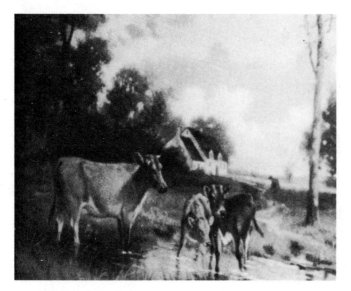

Fig. 314. (#237) Untitled. R. A. Fox. 8″ x 11″. Bill Fox collection. Photograph by author.

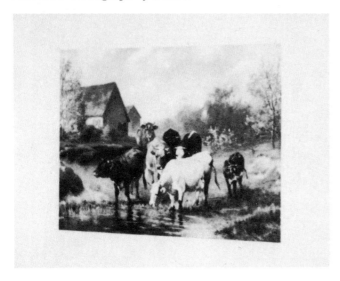

Fig. 315. (#215) Untitled. R. A. Fox. 9″ x 12″. Courtesy Loretta Goad.

Fig. 316. (#114) "Four Chums." © 1911. Library of Congress collection.

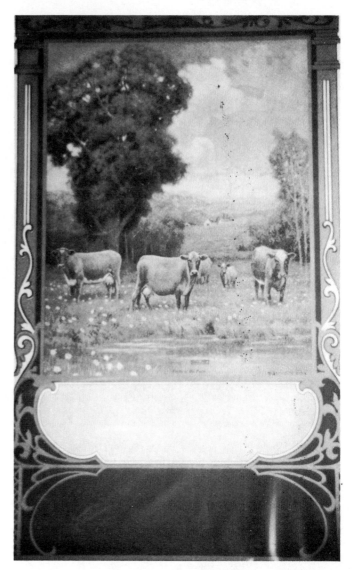

Fig. 317. (#235) "Pride of the Farm." R. Atkinson Fox. © F. A. S., No. 9857. 9½″ x 11″. Example illustrated is a salesman's sample calendar. This has also been found as a puzzle. Courtesy Sherlee Tatum.

114

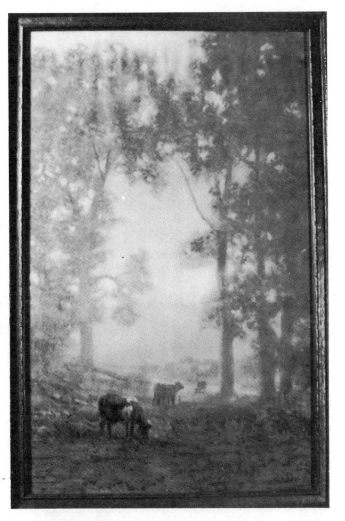

Fig. 318. (#95) Untitled. R. Atkinson Fox. © Edward Gross Co., New York, No 611. Misty greens. 22″ x 14″. Courtesy Loretta Goad.

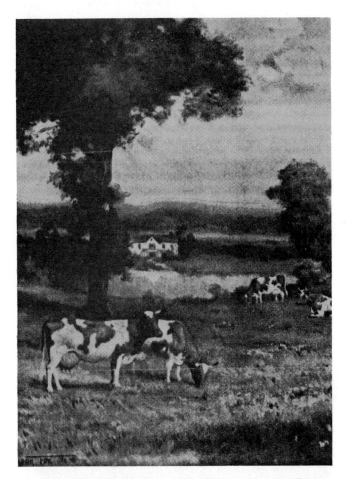

Fig. 320. (#306) Untitled. R. Atkinson Fox. 8″ x 6″. Courtesy John Mohan.

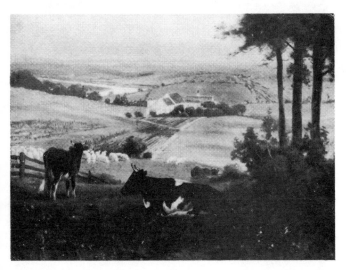

Fig. 319. (#246) "Peace and Plenty." R. Atkinson Fox. 8½″ x 11½″. Bill Fox collection. Photograph by author.

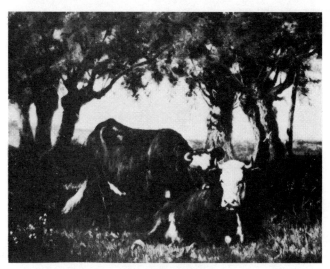

Fig. 321. (#121) "In Quiet Pastures." R. Atkinson Fox. © 1901. Library of Congress collection.

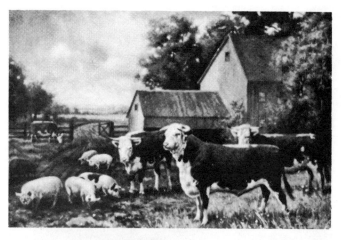

Fig. 322. (#252) "Signs of Prosperity." R. A. Fox. © The Osborne Co., under G-52888, October 19, 1916. 6½″ x 8½″. Bill Fox collection. Photograph by author.

Fig. 325. (#111) Untitled. R. Atkinson Fox. 3″ x 2″. Bill Fox collection. Photograph by author.

Fig. 323. (#122) "In Pastures Green." R. Atkinson Fox. © 1910. Library of Congress collection.

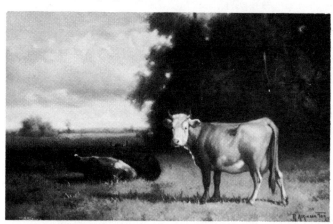

Fig. 326. (#117) "The Edge of the Meadow." R. Atkinson Fox. © 1900. Library of Congress collection.

Fig. 324. (#119) "Down on the Farm." R. Atkinson Fox. © 1912. Library of Congress collection.

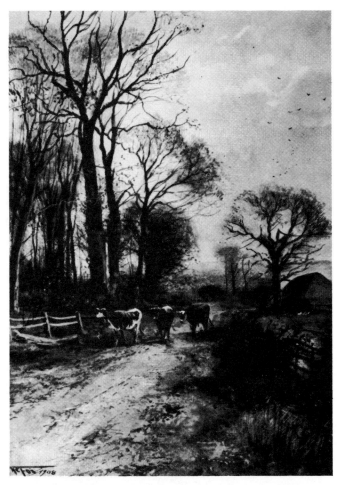

Fig. 327. (#112) Untitled. R. A. Fox. © 1908. Library of Congress collection.

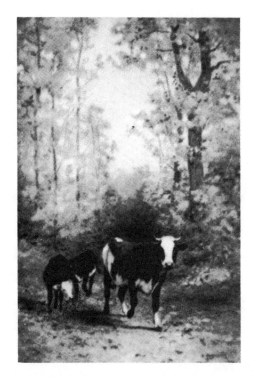

Fig. 329. (#250) Untitled. R. Atkinson Fox. 3″ x 2″. Bill Fox collection. Photograph by author.

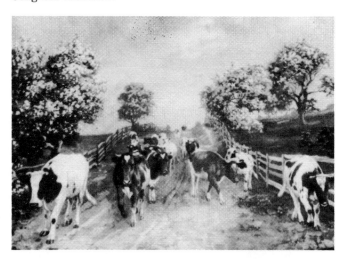

Fig. 328. (#186) "Wending Their Way Homeward." R. Atkinson Fox. No. 2258. Found on back of print, hand-written in pencil: "92/2258, 20 x 16, $15.00 per 100, pad 4.")

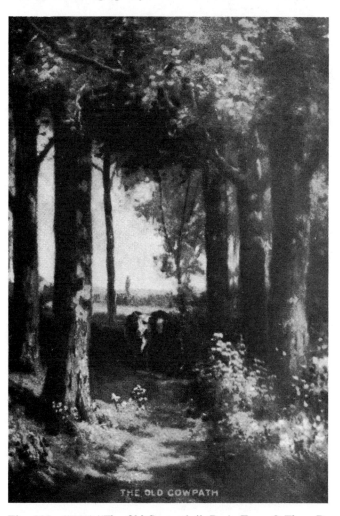

Fig. 330. (#275) "The Old Cowpath." R. A. Fox. © Thos. D. Murphy Co., under G-66291, July 31, 1922. 5″ x 3″. Bill Fox collection. Photograph by author.

117

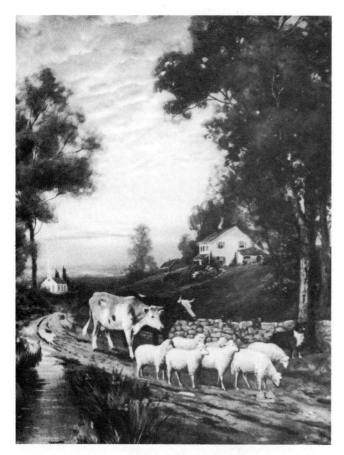

Fig. 331. (#244) "When Shadows Lengthen." R. Atkinson Fox. 11″ x 8″. Bill Fox collection. Photograph by author.

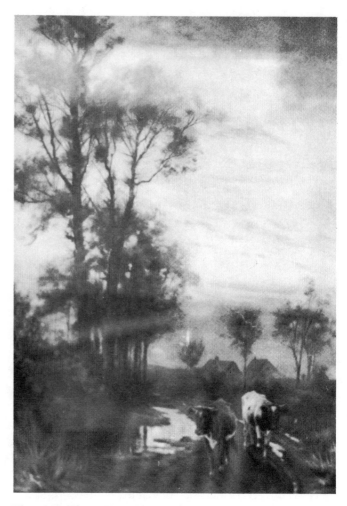

Fig. 333. (#191) "Near Close of Day." R. Atkinson Fox. 11½″ x 10″. Courtesy Loretta Goad.

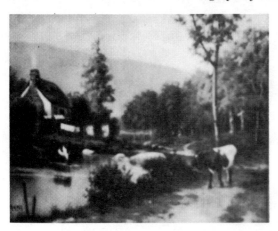

Fig. 332. (#135) Untitled. R. A. Fox. Courtesy Donna Eby.

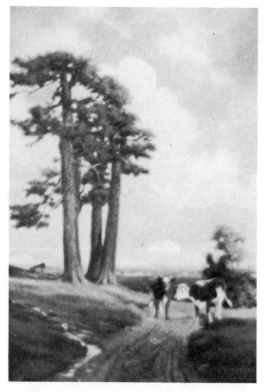

Fig. 334. (#312) Untitled. R. Atkinson Fox. 3″ x 2″. Bill Fox collection. Photograph by author.

Fig. 335. (#256) Untitled. R. Atkinson Fox. 4″ x 6″. Bill Fox collection. Photograph by author.

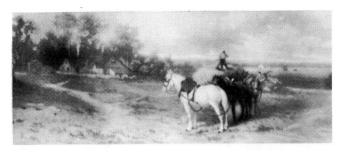

Fig. 338. (#194) Untitled. R. A. Fox. 8″ x 20″.

Fig. 336. (#231) "Peace." R. Atkinson Fox. Red Wing Adv. Co., 1915. 9″ x 12″. Courtesy Clare Cerda.

The Kemper-Thomas Company
Art Calendars

Fig. 339. (#226) "Two Old Cronies." R. A. Fox. Kemper-Thomas Co., Art Calendars, Cincinnatti, Ohio. 9″ x 12″. Courtesy Joan Jenkins.

Fig. 337. (#167) "Old Rosebud." R. Atkinson Fox. Here the jockey sits astride the 1914 Kentucky Derby winner on a poster advertising "Derby Day" at Churchill Downs. This is also found with the advertising trimmed away to fit a frame, and it reportedly has been found on tin. 16″ x 24″ complete.

Fig. 340. (#294) "Ready for the Day's Work." R. Atkinson Fox. © Gerlach-Barklow Co., Joliet, Illinois. Found under the print, © 1908, was this description:

Ready For the Day's Work
From the Original Painting By Fox
Reproduced and Published by The Gerlach-Barklow Co.,
Joliet, Ill. U.S.A.

Just five substantial work horses, the kind that any good farmer likes to have hitched to a plow or harvester. Everything about them betokens thrift and good management. The horses present a well-fed appearance, and it is very evident that they receive kindly treatment at the hands of their masters. The two teams have just been harnessed and hitched ready for the day's work, and in a few moments they will be off to the fields. The picture of these good, honest, gentle-looking horses will carry many a city man back to his boyhood days on the farm when he followed the plow or harrow, or worked in the hay or harvest field. The artist has caught the spirit of the understanding which seems to exist between master and horse, that spirit which enables some men to get more work out of a team with less effort and wear than it is possible for other men to accomplish with the same animals. He has caught the spirit of things on the farm where everyone is in love with his work and everything works in harmony.

R. Atkinson Fox is a versatile artist, but is at his best when painting animals, and especially horses, with appropriate landscape settings. He was born in the city of Toronto in 1860, and is the son of a minister. He studied art under several excellent teachers, and afterwards studied in Europe and traveled all over the continent and in America. He has been a citizen of the United States for many years, and now resides near New York City.

Fig. 341. (#282) "Thoroughbreds." R. A. Fox. © 1906 by R. Hill. 6" x 8". Courtesy Joe Bell.

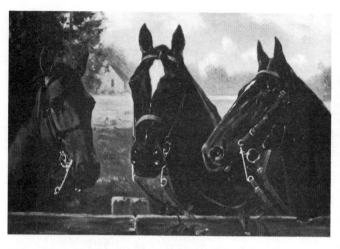

Fig. 342. (#110) "Pleading at the Bar." R. Atkinson Fox. © 1913. Library of Congress collection.

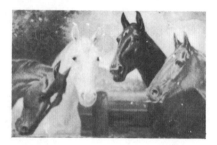

Fig. 343. (#176) "Thoroughbreds." R. Atkinson Fox. Courtesy Sherlee Tatum.

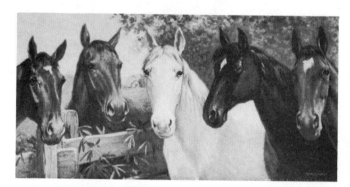

Fig. 344. (#220) "A Legal Holiday." R. Atkinson Fox. © 1910, Gerlach-Barklow Co., Joliet, Illinois. 5¼" x 11½". Courtesy Barbara Kern.

120

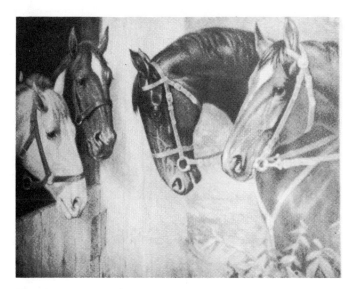

Fig. 345. (#300) "A Neighborly Call." R. Atkinson Fox. ©
1912 by P. D. Thomas, Published by Wilson Chemical Co.,
Tyrone, Pennsylvania. Courtesy Clare Cerda.

Fig. 347. (#304) "At Your Service." R. Atkinson Fox.
American Art Works, Coshocton, Ohio, 1912. Courtesy E. J.
Nowotny.

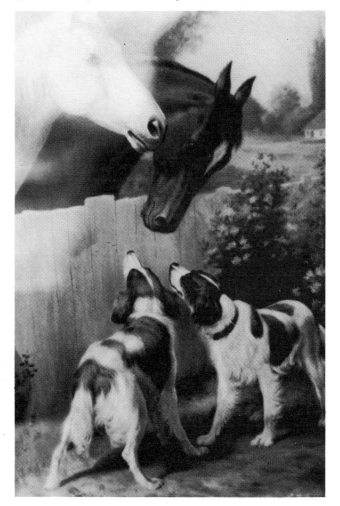

Fig. 346. (#62) Untitled. R. Atkinson Fox. Courtesy Pat
Warhank.

Fig. 348. (#50) "Capital and Labor." R. Atkinson Fox. No.
2441, Cap. 11 by Gerlach-Barklow Co., Joliet, Illinois. 3″ x 2″.
Bill Fox collection. Photograph by author.

Fig. 349. (#24) "Playmate Guardian." R. A. Fox. Bill Fox collection. Photograph by author.

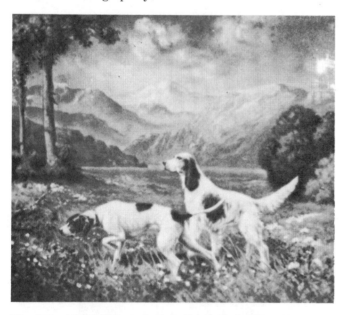

Fig. 350. (#197) "Hunter's Paradise." R. A. Fox. 10″ x 12″. Author's collection.

Fig. 351. (#208) "Ready for Anything." R. A. Fox. Found as No. 2591 in the catalog of the Electro-Tint Engraving Co. Also found as a postcard with the verse, "We are his Highness's dogs at Kew!/Pray tell me, Sir, whose dog are you."—Pope.

Fig. 352. (#177) Untitled. R. Atkinson Fox. Courtesy Sherlee Tatum.

Fig. 353. (#60) Untitled. R. A. Fox. Courtesy Mrs. John Monahan.

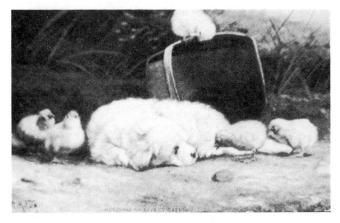

Fig. 354. (#216) "Holding an Investigation." R. A. Fox. © No. 106, R. Hill. Easter Series No. 1, published by Edw. Stern & Co., Philadelphia. Found on a postcard. Gift to the author from Vito Natale II.

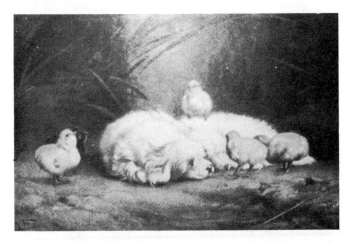

Fig. 355. (#219) "Who Are You?" R. A. Fox. Art Series No. 281, published by Edw. Stern & Co., Inc., Philadelphia. Postcard. Courtesy Barbara Kern.

Fig. 356. (#153) "Just Out." R. A. Fox. Postcard. Courtesy Loretta Goad.

Fig. 357. (#154) "No One at Home." R. A. Fox. Postcard. Courtesy Loretta Goad.

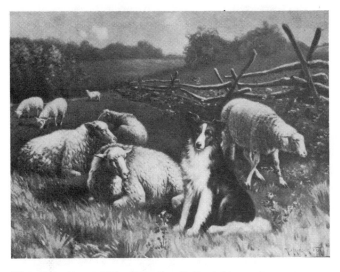

Fig. 358. (#111) "The Guardian." R. Atkinson Fox. © 1907. Library of Congress collection.

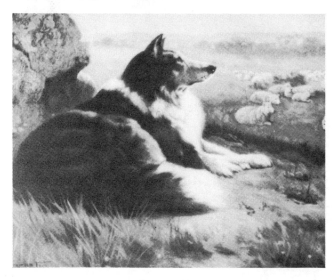

Fig. 359. (#303) "An Efficient Guardian." R. Atkinson Fox.

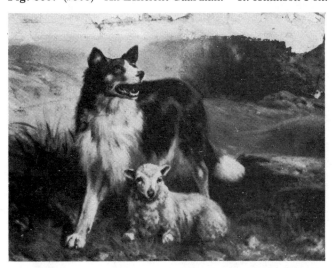

Fig. 360. (#11) "A Trusty Guardian." R. Atkinson Fox. 7" x 9". Bill Fox collection. Photograph by author. (Print shows damage.)

Fig. 361. (#290) "Sunset in the Pines." R. Atkinson Fox. © by The Lutz & Gould Co., Burlington, Iowa, 1901. No. 861. 8¼" x 7". Courtesy Barbara Kern.

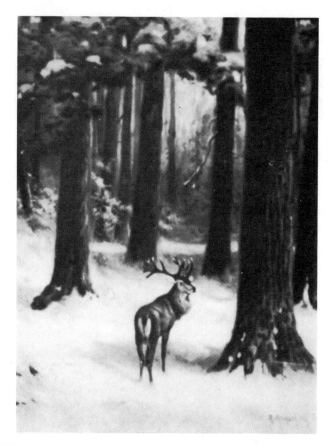

Fig. 363. (#170) "The Forest Primeval." R. Atkinson Fox. Bill Fox collection. Photograph by author.

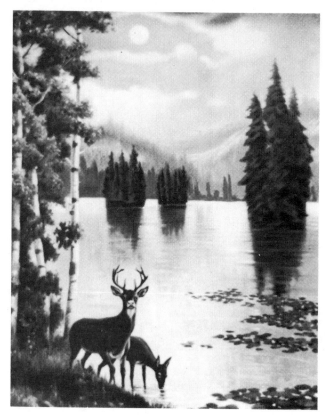

Fig. 362. (#66) "Nature's Silvery Retreat." R. A. Fox. Bill Fox collection. Photograph by author.

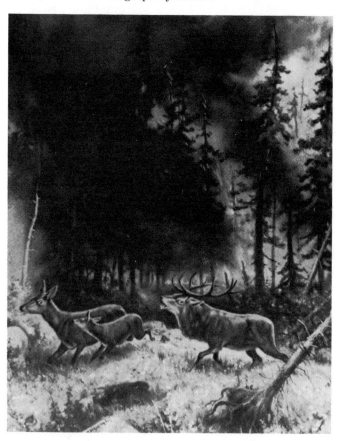

Fig. 364. (#289) "Forest Fire." R. Atkinson Fox. © by F. A. Schneider, No. 4283. 10" x 8". Courtesy Barbara Kern.

124

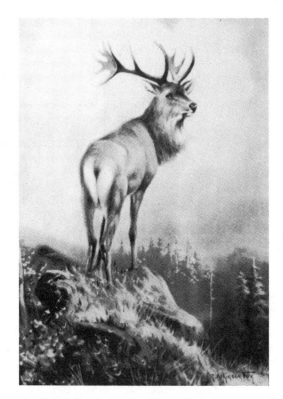

Fig. 365. (#160) Untitled. R. Atkinson Fox. 12″ x 9″. Courtesy Loretta Goad.

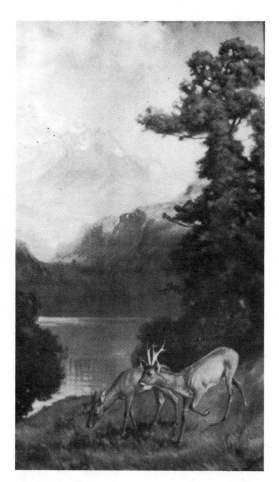

Fig. 367. (#96) "A Sheltering Bower." R. Atkinson Fox. 15″ x 11″, 20″ x 12″. Courtesy Loretta Goad.

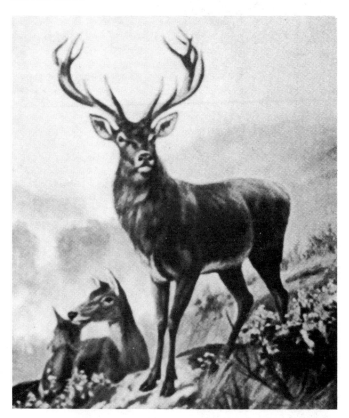

Fig. 366. (#262) "A Brother Elk." R. A. Fox. © Thos. D. Murphy Co., under G-70047, November 30, 1923. 5″ x 3″. Bill Fox collection. Photograph by author.

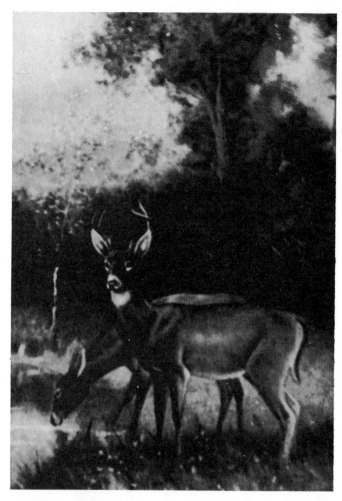

Fig. 368. (#270) "A Speedy Pair." R. A. Fox. © Thos. D. Murphy Co., under G-70052, November 30, 1923. 5″ x 3″. Bill Fox collection. Photograph by author.

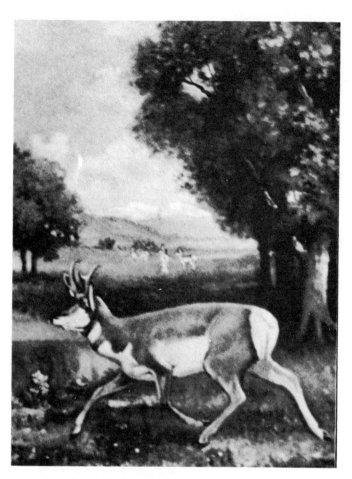

Fig. 370. (#272) "A Racing Model." R. A. Fox. © Thos. D. Murphy Co., under G-70042, November 30, 1923. 5″ x 3″ Bill Fox collection. Photograph by author.

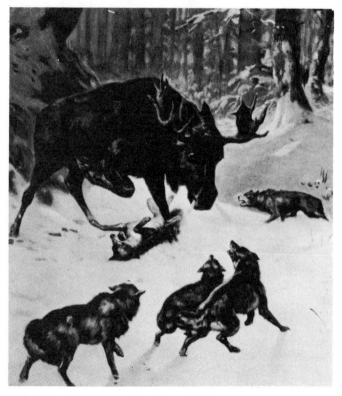

Fig. 369. (#109) "Battle of the Wild." R. Atkinson Fox. © 1911, Red Wing Publisher. 15½″ x 19″. Library of Congress collection.

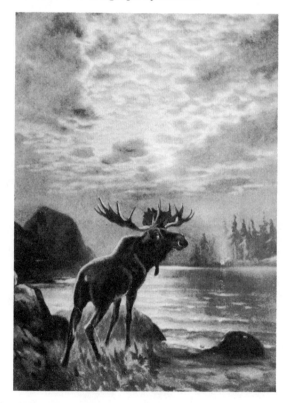

Fig. 371. (#206) "A Danger Signal." R. Atkinson Fox. 14″ x 9″. Courtesy Donna Robinson.

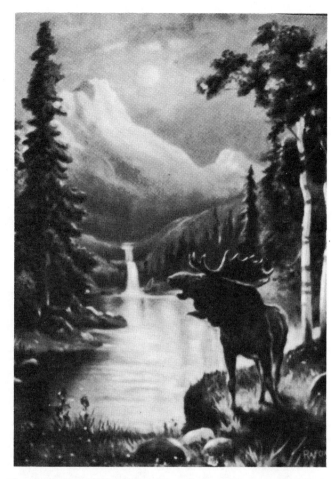

Fig. 372. (#241) "King of the Silvery Domain." R. A. Fox. 9½″ x 7″. Bill Fox collection. Photograph by author.

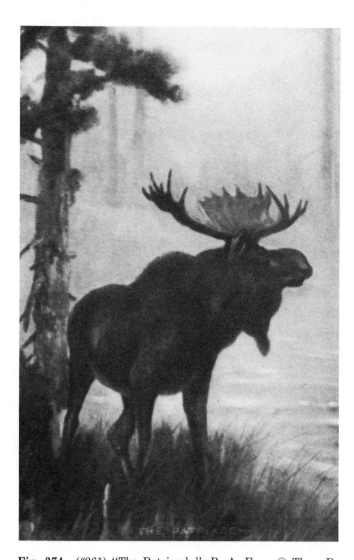

Fig. 374. (#261) "The Patriarch." R. A. Fox. © Thos. D. Murphy Co., under G-70053, November 30, 1923. 5″ x 3″. Bill Fox collection. Photograph by author.

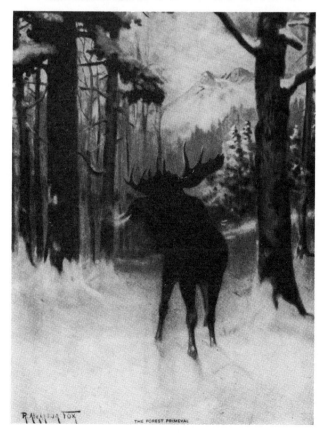

Fig. 373. (#171) "The Forest Primeval." R. Atkinson Fox. Bill Fox collection. Photograph by author.

127

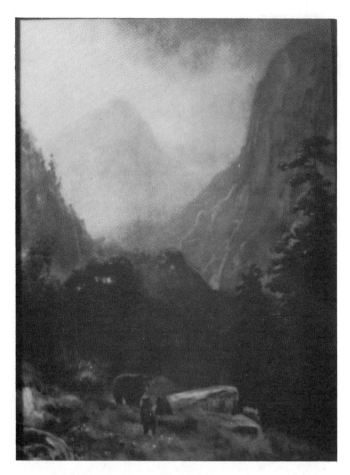

Fig. 375. (#54) "The Mountains." (Also "High up in the Hills.") R. Atkinson Fox. 18″ x 14″. Courtesy Loretta Goad.

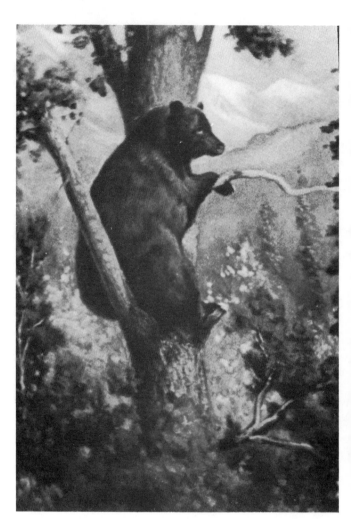

Fig. 377. (#267) "Sittin' Pretty." R. A. Fox. © Thos. D. Murphy Co., under G-70057, November 30, 1923. 5″ x 3″. Bill Fox collection. Photograph by author.

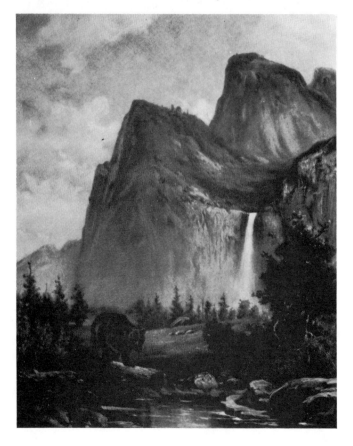

Fig. 376. (#106) "Eternal Hills." R. Atkinson Fox. © 1911. Library of Congress collection.

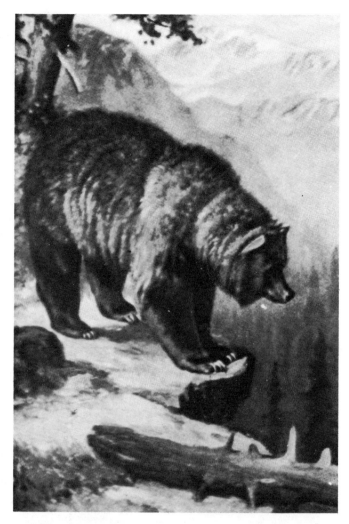

Fig. 378. (#265) "A Grizzled Old Grizzly." R. A. Fox. © Thos. D. Murphy Co., under G-70039, November 30, 1923. 5″ x 3″. Bill Fox collection. Photograph by author.

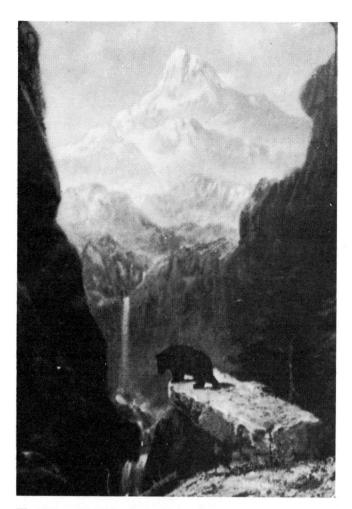

Fig. 380. (#318) Untitled. R. Atkinson Fox. © K. Co., Inc. 5″ x 3″. Courtesy Donna Robinson.

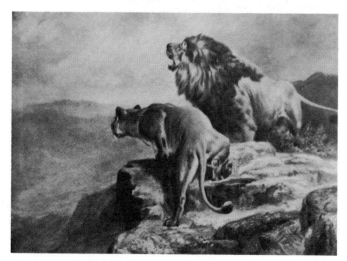

Fig. 379. (#73) "In the Enemy's Country." R. A. Fox. © Thos. D. Murphy Co., under G-60345, June 17, 1920 Bill Fox collection. Photograph by author.

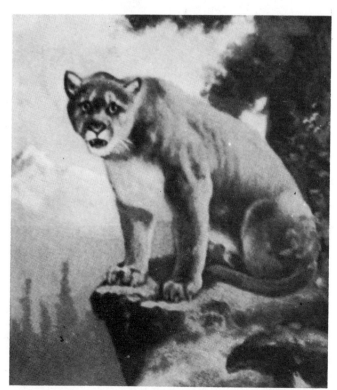

Fig. 381. (#269) "Look Me in the Eye." R. A. Fox. © Thos. D. Murphy Co., under G-70043, November 30, 1923. 5″ x 3″. Bill Fox collection. Photograph by author.

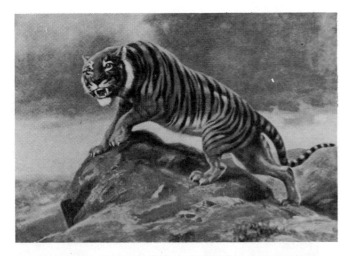

Fig. 382. (#174) "A Royal Outlaw." R. Atkinson Fox. © Thos. D. Murphy Có., under G-63983, November 8, 1921. Bill Fox collection. Photograph by author.

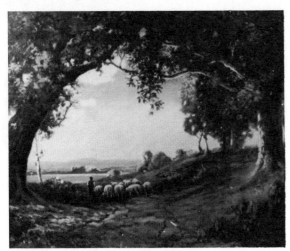

Fig. 383. (#35) "Indian Summer." R. Atkinson Fox. © Turner Mfg. Co., Chicago, Illinois. Also found with a Borin copyright. 12″ x 15″, 14″ x 20″, 20″ x 23″, 18″ x 30″. Courtesy Loretta Goad.

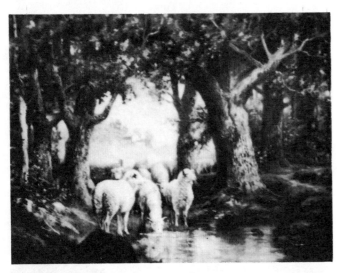

Fig. 384. (#292) "A Quiet Pool." R. Atkinson Fox. © 1909 by Charles W . . ., New York. Found on a 1911 calendar. 6″ x 6″. Courtesy Joan Jenkins.

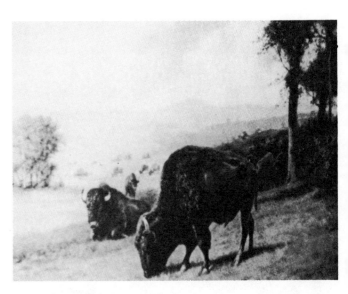

Fig. 385. (#236) "The Pioneers." R. Atkinson Fox. 11″ x 19″. Courtesy Clare Cerda.

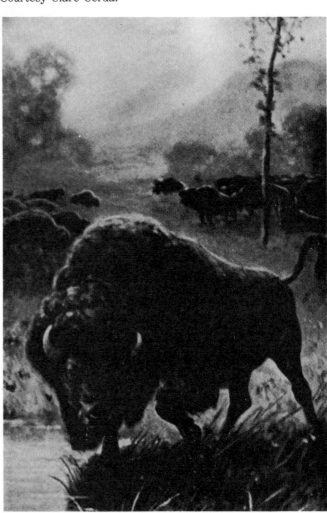

Fig. 386. (#263) "Head of the Herd." R. A. Fox. © Thos. D. Murphy Co., under G-70045, November 30, 1923. 5″ x 3″. Bill Fox collection. Photograph by author.

Fig. 389. (#285) Untitled. R. Atkinson Fox. 15″ x 5″. Author's collection.

Fig. 387. (#287) Untitled. R. A. Fox. 15″ x 5″. Author's collection.

Fig. 388. (#264) "Working Overtime." R. A. Fox. © Thos. D. Murphy Co., under G-66924, November 4, 1922. Bill Fox collection. Photograph by author.

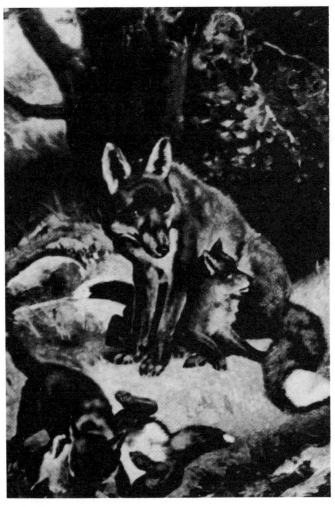

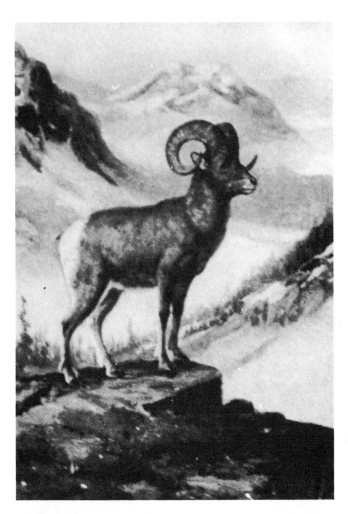

Fig. 390. (#266) "Play While You May." R. A. Fox. © Thos. D. Murphy Co., under G-70040, November 30, 1923. 5″ x 3″. Bill Fox collection. Photograph by author.

Fig. 391. (#271) "King of the Clouds." R. A. Fox. © Thos. D. Murphy Co., under G-70048, November 30, 1923. 5″ x 3″. Bill Fox collection. Photograph by author.

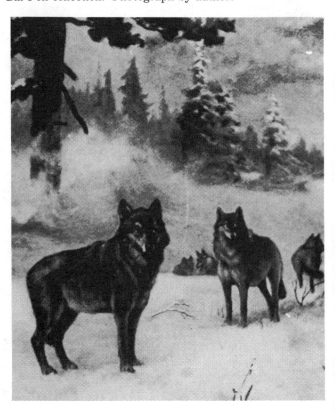

Fig. 392. (#268) "Children of the Forest." R. A. Fox. © Thos. D. Murphy Co., under G-70046, November 30, 1923. 5″ x 3″. Bill Fox collection. Photograph by author.

8
PSEUDONYMS AND OTHER CONFUSING SIGNATURES

One of the most exciting topics of conversation among Fox collectors has been the artist's use of pseudonyms. It is an established fact that Fox sometimes signed his paintings with a nom de plume. Pinpointing the exact names he used has proved less certain. Even the Fox children don't always agree as to which names he used. They do agree that Fox sometimes used pseudonyms when he wasn't particularly proud of a painting or when a publisher did not want the same artist's name signed to several or all prints on a calendar. The names the children agree on are: C. Wainright (we are finding this as Charles or C. N. Wainwright—note the extra "w"), George White, Elmer Lewis, and George W. Turner. Bill Fox also believes his father sometimes used the names John Wainright, L. Capelli, John Calvin, and the last name Dupree or Duprés.

Please remember that a good deal of this is speculation. Neither I, the family, nor the publishers of this book accept any responsibility if any Fox collector purchases a print with one of these signatures and it later proves *not* to be a Fox. Also, if any of these names turn out to have belonged to separate artists, they deserve recognition in their own right and we apologize to them and their descendants for any confusion.

Another name that keeps popping up is "Reynard." It has been seen with the first name "Henry" or "Henri," both with or without the middle initial "G." Speculation among Fox Hunters has been high because of a series of coincidences: Reynard was, of course, the name of the classic fairy-tale fox; RAF's father's name was Henry; and Bill Fox admitted to me that this was "just the kind of humorous trick" his father would have enjoyed. Some people consider the work of Reynard and Fox so similar that they had to have been done by the same man. Some even see a resemblance between the signatures of Fox and Reynard. The only reference I have found to an artist named Reynard is a print by Grant Tyson Reynard (1887-1967) in *American Prize Prints of the 20th Century,* by Albert Reese, N.Y.: American Artists Group, 1949, p. 169.

One collector found a copy of the most common Reynard print, "Love's Echoes," signed *Henrietta* Reynard!

Another signature that can cause confusion is G. B. Fox. G. B. stood for Garnet Bancroft Fox, RAF's nephew. Garnet sometimes used the pseudonym "Guy Fawkes" or "G. B. Fawkes," perhaps because he was entertained by the homonymic relationship between his own name and that of the famous conspirator who was executed in England in 1605.

The signature of "A. Fox," we have learned, was used by Joseph Hoover & Sons to copyright a certain number of their calendar pictures. No A. Fox existed, but the company has owned the name since 1908. No one in their office knew of RAF, but once the situation was explained, it was generally agreed that the name may have been used to capitalize on Fox's popularity.

Another artist whose prints are becoming popular with Fox collectors is W. M. Thompson. I have run across this name several times—usually on a print that features rushing water. I have grabbed for a print because the colors, trees, and mountains look right, then noticed that the print features a rushing stream or river, probably flowing past jagged rocks or carrying splintered timber, and I know immediately that it's a Thompson. We don't know anything about Thompson, but we don't think this is a pseudonym.

Finally, let's not forget that the name "H. Musson" was written in parentheses above "R. A. Fox" in the Name of Artist space on one of the painting records from Thos. D. Murphy Company. This could imply a pseudonym and might be a name to watch for—if for no other reason than to study the work for comparison.

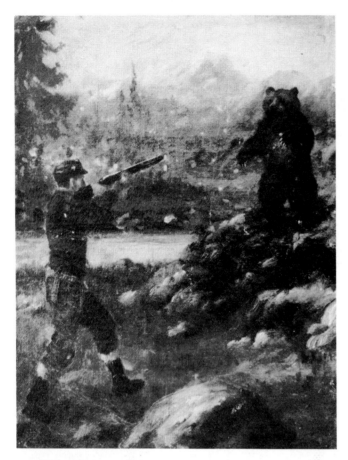

Fig. 393. "Preliminary Sketch" in oil, by Garnet Fox. Collection of Peg and Oscar Mayer.

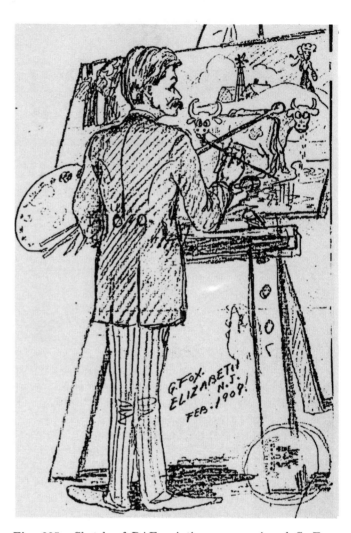

Fig. 395. Sketch of RAF painting a cow, signed G. Fox, Elizabeth, N.J., February, 1909. Bill Fox collection.

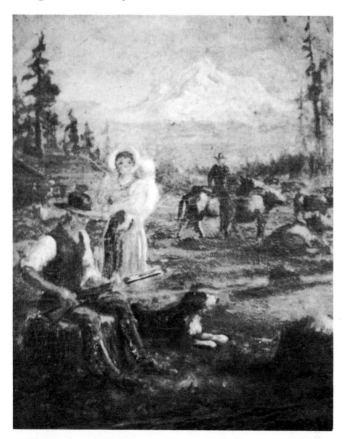

Fig. 394. "Preliminary Sketch" in oil, by Garnet Fox. Collection of Peg and Oscar Mayer.

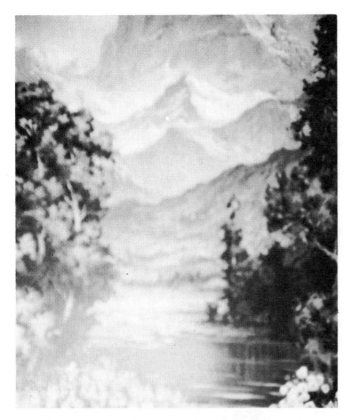

Fig. 396. "Majestic Mountains." G. B. Fox. Print 9″ x 7″.
Courtesy Virginia Totten.

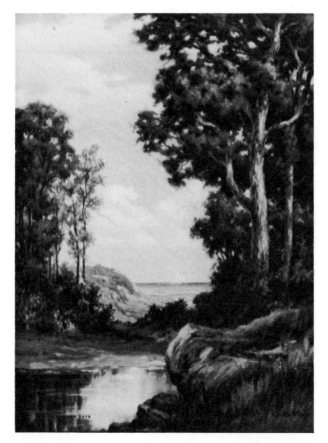

Fig. 397. "Joyous Summer Days." G. B. Fox. Found on a 1938
calendar. 10″ x 7½″. Author's collection.

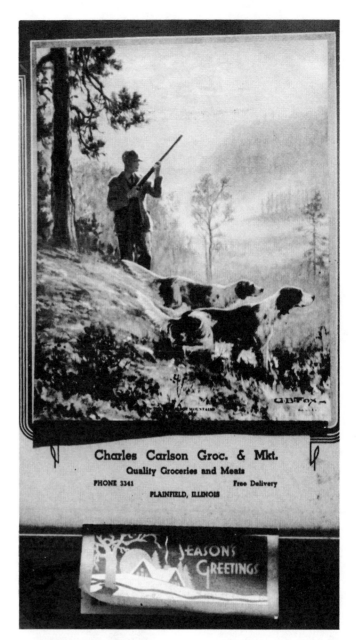

Fig. 398. "In the Blue Ridge Mountains." G. B. Fox. Found
on a 1940 calendar. 10″ x 8″. Author's collection.

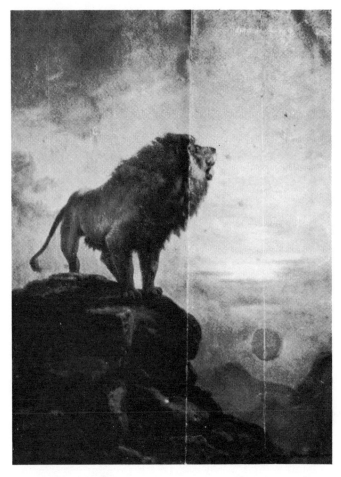

Fig. 399. Untitled. Elmer Lewis. Bill Fox collection. Photograph by author.

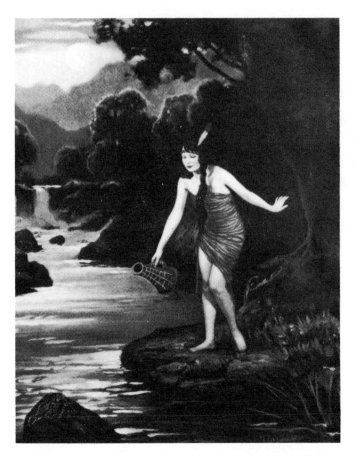

Fig. 401. "By the Light of the Moon." Dupre. Bill Fox collection. Photograph by author.

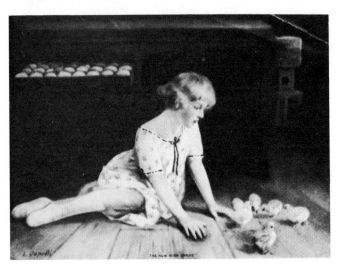

Fig. 400. "The Newborn Chicks." L. Capelli. Bill Fox collection. Photograph by author.

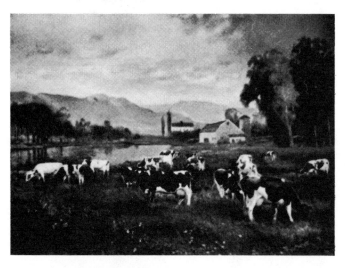

Fig. 402. Untitled. John Calvin. Bill Fox collection. Photograph by author.

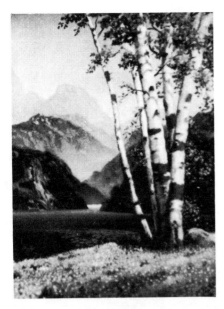

Fig. 403. "Sentinels of the Pass." C. Wainright. Bill Fox collection. Photograph by author.

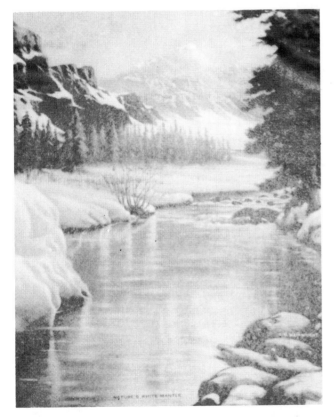

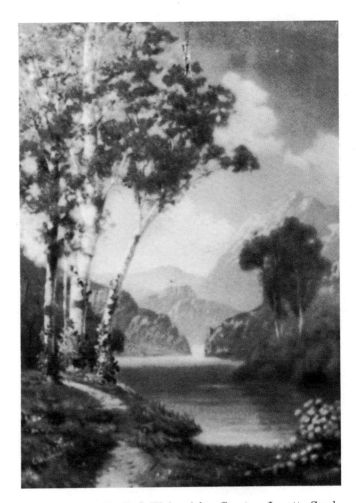

Fig. 405. "Paradise." C. Wainwright. Courtesy Loretta Goad.

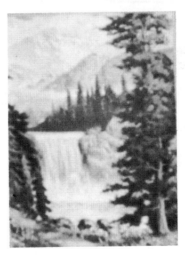

Fig. 404. "Nature's White Mantle." C. N. Wainwright. Author's collection.

Fig. 406. "Two Medicine River Falls (Montana)," C. Wainwright. Courtesy Barbara Kern.

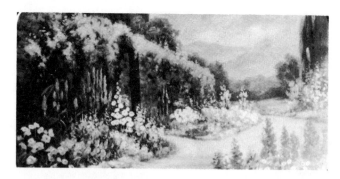

Fig. 407. Untitled. Lewis.

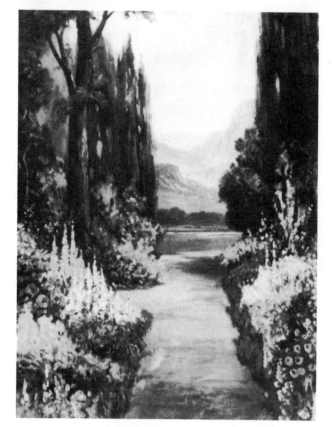

Fig. 408. Untitled. Lewis.

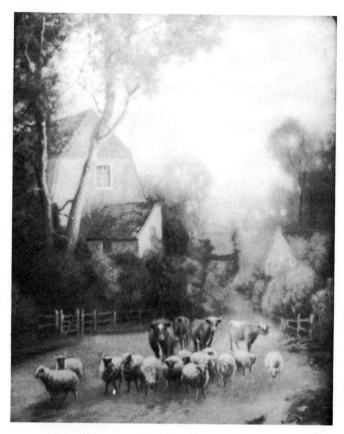

Fig. 409. "As Twilight Approaches." Arthur De Forest. 10"
x 8". Courtesy John and Darlene Boland.

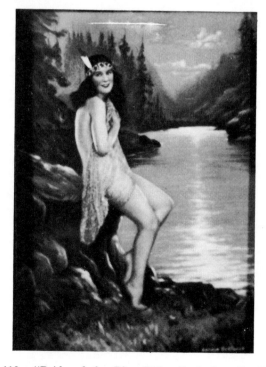

Fig. 410. "Pride of the Blue Ridge." Arthur De Forest.
Courtesy Loretta Goad.

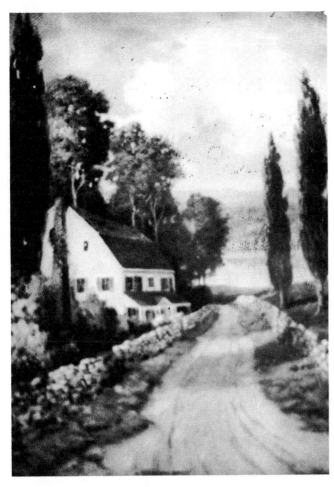

Fig. 411. "A Garden Spot." Arthur De Forest. Courtesy Donna Robinson.

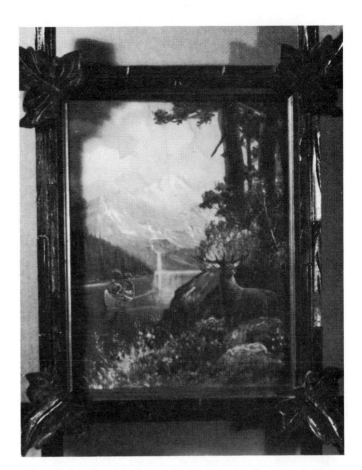

Fig. 413. "Mutual Surprise." De Forest. Courtesy Loretta Goad.

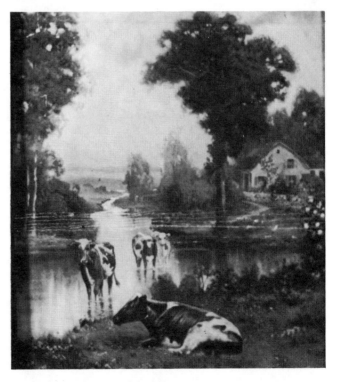

Fig. 412. "Curly Locks." De Forest. Bill Fox collection. Photograph by author.

Fig. 414. "Along the Meadowbrook." Arthur De Forest. Courtesy Loretta Goad.

Fig. 415. Untitled. De Forest. Bill Fox collection. Photograph by author.

Fig. 417. This print is signed (script) "Geo W. Turner" at the bottom right. The title "The Silvery Divide" is printed at the bottom. A © is all that appears at the lower right, as if the remainder of the publisher's data was cut off. At the lower left are lily pads. A second moose is on the distant shore of the lake near the evergreen trees and is facing toward the moose standing on the rock. 7¾″ x 9¾″. Courtesy Barbara Kern.

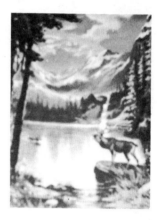

Fig. 416. "Love's Echo." Henri G. Reynard. Courtesy Donna Robinson.

Fig. 418. This print is signed (script) "Geo W" at the bottom right. In fact, even part of the "W" is missing, but enough is there to recognize it. The title "Silvery Grandeur" is printed at the bottom. There is no publisher's data. In the distance behind the standing moose's antlers is a waterfall emptying into the lake. The second moose is in the water swimming toward the one standing on the rock. 6¾″ x 9″. Courtesy Barbara Kern. Note: Figs. 417 and 418 are similar in subject content, yet different. The only real similarity I can find is the way the artist applied the grass brushstrokes at the bottom right with little dots of rose color as flowers. You will note that on both prints, the name George is abbreviated as "Geo."

Following is a list of original works by R. Atkinson Fox, copyrighted by Fox or one of his publishers, that are registered in the Copyright Office of the Library of Congress (L.C.). These do not appear on the Fox list (the list of prints numbered in the order in which they have come to my attention) because they have not been reported to me as having been found on the open market.

It is entirely possible that some of these titles might correspond to untitled prints on the Fox list. Because I cannot see the prints listed by the L.C., I cannot make any comparisons.

No one in the L.C. seems to know what might have happened to the copies deposited when the prints were copyrighted—I suspect they were destroyed or disposed of when the files were converted to microfilm.

Neither does anyone seem to know why the prints that the Prints and Photographs Division has on file (Fox #104-133), most of which have copyright dates on their reverse sides, did not show up on the Copyright Office search list.

Aberdeen Angus; by R. A. Fox. Painting. Registered in the name of The Thos. D. Murphy Co., under G 66921 following the deposit of one copy November 4, 1922. No renewal found.

Abraham Lincoln; by R. A. Fox. Painting. Registered in the name of The Thos. D. Murphy Co., under G 66212 following the deposit of one copy July 15, 1922. No renewal found.

Abraham Lincoln; by R.A. Fox. Head & shoulders; full face. Registered in the name of The Thos. J. Murphy Co., under G 78807 following the deposit of one copy November 20, 1926. No renewal found.

Alexander Graham Bell-Telephone; by R. A. Fox. Painting. Registered in the name of The Thos. D. Murphy Co., under G 66913 following the deposit of one copy November 4, 1922. No renewal found.

America's Bread Basket; by R. A. Fox. Painting. (Wide expanse of shocks of wheat in field, with turkeys feeding in foreground.) Registered in the name of The Thos. D. Murphy Co., under G 84151 following the deposit of one copy September 24, 1928. No renewal found.

Andrew Carnegie; by R. A. Fox. Painting. Registered in the name of The Thos. D. Murphy Co., under G 66216 following the deposit of one copy July 15, 1922. No renewal found.

Andrew Jackson; by R. A. Fox. Painting. Registered in the name of The Thos. D. Murphy Co., under G 66222 following the deposit of one copy July 15, 1922. No renewal found.

At Sundown. Summer landscape. Group of dwellings and church in background; woman and child walking along road. Entered in the name of R. A. Fox, under I 15161, August 11, 1905; one photograph received August 11, 1905.

At Sundown. Entered in the name of R. A. Fox, under F 38246, December 27, 1905; two copies received December 27, 1905.

Autumn Glow; by R. Atkinson Fox. Registered in the name of John Drescher Co., Inc., under K 205752 following publication August 2, 1926. No renewal found.

Avenue, Sherwood Forest; by R. A. Fox. Painting. Registered in the name of The Thos. D. Murphy Co., under G 67794 following the deposit of one copy February 12, 1923. No renewal found.

Ayrshires; by R. A. Fox. Painting. Registered in the name of The Thos. D. Murphy Co., under G 66919 following the deposit of one copy November 4, 1922. No renewal found.

Benjamin Franklin; by R. A. Fox. Painting. Registered in the name of The Thos. D. Murphy Co., under G 66219 following the deposit of one copy July 15, 1922. No renewal found.

Burn's Cottage, Alloway; by R. A. Fox. Painting. Registered in the name of The Thos. D. Murphy Co., under G 66321 following the deposit of one copy July 31, 1922. No renewal found.

The Call; by R. Atkinson Fox. Moose standing by stream at dusk, listening to a call coming from the distance. Oil Painting. Registered in the name of E. C. Cutler, under G 42515 following the deposit of one copy December 26, 1912. No renewal found.

The Challenge; by R. A. Fox. Painting. Registered in the name of The Thos. D. Murphy Co., under G 59306 following the deposit of one copy January 3, 1920. No renewal found.

Chums; by R. Atkinson Fox. Painting. Registered in the name of The Knapp Company, Inc., under G 54734 following the deposit of one copy August 21, 1917. No renewal found.

Columbia River-Oregon; by R. A. Fox. Registered in the name of John Drescher Co., Inc., under K 202241 following publication March 17, 1926. No renewal found.

Come Along, My Beauty; by R. A. Fox. Fisherman standing in stream, rod in right hand, net in left hand, fish on end of line. Painting. Registered in the name of The Thos. D. Murphy Co., under G 81396 following the deposit of one copy October 5, 1927. No renewal found.

Contentment; by R. Atkinson Fox. To left of picture can be seen open field with two cows in foreground standing in pond. Black cow is drinking water, while brown and white cow is looking at cows in distance. Painting. Registered in the name of The Osborne Company, under G 57348 following the deposit of one copy January 6, 1919. No renewal found.

A Corner of the Pasture; by R. A. Fox. Painting. Registered in the name of The Thos. D. Murphy Co., under G 43881 following the deposit of one copy May 3, 1913. No renewal found.

Cyrus H. McCormick-Harvester; by R. A. Fox. Painting. Registered in the name of The Thos. D. Murphy Co., under G-66909 following the deposit of one copy November 4, 1922. No renewal found.

Eli Whitney-Cotton Gin; by R. A. Fox. Painting. Registered in the name of The Thos. D. Murphy Co., under G 66917 following the deposit of one copy November 4, 1922. No renewal found.

Elias Howe-Sewing Machine; by R. A. Fox. Painting. Registered in the name of The Thos. D. Murphy Co., under G 66908 following the deposit of one copy November 4, 1922. No renewal found.

Emerson's Home, Concord; by R. A. Fox. Painting. Registered in the name of The Thos. D. Murphy Co., under G 66287 following the deposit of one copy July 31, 1922. No renewal found.

Faithful Guardian; by R. Atkinson Fox. Painting. Little girl sitting on floor before fireplace with story book in her lap. Behind her is a collie. Registered in the name of The Osborne Company, under G 70149 following the deposit of one copy December 12, 1923. No renewal found.

The Favorite; by R. A. Fox. Painting. Young woman with dark hair and eyes, wearing pink waist and black pleated skirt, standing with her left hand holding bridle of gray horse which (with) has head extended toward a fountain in foreground. Trees in background. Registered in the name of R. A. Fox, under G 39744 following the deposit of one copy February 2, 1912. No renewal found.

Galloways; by R. A. Fox. Painting. Registered in the name of The Thos. D. Murphy Co., under G 66923 following the deposit of one copy November 4, 1922. No renewal found.

Garden of Rest (Sunshine Gardens); by R. A. Fox. Registered in the name of John Drescher Co., Inc., under K 202261 following publication March 4, 1926. No renewal found.

Gates of Dreamland; by R. A. Fox. (Representation of the city of dreamland. Body of water in center of picture surrounded by trees and buildings, auto by mountains in background.) (Figure mounting steps in foreground.) Painting. Registered in the name of The Thos. D. Murphy Co., under G 84160 following the deposit of one copy September 24, 1928. No renewal found.

Geo. Stephenson-Locomotive; by R. A. Fox. Painting. Registered in the name of The Thos. D. Murphy Co., under G 66910 following the deposit of one copy November 4, 1922. No renewal found.

Geo. Washington; by R. A. Fox. Painting. Registered in the name of The Thos. D. Murphy Co., under G 66220 following the deposit of one copy July 15, 1922. No renewal found.

The Girl of the Golden West; by R. Atkinson Fox. Three-quarter figure of western girl on the plains. She wears dark red skirt and blue waist with red hankerchief round neck. Also wears pair of gloves and felt hat. Standing beside her is brown horse in harness. He has two white spots at forehead and nose and is eating out of girl's hand. Behind them watching herd of cattle is brown and white collie. In blue sky are several white clouds. Registered in the name of R. Atkinson Fox, under G 38733 following the deposit of one copy September 20, 1911. No renewal found.

Golden Autumn Days; by R. Atkinson Fox. Registered in the name or R. Atkinson Fox, under K 193164 following publication December 26, 1924. No renewal found.

The Grand Canyon; by R. A. Fox. (High mountains on left, small clump of trees in right foreground.) Registered in the name of The Kemper-Thomas Company, under K 98791 following publication January 1, 1916. No renewal found.

Grover Cleveland; by R. A. Fox. Painting. Registered in the name of The Thos. D. Murphy Co., under G 66215 following the deposit of one copy July 15, 1922. No renewal found.

Guernseys; by R. A. Fox. Painting. Registered in the name of The Thos. D. Murphy Co., under G 66922 following the deposit of one copy November 4, 1922. No renewal found.

Guglielino Marconi-Wireless; by R. A. Fox. Registered in the name of The Thos. D. Murphy Co., under G 66912 following the deposit of one copy November 4, 1922. No renewal found.

Haven of Beauty; by R. A. Fox. Registered in the name of John Drescher Co., Inc., under K 222323 following publication December 30, 1926. No renewal found.

Hawthorne's Home, Concord; by R. A. Fox. Painting. Registered in the name of The Thos. D. Murphy Co., under G 66318 following the deposit of one copy July 31, 1922. No renewal found.

Heart's Desire; by R. A. Fox. Garden with house. 14x28 oblong shape. Registered in the name of Master Art Publishers, Inc., under K 225988 following publication June 1, 1927. No renewal found.

Herefords; by R. A. Fox. The heads of three Herefords appearing over a fence board, wooded landscape in background. Of the cattle which are full face, the center animal has a halter on. The head at left is in profile. Painting. Registered in the name of R. A. Fox, under G 45323 following the deposit of one copy December 16, 1913.

Holsteins; by R. A. Fox. Painting. Registered in the name of The Thos. D. Murphy Co., under G 66920 following the deposit of one copy November 4, 1922. No renewal found.

Italian Royal Family; by R. Atkinson Fox. King and Queen of Italy, and four children; King standing. Oil painting. Registered in the name of Joseph E. Ellery, under G 44903 following the deposit of one copy October 18, 1913. No renewal found.

James J. Hill; by R. A. Fox. Painting. Registered in the name of The Thos. D. Murphy Co., under G 66213 following the deposit of one copy July 15, 1922. No renewal found.

James Watt-Steam Engine; by R. A. Fox. Painting. Registered in the name of The Thos. D. Murphy Co., under G 66911 following the deposit of one copy November 4, 1922. No renewal found.

Jerseys; by R. A. Fox. Painting. Registered in the name of The Thos. D. Murphy Co., under G 66936 following the deposit of one copy November 4, 1922. No renewal found.

Johannes Gutenberg-Printing; by R. A. Fox. Painting. Registered in the name of The Thos. D. Murphy Co., under G 66914 following the deposit of one copy November 4, 1922. No renewal found.

The Journey's End-Oregon; by R. A. Fox. Line of conestoga wagons in center, group of pioneers standing at right, trees and mountains in background. Registered in the name of The Thos. D. Murphy Co., under G 81397 following the deposit of one copy October 5, 1927. No renewal found.

Letter from the Boy; by R. A. Fox. Interior scene with elderly lady seated in plush chair, wearing blue skirt, pink flower-design waist. Also black bonnet with long strings. She's reading letter which she holds in left hand—holds cheek in right. Elderly husband wearing brown trousers, white shirt at her left. Has long white hair and beard. Right, is mantlepiece; on wall hangs man's coat. He holds envelope of letter in hands. Registered in the name of R. A. Fox, under G 39310 following the deposit of one copy December 29, 1911. No renewal found.

Longfellow's Home, Cambridge; by R. A. Fox. Painting. Registered in the name of The Thos. D. Murphy Co., under G 66320 following the deposit of one copy July 31, 1922. No renewal found.

Man Fishing; by R. A. Fox. Painting. (Man standing on bank of stream fishing with hook and line.) Registered in the name of The Osborne Company, under G 64087 following the deposit of one copy November 17, 1921. No renewal found.

Mark Twain's Home, Hartford; by R. A. Fox. Painting. Registered in the name of The Thos. D. Murphy Co., under G 66327 following the deposit of one copy July 31, 1922. No renewal found.

Marshall Field; by R. A. Fox. Painting. Registered in the name of The Thos. D. Murphy Co., under G 66214 following the deposit of one copy July 15, 1922. No renewal found.

The Meadow Brook. Country landscape summer. Road running through small wood at left. Entered in the name of R. A. Fox, under I 18616, July 14, 1906; one photograph received July 14, 1906.

Mid Mountain Verdure. Small shrubbery along bank of stream flowing between high rocks. Registered in the name of R. A. Fox, under G 45005 following the deposit of one copy November 6, 1913. No renewal found.

The Monarch. Steer standing at edge of brook in pasture; clump of trees in background at left. Entered in the name of R. A. Fox, under I 15162, August 11, 1905; one photograph received August 11, 1905.

Native Son; by R. A. Fox. Bear, standing on fallen tree trunk, looking down; clouds in background. Painting. Registered in the name of The Thos. D. Murphy Co., under G 81387 following the deposit of one copy October 5, 1927. No renewal found.

October Sport. Man in hunting costume firing gun at bird. Setter a little ahead of him ready to point. Entered in the name of R. A. Fox, under I 15163, August 11, 1905; one photograph received August 11, 1905.

The Old Bridge; by R. A. Fox. Painting. Registered in the name of The Thos. D. Murphy Co., under G 66314 following the deposit of one copy July 31, 1922. No renewal found.

Old English Garden; by R. Atkinson Fox. Registered in the name of The Master Art Publishers, Inc., under K 223106 following publication November 15, 1926. No renewal found.

Old Faithful Geyser; by R. A. Fox. Painting. As Faithful as Old Faithful. "Old Faithful" of the Yellowstone in action surrounded by Indians and their tepees. Registered in the name of Mutual Trust Life Ins. Co., under G 79564 following the deposit of one copy January 17, 1927. No renewal found.

The Old Farmyard; by R. A. Fox. Painting. (Flock of sheep in yard near barn.) Registered in the name of The Thos. D. Murphy Co., under G 66296 following the deposit of one copy July 31, 1922. No renewal found.

The Old Meeting House; by R. A. Fox. Painting. Registered in the name of The Thos. D. Murphy Co., under G 66316 following the deposit of one copy July 31, 1922. No renewal found.

The Old Red Schoolhouse; by R. A. Fox. Painting. Registered in the name of The Thos. D. Murphy Co., under G 66293 following the deposit of one copy July 31, 1922. No renewal found.

The Old Well; by R. A. Fox. Painting. Registered in the name of The Thos. D. Murphy Co., under G 66295 following the deposit of one copy July 31, 1922. No renewal found.

One Strike. Small boy in red flannel shirt and knicker-bockers holding a bat. Near him is a small fox terrier, boy is smiling. Entered in the name of R. Atkinson Fox, under I 12752, November 26, 1904; one photograph received November 26, 1904.

Pals; by R. Atkinson Fox. A stable window through which a chestnut horse and a dark brown horse are thrusting their heads. Two dogs looking up at them. Painting. Registered in the name of The Osborne Company, under G 51231 following the deposit of one copy December 27, 1915. No renewal found.

Path to the Pond; by R. Atkinson Fox. Registered in the name of R. Atkinson Fox, under G 59976 following the deposit of one copy April 22, 1920. No renewal found.

Philip D. Armour; by R. A. Fox. Painting. Registered in the name of The Thos. D. Murphy Co., under G 66218 following the deposit of one copy July 15, 1922. No renewal found.

Please Don't Make Us Go to Bed; by R. Atkinson Fox. (Child seated by dog on rug before open fireplace.) Painting. Registered in the name of The Osborne Company, under G 63015 following the deposit of one copy June 6, 1921. No renewal found.

A Pure Bred Herd; by R. A. Fox. Painting. Registered in the name of The Thos. D. Murphy Co., under G 63974 following the deposit of one copy November 8, 1921. No renewal found.

A Quiet Stream; by R. Atkinson Fox. Registered in the name of R. Atkinson Fox, under G 59977 following the deposit of one copy April 22, 1920. No renewal found.

Robert Fulton-Steamboat; by R. A. Fox. Painting. Registered in the name of The Thos. D. Murphy Co., under G 66915 following the deposit of one copy November 4, 1922. No renewal found.

Roses Fair; by R. Atkinson Fox. Registered in the name of R. Atkinson Fox, under K 193146 following publication December 26, 1924. No renewal found.

Samuel F. B. Morse Telegraph; by R. A. Fox. Painting. Registered in the name of The Thos. D. Murphy Co., under G 66916 following the deposit of one copy November 4, 1922. No renewal found.

Scotch Shorthorns; by R. A. Fox. Painting. Registered in the name of The Thos. D. Murphy Co., under G 67790 following the deposit of one copy February 12, 1923. No renewal found.

Shakespeare's Home, Stratford; by R. A. Fox. Painting. Registered in the name of The Thos. D. Murphy Co., under G 66326 following the deposit of one copy July 31, 1922. No renewal found.

Shorthorns Nooning; by R. Atkinson Fox. Painting. (Herd of shorthorned cattle wading in stream.) Registered in the name of The Osborne Company, under G 64074 following the deposit of one copy November 17, 1921. No renewal found.

Silvery Moon; by R. Atkinson Fox. Registered in the name of John Drescher Company, Inc., under K 202447 following publication March 24, 1926. No renewal found.

Sir Thomas Lipton; by R. A. Fox. Painting. Registered in the name of The Thos. D. Murphy Co., under G 66217 following the deposit of one copy July 15, 1922. No renewal found.

Snow Glowed Mt. Rainier; by R. Atkinson Fox. Oil painting. Registered in the name of R. Atkinson Fox, under G 56300 following the deposit of one copy June 21, 1918. No renewal found.

Solitary Heights. (Small trees on bank of stream at foot of high rocky mountain.) Registered in the name of R. A. Fox, under G 45006 following the deposit of one copy November 6, 1913. No renewal found.

Spirit of Youth; by R. Atkinson Fox. Registered in the name of Borin Manufacturing Company, under K 218148 following publication August 19, 1926. No renewal found.

Tennyson's Home, Isle of Wight; by R. A. Fox. Painting. Registered in the name of The Thos. D. Murphy Co., under G 66319 following the deposit of one copy July 31, 1922. No renewal found.

Theodore Roosevelt; by R. A. Fox. Painting. Registered in the name of The Thos. D. Murphy Co., under G 66221 following the deposit of one copy July 15, 1922. No renewal found.

There Is the Grand Canyon; by R. A. Fox. Girl in striped coat sitting on rock looking towards Canyon, man in dark suit standing in back of her pointing at Canyon. Painting. Registered in the name of Kaufmann & Strauss Co., under G 53101 following the deposit of one copy November 21, 1916. No renewal found.

Thinking of Her; by R. Atkinson Fox. Oil painting. Registered in the name of R. Atkinson Fox, under G 56675 following the deposit of one copy August 21, 1918. No renewal found.

Thinking of Him; by R. Atkinson Fox. Oil painting. Registered in the name of R. Atkinson Fox, under G 56674 following the deposit of one copy August 21, 1918. No renewal found.

This Good Old Earth; by R. Atkinson Fox. Summer landscape. Through center of picture is river and two cows are standing in the water on the right while another is drinking in the foreground. They are white and black. Painting. Registered in the name of The Osborne Company, under G 55372 following the deposit of one copy December 18, 1917. No renewal found.

Thomas Edison-Phonograph; by R. A. Fox. Painting. Registered in the name of The Thos. D. Murphy Co., under G 66907 following the deposit of one copy November 4, 1922. No renewal found.

Through the Mountain Pass; by R. Atkinson Fox. Stagecoach in foreground, mountain in distance. Registered in the name of Regensteiner Colortype Company, under K 95614 following publication January 1, 1916. No renewal found.

Waiting for Their Master. Golden collie and black and brown striped cat with white breast. Entered in the name of R. Atkinson Fox, under I 16084, November 18, 1905; one photograph received November 18, 1905.

Warren G. Harding; by R. A. Fox. Painting. Registered in the name of The Thos. D. Murphy Company, under G 66223 following the deposit of one copy July 15, 1922. No renewal found.

Washington at Valley Forge; by R. A. Fox. Painting. Registered in the name of The Thos. D. Murphy Company, under G 70049 following the deposit of one copy November 30, 1923. No renewal found.

Washington, the Soldier; by R. A. Fox. Painting. Registered in the name of The Thos. D. Murphy Company, under G 70050 following the deposit of one copy November 30, 1923. No renewal found.

Washington, the Surveyor; by R. A. Fox. Painting. Registered in the name of The Thos. D. Murphy Company, under G 70035 following the deposit of one copy November 30, 1923. No renewal found.

The Wealth of Our Fields; by R. A. Fox. Summer landscape with cows and sheep. Standing in a small stream in foreground is large brown and white cow. Painting. Registered in the name of The Osborne Company, under G 55378 following the deposit of one copy December 18, 1917. No renewal found.

The Western Girl; by R. A. Fox. Girl in western riding costume seated at side of watering trough, face in profile. Her horse is leaning over her left shoulder, head raised a little above the trough, water dripping from its mouth. Horse has white streak on forehead. Girl wears felt hat turned up in front, bandana kerchief knotted around neck; leather gloves with cuffs, has cartridge belt with leather pistol holster around waist. Her left hand holds bridle. Painting. Registered in the name of R. A. Fox, under G-36923 following the deposit of one copy February 23, 1911. No renewal found.

Wilbur Wright-Aeroplane; by R. A. Fox. Painting. Registered in the name of The Thos. D. Murphy Company, under G 66918 following the deposit of one copy November 4, 1922. No renewal found.

Willamette River, Oregon; by R. A. Fox. Registered in the name of John Drescher Co., Inc., under K 203676 following publication May 4, 1926. No renewal found.

Won By a Length; by R. A. Fox. Horse race, horse number 4 crossing the finish line and closely followed by number 2 and two others. Painting. Registered in the name of Kaufmann & Strauss Co., under G 53188 following the deposit of one copy December 5, 1916. No renewal found.

Woodland Path; by R. Atkinson Fox. Oil Painting. Registered in the name of R. Atkinson Fox, under G 56298 following the deposit of one copy June 21, 1918. No renewal found.

Wordsworth's Home, Rydal Mount; by R. A. Fox. Painting. Registered in the name of The Thos. D. Murphy Company, under G 66328 following the deposit of one copy July 31, 1922. No renewal found.

Yearling Shorthorns; by R. A. Fox. Painting. Registered in the name of The Thos. D. Murphy Company, under G 66924 following the deposit of one copy November 4, 1922. No renewal found.

A Young Niagara; by R. Atkinson Fox. Water color painting #4662. Registered in the name of R. Atkinson Fox, under G 59978 following the deposit of one copy April 22, 1920. No renewal found.

ABOUT THE AUTHOR

Rita Mortenson graduated *magna cum laude* from Central Missouri State University (CMSU) with an undergraduate degree in education and a Master's degree in English. She has also studied art and photography at Longview College and the Kansas City Art Institute, and plans to continue her education in the sciences.

She has taught high school and college, dealt in antiques, organized and taught a series of antiques seminars, and worked as "everything from a psychiatric nurse to a model." She has published numerous articles on a variety of subjects and is also the author of prizewinning poems and short stories. In 1980, she published her first article on R. Atkinson Fox and started "Fox Hunt," a collector's newsletter with an audience that increases every year.

In addition to writing, the author is an accomplished photographer and woodcarver. For recreation, she bicycles, walks and swims. With her husband, Bob, she enjoys raising butterflies and taking the telescope out for an evening under the stars.

Rita and Bob live in a quiet Kansas City suburb with their sons, Scott, a veterinary student, Alex, who is attending college, two cats, and numerous collections. Rita teaches English and Astronomy at an area college. Colorful Fox prints grace the Mortenson living room and the home office where Rita compiles her research on Fox and corresponds with "Fox Hunters."

PG	FIG.	AVL.	SIZE	VALUE	OTHER COMMENTS
45	63	SC	7 x 9	75-90	Also: American Art Works, Coshocton, O. with "See America First" as title.
	64	NC	9 x 12	60	Title is "Majestic Solitude"
			16 x 20	70-85	Souvenir Art Co. Found on a 1924 calendar.
	65	NC	6 x 14	60	**Also on puzzle by Brundage-Empire.**
			14 x 22	70-85	
46	66	NC	6 x 14	55	
	67	SC	10 x 16	60 (85)	
	68	SC	15 x 10	60	
	69	NC	10 x 14	60	**Found in Bintliff catalog with title, "Mountain Valley."**
47	70	NC	3 sizes	50-65	Title is "After the Storm/Rain"
	71	NC	16 x 10	60	Found on blotter with title "The Land of Memory"
	72	FC/ HSA	13 x 17	60	
			14 x 20	75-90	
	73	NC	10 x 8	60	Also on titled, unsigned adv. fan.
48	74	NC	12 x 9	60	With shaped frame. Also signed & titled on adv. fan.
	75	NC	8 x 16	60-70	Captions for Figs. 75 & 76 are reversed.
	76	SC	11 x 8	45	
	77	NC	10 x 7	60	**A more complete version, found as the "guide picture" for a 300 pc. Wayne Jig-a-Jig puzzle, extends farther on each side.**
49	78	NC	10 x 8	50	Title is "The Gateway to Golden Gorge" **Found 12 x 9 on sample calendar -- "Golden Glow" series.**
			adv. fan	40-45	
	79	FC	13 x 15	60	
			18 x 30	75-90	
	80	SC	11 x 8	50-60	
	81	NC	14 x 20	65-80	
50	82	NC	16 x 10	55	Found on blotter with title, "A Song of Evening" **Found with title "Water's Edge" by Bintliff Mfg.**
	83	NC	10 x 16	55	
	84	NC	12 x 9	55	**Found as bkgrnd. of a silhouette picture/adv. thermometer - curved glass & tip frame.**
	85	NC	medium	50-60	
51	86	NC	16 X 10	55	**Title: "Rippling Brook," Bintliff Mfg. Co.**
	87	NC	14 x 21	60-75	
	88	NC	10 x 16	55	
52	89	NC	22 x 14	70-85	
	90	FC	10 x 20	60	
	91	SC	6 x 4	45	**Title: "Grandeur of Nature."**
	92	SC	5 x 4	45	
53	93	FC	10 x 20	65	
	94	SC	10 x 7	45	
	95	NC	10 x 7	45	**Also puzzle: Jiggety Jig - - Series II - - No. 9**
	96	NC	10 x 7	50-60	
			16 x 12	75-90	
		SC	puzzle	100	
54	97	SC	22 x 14	75-90	
		SC	puzzle	100	Puzzle found titled: "The Old Stone Bridge"
	98	NC	tray	75	Title is "A Rustic Bridge" **Also found with title, "Turn of the Road."**

PG	FIG.	AVL.	SIZE	VALUE	OTHER COMMENTS
	99	FC/HSA	10 x 16	60	*Titled, "In the Country," by Bintliff Mfg. Co. Also on puzzle by Rariton Valley.*
	100	NC	med-lg	60-75	Same as Fig. 98
	101	NC	10 x 22	65	*Right portion found with title, "Lover's Walk."*
55	102	NC	16 x 10	50-60	
	103	NC	16 x 10	50-60	Titled "Birch Lane" by Bintliff Mfg.
	104	FC	8 x 16	50	
	105	FC	10 x 16	45-60	
			postcard	20-22	
56	106	FC	16 x 10	50-60	
			18 x 14	60	
	107	FC	8 x 16	50	
	108	FC	18 X 14	60-70	Shaped frame.
	109	FC	20 x 14	60-75	Found on blotter with title "An Inviting Pathway" *New titles found: "The New England Hills," and "Inviting Roads O'er Hill and Dale" (on monthly mailing calendar.)*
57	110	FC	16 x 10	50-60	*New titles: "The Wandering Winds"; "Poplar Avenue" (Bintliff); and "The Wandering Winds of Golden Eyes in Autumn," on a monthly mailing calendar. Also found on blotter.*
			18 x 14	60-75	
	111	FC	9 x 11	50	
			16 x 20	75	
			6 x 8	45	1924 calendar
	112	NC	10 x 8	45	
			8 x 6	35	Adv. fan titled "In the Land of the Sky"
	113	NC	10 x 12	45-50	"Mt. Ranier" Broderick Co., St. Paul
58	114	FC/HSA	10 x 13	60-75	
			16 x 20	90-120	Extreme left portion found titled, "A Forest Giant"
	115	NC	9 x 7	45	
			16 x 10	60-75	
	116	NC	8 x 10	50	*Also found on blotter.*
			blotter	18-20	See Fig. 148
	117	NC	10x14	50-60	
59	118	LC	unknown	85+	*Signed oil has been found.*
	119	LC	unknown	75+	
	120	SC	6 x 4	45	"Pikes Peak, Colorado" Famous Scenic Wonders of America (FSWA), series of monthly adv. cards by Red Wing, 1912
	121	NC	small	45	*Title, "Grand Canyon," found on signed TUCO puzzle 15 x 20.*
			16 x 22	75-90	
60	122	NC	6 x 4	40	"Colbourne Buttes, Colorado" FSWA, Red Wing, 1912
	123	NC	6 x 14	50	*10 x 24 version extends much farther to the left.*
	124	FC	med to lg	50-60	
	125	FC	10 x 24	60-75	Title is "Shower of Daisies"
			6 x 14	50-60	
61	127	NC	9 x 16	50-60	
			6 x 12	45-50	
	128	NC	10 x 12	50	"In America's Wonderland" Also found with "In America's Wonderland" as title on a complimentary print to readers of The Page Reporter, Page, Nebraska, K.T. Co., Cin., O.
	129	NC	6 x 4	45	Title is "The Royal Gorge-Colorado" FSWA, Red Wing, 1912

PG	FIG.	AVL.	SIZE	VALUE	OTHER COMMENTS
62	130	SC	10 x 8	50	
	131	NC	small	45	Title is "Tourist Mecca." **Also found on blotter.**
	132	NC	7 x 5	45	**Also found on a blotter.**
	133	SC	4 x 3	30-35	"Lake Louise in the Canadian Rockies: A Crystal Gem in Nature's Crown." **Found on a 1933, Brown & Bigelow mailing card.**
63	134	FC	12 x 10	50-60	
			20 x 16	75-80	
			postcard	18-20	
	135	NC	10 x 8	50	Also found on a Jan.,1939, calendar/laundry checklist adv. "Elk Laundry-St. Paul." 3 x 3 print extends farther on each side and carries a B & B copyright.
	136	SC	9 x 7	45	
	137	SC	7 x 9	50+	
64	138	NC	16 x 20	70-80	
	139	SC	small-med.	45-50	
			blotter	18	
	140	SC	16 x 12	50-60	
	141	FC	16 x 20	60-75	
65	142	NC	16 x 10	50-60	
	143	NC	7 x 5	45	Also found on a blotter.
	144	NC	10 X 8	50	Found on adv. fan titled "The Colorful Rockies." **Also found on 1953 calendar.**
	145	NC	postcard	20(50)	
			4 x 6	30-40	
			blotter	18	
66	146	FC	16 x 11	50-60	
			6 X 4	30-40	
			blotter	15-18	
	147	FC	6 x 3	25-30	
			postcard	18	
			9 x 7	40-45	
	148	NC	8 x 10	45-50	Also found on 1944 calendars as "Wonders of Nature" See Fig. 116
			blotter	18-20	
	149	NC	6 x 4	25-30	
			postcard	20-22	
67	150	NC	blotter	18-20	
	151	SC	15 X 9	75-90	**Several companies used this with advertising, "As Faithful as Old Faithful."**
	152	NC	2.5 x 3	25-30	
			6 x 4	30	1923 calendar. Also found on blotter.
68	153	NC	2.5 X 3	25-30	
			6 X 4	30	1923 calendar. Also found on blotter.
	154	SC	5 x 3	35+	
	155	SC	5 x 3	35+	
	156	SC	5 x3	35+	
69	157	SC	7 x 9	50	
	158	NC	9 x 11	45-50	
	159	NC	15 x 11	80-90	**Also on stick fan.** Title is "River of Romance." Also found as titled,
	160	FC/HSA	5 x 7	60-75	signed puzzle & 1/2 of "Perfect Double" puzzle, **Also on puzzles by Big Star and Blue Ribbon.**

PG	FIG.	AVL.	SIZE	VALUE	OTHER COMMENTS
70	161	SC	9 x 7.5	75	*Found with title, "After the Rain," Bintliff Mfg. Co.*
	162	SC	Small-med	75-90	*Also on Wayne, No.11, puzzle.*
	163	SC	16 x 20	150	
	164	NC	13 x 17	75-90	
71	165	NC	12 x 9	65	Also found on playing cards.
			16 x 12	75-90	
	166	SC	22 X 9	65	*Found on puzzle marked, "Jig-Jag-Jumbles, No.1."*
	167	NC	7.5 x 5	50	Found on a 1930 calendar for Crosley Radios. Found in a salesman's sample portfolio, "The New Stratford Art Calendar Offering, "publ. by Baumgarth.
	168	FC	9 x 12	50	
			15 x 19	60-75	Right portion found with title "Home Sweet Home."
	169	FC	9 x 12	50	Right portion found with title "A Restful Spot." *Found as wooden puzzle with title and attribution to RAF.*
72	170	SC	16 x 20	75-90	1932 Calendar titled, "Be It Ever So Humble,
			30 x 42	125	There's No Place Like Home."
	171	SC	small-med	50-65	Some confusion exists about the titles of Figs.171 &
	172	LC	med-lg	60-75+	172...They might be transposed. *Print has been found with stamp, "Library of Congress."*
	173	LC	med-lg	60-75+	
	174	NC	4.5 x 5	30	Right portion found on advertising fan.
73	175	NC	12 x 9	50-60	
			20 x 16	75-90	
	176	NC	22 x 9.5	55-60	Also found with title, "Home in Summertime." *Also found on titled,3-part, foldout fan. Another fan is titled "Dream Time, & 7½ x 9.*
	177	NC	10 x 20	60-75	
	178	NC	15 x 20	65-75	Also found under glass with thermometer. No adv.
	179	NC	9 x 12	50	*Titled " Tis a Garden Spot" on TUCO puzzle.*
			16 x 20	70-80	
74	180	FC	18 x 30	85-90	Known reproduction marked "Borin". Title & "c.1988 Gallery Graphics, Inc." on bottom margin. Also Fig.24. Featured with Fig. 207 on pp 71-72 Oct.,'90 issue of Country Home magazine. *Titled "Thatched Cottage" on 22-pc. sgnd. puzzle by Cooper Paper Box Corp.*
	181	NC	12 X 9	50	
	182	FC	10 X 20	65-75	I have been told this print appears behind Geraldine Page in the bus station in movie "A Trip to Bountiful"
			13 X 27	80-90	
	183	NC	15 x 10	60-65	*Found as No. 1588 in Bintliff catalog. Also found on blotter. Found with title, "The Whispering Winds."*
75	184	NC	18 x 14	65	
			20 x 12	75	
	185	FC	12 x 20	70	
			14 x 22	75-90	
	186	FC	10 x 18	60-70	*Also found on three puzzles by Brundage: New 200-pc, No.2; New 250-pc., No. 2; and Woozy Jig, No.2.*
			14 x 22	70-80	
	187	NC	18 x 30	80-90	*Reported with label on back: "Morris & Bendien. . . No. 53885, Title--"Garden of Sunshine."*
	188	FC	14 x 24	70-85	
			18 x 30	90-100	
			20 x 40	125-150	Some versions extend the image further on both sides.
76	189	FC	8 x 12	55	
			14 x 22	75	

PG	FIG.	AVL.	SIZE	VALUE	OTHER COMMENTS
	190	NC	17 X 9	60	
	191	FC	14 X 20	75	
			18 X 30	90(150)	
	192	NC	20 X 10	75	
77	193	NC	22 X 14	75	
	194	NC	14 X 18	60	
78	195	NC	30 X 18	90-100	
	196	NC	18 X 10	60	Title is "Garden of Rest" *Also found on (titled) 20th-Century Picture Puzzle, 375 pcs., 13 x 18 3/4.*
	197	FC	18 x 14	75	
	198	FC	10 x 18	60	Also 10 x 12 signed puzzle, " Rainbow Garden " $100 *Also found on adv. thermometer.*
79	199	FC	10 x 8	50	
			22 x 14	75	
	200	NC	10 x 15	55	*Found as No. 1590 (same title) in Bintliff catalog.*
	201	NC	10 x 20	75	Also, 14 x 28 wooden puzzle titled "Nature's Glory"
			14 x 22	90	Parker Bros., 1932, $125
	202	FC	14 x 18	70	*Reportedly appears in movie, " An Unremarkable Life."*
	203	NC	20 x 10	70-80	
80	204	FC	16 x 12	60	
	205	NC	19 x 32	80	Title is "Summer Glory"
	206	NC	10 x 16	60	*Found as No. 1589 (same title) in Bintliff catalog.*
	207	FC	14 x 22	65	Featured with Fig.180 on pp 71-72 of Oct.'90 issue
			18 x 30	80(100)	of Country Home magazine.
	208	FC	12 X 8	50	
81	209	FC	10 X 8	50	*Also on Dee-Gee Puzzle(s): 125-pc. & 190-pc. And on 4 x 6 adv. thermometer.*
			16 x 12	65	
	210	NC	14 x 20	60	
			18 x 20	70	
	211	FC	16 x 13	75(125)	*Also found on titiled & signed puzzle.*
			9 x 7	50	
			puzzle	75-100	
	212	NC	18 x 30	90	*Found with title, "Flowerland," © in Great Britain. Also found on Milton Bradley-- Windsor puzzle.*
82	213	NC	18 x 30	75-90	
	214	NC/HSA	30 x 18	90-110	Title is "Majestic Splendor." *Also Milton Bradley puzzle.*
	215	FC	14 x 18	60-75	
			18 x 30	75-90	
	216	FC	9 x 17	65	
	217	FC	10 x 18	60	*Titled " Sunshine Gardens " by Bintliff Mfg. Co.*
83	218	FC	16 x 10	60	*Found as No.1587, " Rose Bower, " in Bintliff catalog. Also found titled, " When All the World's in Tune, " on a monthly mailing calendar.*
	219	NC	14 x 22	60	
	220	FC	14 x 18	60-70	A number of these reportedly sold at a 1989 auction for $12.50 each.
	221/222	FC	15 x 20	50-60	
			18 x 30	75-90	
84	223	SC	8 x 10	75-90	
	224	SC	9 x 12	60-75	

PG	FIG.	AVL.	SIZE	VALUE	OTHER COMMENTS
			9 x 7 adv. fan	45	
	225	SC	9 x 7	50-60	Also found on 10 x 18 adv. thermometer with calendar.
85	226	NC/HSA	20 x 13	160-175	Title is " June Morn."
	227	NC/HSA	10 x 13	75-90	*Also found as Regent- Deluxe puzzle.*
			16 x 20	125-150	
			4 x 5	35-40	On adv. thermometer
	228	FC	8 x 14	45	*Also reported with signature, "Henri Reynard. "*
			10 x18	50-65	
	229	NC/HSA	22 x 27	150-175	
86	230	NC/HSA	15-18 x 12	110-125	*Found on puzzles: " Big 10," 5¼ x 10 1/4 , 280 pcs; Regent-Deluxe; and TUCO. also found on adv. fan.*
			8 x 6	75	Also found on adv. thermometer.
			smalller	25-35	Several of these have been found on box lids.
	231	FC	9 x 12	75(95)	Right portion on adv. fan. Some of the puzzle pieces *Found on an Xmas adv. card with a tiny calendar pad attached.*
			wood puzzle	100-125	Are in shapes #3, a heart & a horse's head, e.g.
	232	NC	23 x 10	90-110	
	233	FC	4 x 5	35	*Found on chrome cigar box.*
			10 x 12	75	
			16 x 20	90-110	
87	234	FC	8 x 6	45	Also found on box lid. *Also on 16 x 20 Regent-Deluxe puzzle.*
			12 x 10	45-50	
			16 x 12	60-75	
			20 x 16	90-110	Reproduced and sold for $6.
	235	NC	8 x 7	45	
			3" round	35	
	236	FC	8 x 14	45-50	
			10 x 18	55-65	
		NC	18 x 30	90-110	
	237	FC	12 x 16	75-90	
	238	FC	9 x 15	50	
			10 x 18	60-70	
			18 x 30	90-110	
88	239	NC	11 x 9	65-70	
	240	SC	9 x 11	125-150	Also found as signed fan " Carefree", publ. by (AAW)
	241	FC	7 x 13	60	
			9 x 17	75	
89	244	FC	3.5 X 3	35-40	Also found on adv. thermometer. *Found with arched window printed over it--as if you're looking through the window at this scene outside. Also found on TUCO puzzle and on an adv. fan.*
			6 x 4	45-50	
			12 x 9	60-75	
	245				Copyright A. Fox, not R.A.F.
	246	LC		400	*Figs.246-252 have not been reported as available on the open market. Collectors would pay a lot for an isolated find. However, as with any print, a large or "warehouse" find would reduce these values considerably.*
	247	LC		400	
90	248	LC		250	
	249	LC		450	
	250	LC		400	
	251	LC		175	

PG	FIG.	AVL.	SIZE	VALUE	OTHER COMMENTS
91	252	LC		450	
	253	SC	6 X 4	45	
	254	NC	11.5 X 9	75	
	255	SC	12 X 8.5	90	
			postcard	25	
92	256	SC	16 x 10.5	100-110	
	257	SC	11 x 9	125	*Also 9 x 6 on 1930 calendar.*
	258	SC	11 X 9	110-125	
	259	SC	medium	125-150	Found on 1913 calendar.
93	260	SC	8 x 6	65	
	261	SC	10 x 8	75-90	
	262	SC	9 x 7	75-90	Also part of a poster advertising "The Danbury Fair."
	263	SC	8 x 6	65	
94	264	NC	6 x 4	60	
	265	SC	cover	90-110	
	266	SC	16 x 12	90-125	Title is " Girl of the Golden West." *Found printed on the cover of a Parker Bros. puzzle box, "Horses & Dogs."*
	267	FC/HSA	16 x 12	90-110	Also, "Who's Jealous?"
95	268	SC	8 x 7	45-50	*RAF authorship is questionable.*
	269	SC	12 X 16	110-125	Found on a 1923 adv. calendar.
	270	SC	5 x 3	35	
			6 x 8	45-50	Adv. thermometer.
96	271	SC	20 x 16	125(285)	
	272	SC	14 X 10	110	
	273	NC	16 X 12	125	Found on a 1927 calendar. *Found on stick fan.*
	274				Title is "The Robin"
105	275	FC	7 x 5	65	
	276	NC/HSA	24 x 19	400(700)	*Found with advertising, "Dressed or Undressed, You Will Find Our Lumber Best/The Flemingsburg Lumber Co." (!) Also on stick fan. Note: Not even a small "ware house find" has reduced the price of this print. (See " Note, " Fig.279.)*
			14 x 11	200	
	277	SC/HSA	20 X 16	350	*On Detroit Gasket (Dee Gee) puzzle--125 pc & 300 pc.*
			16 x 14	225-250	1929 calendar
	278	SC	15 x 11	175+	
	279	SC	15 x 11	200+	*Also on Dee Gee, 300-pc.puzzle, as well as Brown & Bigelow, 10 x 18, 100-pc. puzzle,© 1930. Note: An informal poll taken at the 1933 Fox convention resulted in a tie between this & Fig. 276 for "most popular print."*
			20 x 16	350+	
106	280	SC	medium	150	
	281	SC	medium	125	6 x 8 signed example appears in the Dec.,1909 issue of "The Christmas Echo" London & Ontario *Reversed Image found with Lucky-Strike Ad--"Nature in the Raw is Seldom Mild."* Found on a plaque adv. " Crystal Cave, Spring Valley,WI."*Top half of "Perfect Double" puzzle (titled).*
			postcard	35	
	282	SC	12 x 16	125(140)	
	283	SC	8 x 6	65-75	*Also found on " Big Star" puzzle. Jus the center--Indian & canoe-- has been found on a handkerchief box.*
107	284	SC	5 x 3	35-40	
	285	SC	6.5 x 8	45-60	*Also found on 1910 calendar.*

PG	FIG.	AVL.	SIZE	VALUE	OTHER COMMENTS
	286	SC	8 x 10	50-60	Title is "Good Day's Sport"
	287	SC	15 x 5	75-90	Title is "Fisherman's Luck"
			7 x 2.5	45	
108	288	SC	8.5 x 6	45	
	289	FC	7.5 x 6	45	*"Warehouse find" of about 500 old prints reported.*
	290	NC	9.5 X 7	50	
	291	FC	10 X 8	45	
109	292	SC	16 X 20	150+	
	293	SC	medium	75-90	
	294	SC	9 x 7	65(90)	
	295		9 x 13	110-125	
110	296	SC	4 x 11	95	
	297	NC	5 x 7	50	*Also reported with title, "Now I Tell You."*
			7 x 10	65	
			postcard	25	
	298	FC	16 x 12	75(145)	
	299	SC	5 x 3	45	
111	300	SC	5 x 7	45	5 x 7 extends slightly further to the left. *Title: "The Brook." Also found on a postcard titled "The Edge of the Woods, "* © 1903, R. Hill
	301	SC	7 x 5	45	
	302	SC	5 x 7	45	
	303	NC	9.5 x 7	45-50	
112	304	SC	5 x 7	45-50	*Appears to have been painted from a still photo in a brochure promoting the (1923?) movie, "The Covered Wagon, " starring-- Johnny Fox! See also, Book 2, Figs. 205 & 213.*
			8 X 10	60-75	
	305	SC	6 x 8	45+	
	306	NC	8 x 10	50	Copyright 1900 by Gibson *Also found on a 1904 advertising calendar.*
	307	NC	postcard	25	
	308	NC	11 x 17	60-75	Taber- Prang Art Co.,1913 *Sepia, 4 3/4 x 73/4.*
113	309	SC	tiny	45	
			20 x 16	100(200)	
	310	SC	8 x 11	50	*Title: " In Green Pastures."*
	311	SC	9 X 14	55	
	312	LC	med-lg.	75+	
	313	SC	8.5 x 11	75+	
114	314	NC	3 x 7	40	1916 Calendar
			8 x 11	50	Title is "A Cool Retreat."
	315	NC	9 x 12	50-60	Also found on a postcard.
	316	SC	8 x 10	60-75	Copyright, F.A. Schneider
	317	NC	9.5 X11	55	
			signed puzzle	90	
115	318	SC	22 x 14	75	
	319	SC	8 x 11	50	Also found titled "At Peace with the World" **VERY** similar print found with no sig., 5 x 7 titled " At Peace with the World." Also on wooden "library puzzle" by J.L.Hudson Co
	320	SC	8 X 6	45	Pieces & shapes.
	321	SC	med-lg	60-70	These cows have been found with a different background on an unsigned, untitled print.

PG	FIG.	AVL.	SIZE	VALUE	OTHER COMMENTS
116	322	SC	7 x 9	50-60	
	323	LC	med-lg	50-60+	
	324	SC	med-lg	75-90	
	325	SC	3 x 2	25-30	
	326	SC	medium	60	
			postcard	25	
117	327	SC	medium	50-60	
	328	NC	9 x 12	50-60	*Also found as two separate, titled prints: Left half titled, "Homeward Bound," with sig; Right half titled "Winding Their Homeward Way."*
			16 x 20	75-90	
	329	SC	3 x 2	25	
			9 x 7	45-50	
	330	SC	5 x 3	35+	
118	331	SC	10 x 8	55	
	332	SC	medium	50-55	
	333	NC	11 x 10	60	
	334	SC	3 x 2	25-30	*Also 12 x 18 puzzle*
			6 x 4	35-40	
119	335	SC	4 X 6	45-50	
	336	SC	9 X 12	50-55	Also found titled "Supper Time"
	337	NC	16 x 24	150+	*Original reportedly hangs in the Nat'l Museum of Racing, Saratoga Springs, NY, a gift from Mrs. John McCabe, widow of the jockey who rode Old Rosebud.*
			on tin	300	
	338	SC	8 x 20	70-80	*Also found with different bkgrnd- just trees, no bldgs., & © 1902, Chad Williams.*
	339	SC	9 x 12	75-90	
120	340	SC	calendar	75-90	
	341	SC	6 x 8	55	
	342	SC	medium	65-70	Right portion found with title, "Good Morning!"
	343	SC	small-med	50-75	
	344	NC	5 x 11.5	75-80	
121	345	SC	13 X 16	75-90	
	346	NC	medium	65	Title is "An Afternoon Call"
	347	SC	medium	65-70	
	348	SC	3 x 2	35-40	
122	349	NC	9 x 7	60-70	Also found on thermometer. **Also found on fan.**
			17 x 10	90-100	Some versions show entire basket.
	350	FC	10 x 12	60	Also on a signed "Picture Perfect Puzzle" - $100 *Found with title, "Hold It," on a Deluxe Picture Puzzle. Also found on several TUCO puzzles.*
			16 x 20	75-80	Also found on a 3.5 x 3 cigarette case.
	351	SC	6 x 8	45-50	Also found as bookplate in 1927 "Chatterbox" Magazine. *Also found with title, "Toeing the Mark."*
			postcard	25-30	Postcard title is "Young Dogs."
	352	SC	medium	60-75	
	353	SC	5 x 7	50-60	
123	354	NC	postcard	25	
	355	NC	postcard	25	
	356	SC	postcard	25-30	Reissued by Hallmark (1990) from their historical coll. Value is for old card.
	357	SC	postcard	25-30	

PG	FIG.	AVL.	SIZE	VALUE	OTHER COMMENTS
	358	SC	medium	75-90	
	359	SC	16 x 15	75-90	Found on a 1921 calendar.
	360	SC	7 x 9	50	
124	361	NC	8 x 7	50	
	362	SC	9 x 7	55	
	363	SC	12 x 10	60-70	
	364	FC	10 x 8	50-60	
125	365	SC	12 x 9	50-60	Title is "Over the Top"
	366	SC	5 x 3	35-40	
	367	FC	15 x 11	50-60	*Also 20 x 16. Found on cover of Oct., 1930, "Western Funeral Director," pub. by Wichita Casket Co., Wichita, KS Cover is titled, "In the North Woods." These deer are found with a different bkgrnd. on an unsigned print titled "When Morning Wakens in the Hills."*
			20 x 12	60-75	Also on Adv. thermometer.
126	368	SC	5 X 3	35-40	
	369	NC	10 X 8	65	*Also unsigned, untitled TUCO puzzle, and Guild puzzle, titled on box.*
			15 x 19	90	On a 1940 calendar.
	370	SC	5 x 3	35	
	371	NC	14 x 9	65	
127	372	NC	9.5 x 7	60	Also on adv. thermometer.
	373	SC	9 x 6	55	
	374	SC	5 x 3	35	
128	375	NC	18 x 14	70-80	
			20 x 16	90-100	
	376	SC	medium	65	Also found with title, "Bruin's Watering Place." *Also on 1912 calendar.*
	377	SC	5 x 3	35-40	*In a 1925, Thos, D. Murphy Co., salesman's sample catalog, the writer of the blurb that accompanied the illustration of "Sittin' Pretty" said (among other things) that "(RAF) is a man of real genius and if he had not cheapened himself by painting for some of the second-rate houses, he might take very high rank among American Artists." (!)*
129	378	SC	5 x 3	35-40	
	379	SC	17 x 25	125	
	380	FC	4 x 3	35	Found titled, "The Silent Rockies" *Also found in 7x7 on 1934 calendar - scene extends farther to right.*
			9 x 7	50	
			14 x 11	60-70	1934 sample calendar
			7 x 7	45	Found on 8" sq. box labeled "Ladies Embroidered Handkerchiefs, 1/4 doz."
	381	FC	5 x 3	35-40	*Also found on a two-sided, 36-pc. "Princess" puzzle, signed & titled.*
130	382	SC	medium	75-90	
	383	FC	4 sizes	55-90	
	384	SC	6 x 8	45	Copyright by Charles Williams
	385	SC	11 x 19	75-90	
	386	SC	5 x 3	35-40	Also found on a blotter.
131	387	SC	15 x 5	65	Title is "Their Journey's End."

PG	FIG.	AVL.	SIZE	VALUE	OTHER COMMENTS
	388	SC	small	35-40	*This has been found, with a different background, on an unsigned advertising blotter.*
	389	SC	15 x 5	65	Title is "The Feeding Ground." Copyright 1911, Redwing
32	390	SC	5 x 3	40-50	
	391	SC	5 x 3	35-40	
	392	SC	5 x 3	35-40	

INDEX TO "R. ATKINSON FOX: HIS LIFE AND WORK"

Title	Fig.	Color Pg.	Title	Fig.	Color Pg.
A Brother Elk	366		Elysian Fields	227	C-101
A Campfire Girl	261	C-102	Enchanted Steps	184	
A Danger Signal	371		English Garden	191	
A Fallen Monarch	114		Eternal Hills	376	
A Grizzled Old Grizzly	378		Forest Fire	364	
A Jersey Homestead	172		Fountain of Love	200	
A Legal Holiday	344		Four Chums	316	
A Mountain Lake	141		Garden of Contentment #78	217	
A Mountain Paradise	75		Garden of Contentment #15	273	
(Description is reversed with Fig.76)			Garden of Happiness #63	216	C-101
A Neighborly Call	345		Garden of Happiness #68	204	
A Peaceful Summer's Day	303		Garden of Hope	186	C-99
A Quiet Pool	384		Garden of Love	198	
A Racing Model	370		Garden of Nature	190	
A Royal Outlaw	382		Garden of Realm	203	
A Shady Pool	308		Garden Retreat	192	
A Shady Pool	309		Garden of Romance	199	
A Sheltering Bower	367	C-104	Guardians of Liberty	295	
A Speedy Pair	368		Great Fall of Yellowstone	139	
A Thrill Before Breakfast	288		Going to Sun Mountain	143	
A Trusty Guardian	360		Good Ship Adventure #17	165	
A York State Homestead	171		Good Ship Adventure	55	
After the...	70		Glorious Vista	79	C-97
An Ambassador of Good Will	225		Generals Foch, Pershing...	292	
An Approaching Storm	306		Geyser	61	
An Efficient Guardian	359		Haven of Beauty	213	
An Old-Fashioned Garden, #12	180 & 24		Head of the Canon	119	
An Old Oak	83		Head of the Herd	386	
At Your Service	347		Heart's Desire	182	C-98
Autumn Gold	90		Heart of the Hills	235	
Battle of the Wild	369		High Up in the Hills(The Mntns.)	375	
Beatrice	248		His Last Cartridge	289	
Beauties of the Country	255		Holding an Investigation	354	
Blooming Time	197	C-100	Home Sweet Home	176	C-98
Blossom Time	177		Hunter's Paradise	350	
Bluegrass Beauties	262,263		Indian Paradise	282	
Blue Lake	210		Indian Summer	383	C-104
Bubbles	272		In Flanders Field	127	
By the Waterfall	96		In Meditation Fancy Free	276	C-103
Canadian Landscape	65		In Moonlight Blue	275	
Capital and Labor	348		In My Garden of Dreams	232	
Chicago, MIlwaukee, St.Paul & Pac.	223		In Pastures Green	323	
Children of the Forest	392		In Quiet Pastures	321	
Cleo	250		Inspiration Inlet	93	
Clipper Ship	164	C-98	In the Enemy's Country	379	
Comrades	265		In theValley of Enchantment	229	C-101
Coralie	247		Jealousy	267	
Country Garden	188	C-99	Just Out	356	
Dandelion Time	123		King of the Clouds	391	
Daughters of the Incas	278		King of the Silvery Domain	372	
Daughter of the Setting Sun	277		Land of Dreams	209	
Dawn	241	C-102	Land of Sky Blue Waters	74	
Daydreams	233		Land Where Shamrock Grows	81	
Down in Old Virginia	173		Look Me in the Eye	381	
Down on the Farm #119	324		Love's Paradise	238	
Down on the Farm #205	158		Love Birds	211	C-100
Dreamland	189	C-100	Maxine	249	

TITLE	FIG.	COLOR PG.
Memories of Childhood Days	181	
Midsummer Magic	208	
Minnehaha Falls	152	
Moonbeam Enchantment	94	
Moonlight and Roses	202	C-100
Moonlight on the Camp	290	C-103
Morning Mist	71	
Mother's Day	294	
Mountain Vista	118	
Mount Hood	111	
Mount Ranier	146	
Music of the Waters	244	
My Pet	259	
Nature's Beauty	201	
Nature's Charm	97	
Nature's Grandeur	219	C-101
Nature's Mirror	85	
Nature's Retreat	193	
Nature's Silvery Retreat	362	
Nature's Sublime Grandeur	138	
Nature's Treasure	207	
Near Close of Day	333	
'Neath Turquoise Skies	115	
Niagara Falls	153	
Noble Protector	271	
No One at Home	357	
Oaks by the Roadside	105	
October Days	84	
Off Treasure Island	167	
Old Ironsides	166	
Old Pals	264	
Old Rosebud	337	
On the Range	313	
On the Road	260	
Our Country Cousin	256	
Path to the Valley	102	
Pax Vobiscum	302	
Peace	336	
Peace & Plenty	319	
Perfect Day	220	
Playmate Guardian	349	
Play While You May	390	
Pleading at the Bar	342	
Poppies	221	
Precious	269	
Pride of the Farm #225	254	C-102
Pride of the Farm #235	317	
Promenade	185	
Prospect	194	
Ready for Anything	351	
Ready for the Day's Work	340	
River of Romance	160	
Rocky Mountain Grandeur	136	
Rocky Waterway	140	
Romance Canyon	230	
Rose Bower	218	
Russet Gems	169	C-98
Sapphire Sea	72	C-97
See America First Series	63	
Sitting Pretty	377	
Signs of Prosperity	322	
Spirit of Adventure	162	
Spirit of Youth	228	
Spring Beauties	124	
Stately Sentinels	87	
Stephanie	246	C-102
Supremacy	163	C-98
Sunrise	234,235	
Sunset	104	
Sunset Dreams	236	
Sunset in the Pines	361	
Sunset Rock Lookout Mountain	145	
Sweet Ol' Spot	168	

TITLE	FIG.	COLOR PG.
The Approaching Storm	134	
The Bridal Veil of Yosemite Falls	116	
The Bridal Veil Falls of Yos. Valley	147,148	
The Buffalo Hunt	281	
The Covered Wagon Crossing ...	304	
The Edge of the Meadow	326	
The Forest Primeval	363	
The Forest Primeval	373	
The Golden Gate at San Francisco	132	
The Good Shepherd	298	C-103
The Guardian	358	
The Magic Pool	206	
The Mediterranean Coast	89	
The Mountains	375	C-104
The Mount of the Holy Cross	108	
The Natural Bridge of Virginia	149,150	
The New Overland Express	224	
The Old Cowpath	330	
The Old Fishing Hole	284	
The Old Folks	299	
The Old Home	170	C-98
The Old Mill	155	
The Old Road	156	
The Old Swimming Hole	270	
The Patriarch	374	
The Pioneers	385	
The Political Argument	297	
The Prize Winner	257	
The Road of Poplars	107	
The Roundup	291	
The Sunny South, #224	159	C-97
The Sunny South, #69	183	C-99
The Valley of Enchantment	231	
There's No Place Like Home	178	
Thoroughbreds, #282	341	
Thoroughbreds, #176	343	
Twilight	237	
Twilight Glories	73	
Two Old Cronies	339	
Under the Oaks	312	
Valley Farm	258	
Valley of Golden Dreams	77	
Venetian Garden	215	
Vikings Bold	161	
Washburn/Langford Expedition ..	151	
Wayside House	48	
Well Done	285	
Wending Their Way Homeward	328	
When Evening Shadows Fall	301	
When Shadows Lengthen	331	
Where Dreams Come True	95	
Where Nature Beats in Perfect...	175	C-99
Where Skies are Blue	311	
White Feather	279	
Who Are You?	355	
Working Overtime	388	

INDEX BY FOX LIST NUMBER (F.L.) TO FIGURE NUMBER IN BOOK (FIG.)

F.L.	FIG.	F.L.	FIG.	F.L.	FIG.	F.L.	FIG.	F.L.	FIG.
1	241	65	220	129	249	193	294	257	122
2	140	66	362	130	252	194	338	258	120
3	200	67	211	131	250	195	166	259	91
4	228	68	204	132	259	196	176	260	129
5	210	69	183	133	251	197	350	261	374
6	79	70	227	134	139	198	130	262	366
7	215	71	290	135	332	199	71	263	386
8	208	72	169	136	111	200	231	264	388
9	144	73	379	137	142	201	102	265	378
10	185	74	206	138	233	202	95	266	390
11	360	75	164	139	163	203	212	267	377
12	24	76	127	140	65	204	213	268	392
13	238	77	125/126	141	77	205	158	269	381
14	209	78	217	142	143	206	371	270	368
15	273	79	187	143	196	207	297	271	391
16	201	80	188	144	96	208	351	272	370
17	165	81	192	145	82	209	281	273	155
18	67	82	203	146	149/150	210	291	274	156
19	109	83	177	147	145	211	83	275	330
20	186	84	266	148	168	212	73	276	300
21	110	85	134	149	178	213	101	277	284
22	219	86	132	150	232	214	295	278	270
23	236	87	76	151	99	215	315	279	293
24	349	88	97	152	92	216	354	280	63
25	87	89	269	153	356	217	117	281	128
26	107	90	271	154	357	218	244	282	341
27	94	91	207	155	175	219	355	283	27/287
28	301	92	98/100	156	282	220	344	284	310
29	298	93	214	157	103	221	152	285	389
30	234/235	94	89	158	72	222	153	286	154
31	229	95	318	159	66	223	303	287	387
32	230	96	367	160	365	224	159	288	299
33	226	97	193	161	105	225	254	289	364
34	237	98	114	162	123	226	339	290	361
35	383	99	146	163	277	227	64	291	267
36	262/263	100	174	164	280	228	304	292	384
37	197	101	276	165	260	229	288	293	311
38	257	102	81	166	69	230	255	294	340
39	202	103	70	167	377	231	336	295	*
40	199	104	116/148	168	68	232	275	296	205
41	189	105	119	169	306/307	233	256	297	*
42	198	106	376	170	363	234	272	298	75
43	108	107	118	171	373	235	317	299	80
44	84	108	115	172	162	236	385	300	345
45	221	109	369	173	161	237	314	301	141
46	218	110	342	174	382	238	265	302	112
47	240	111	358	175	124	239	264	303	359
48	195	112	327	176	343	240	285	304	347
49	170	113	309	177	352	241	372	305	181
50	248	114	316	178	160	242	113	306	320
51	289	115	302	179	85	243	286	307	283
52	106	116	308	180	88	244	331	308	135
53	258	117	326	181	78	245	239	309	279
54	375	118	312	182	104	246	319	310	15/16/223
55	182	119	324	183	261	247	121	311	*
56	184	120	313	184	167	248	136	312	334
57	191	121	321	185	151	249	130	313	137
58	93	122	323	186	328	250	329	314	157
59	86	123	171	187	245	251	305	315	296
60	353	124	172	188	74	252	322	316	224
61	278	125	173	189	190	253	179	317	225
62	346	126	246	190	90	254	*	318	380
63	216	127	248	191	333	255	133	319	268
64	138	128	247	192	292	256	335	320	253

*Publisher omitted because of photo quality
(or lack thereof)

A CAVEAT TO COLLECTORS

This book is intended to reflect market values. It is not an attempt to set prices. A number of factors can affect the price a print will bring: geographic area, supply and demand, condition and color of the print, and desirability of the frame, to mention a few.

Collectors should be aware that the print market is a particularly fickle one (reproductions and "warehouse finds" are but a few elements that can cause the value of a print to plummet.) Buy prints because you love them and want to live with them rather than because of the possibility the print will increase in value.

KEY TO ABBREVIATIONS
UNDER "AVAILABILITY" (AVL.)

LC Library of Congress. Print was photographed at the Library of Congress and may not have been found on the open market.

SC Scarce. Has been found on the open market at least once.

NC Not Common. Self-explanatory.

FC Fairly Common. Self-explanatory.

HSA Highly Sought After. Can increase the value of even a commonly available print.

Values provided here presume a print is in mint or near mint condition (no wrinkles, tears, stains, or fading) and is signed. The frame should be in good condition and representative of the period:

1900-1920 Flat wood, usually brown or dark green - sometimes with carving or a touch of gilt.

1920-1935 More ornate, often elaborate, with more of the Art Deco influence.

Frames can seldom be said to be "original" to the print because so many of these prints were found on calendars or other forms of advertising. Sometimes they were sold or distributed as unframed prints. The owner then put the print into a frame, presumably of the period. Unfortunately, the owner did not always have available a frame of the exact size, and prints are often found trimmed, a condition that can seriously deplete the value.

Exceptions are prints such as No. 31, "In the Valley of Enchantment," which is in an elaborate frame bearing the name of the advertiser, and those cut by the manufacturer to fit specially shaped frames.

Where a range of prices has been reported, I have tried to indicate that range without going too far afield. I don't think, for example, that it would be helpful to report a range of $6 to $75 for a print, even if I know one sold for $6 and another sold for $75, when typically most examples of the print are selling in the $35 to $40 range. I will, however, let you know about that isolated sale for $75 by placing it in parentheses ($75). Parentheses around a print indicate two things: (1) Someone, somewhere, sometime was willing to pay that much for the print; (2) The market does not indicate a price that high.

Where a print is listed as "scarce" or "one only," value is based on general market appeal and the price collectors have indicated they would be willing to pay.

Finally, in most cases, sizes are rounded off to the nearest whole number, eliminating fractions. Wherever possible, I have indicated height first in reporting the size of a print.